THE DAILY BOOK OF

PHOTOGRAPHY

SIMON ALEXANDER

GRIER COOPER

BILL DILLER

DAVID GREENBERG

TOM HAUCK

MELISSA LaRose

MATTHEW ROHARIK

DAVID J. SCHMIDT

CHRISTINE WALSH-
NEWTON

Introduction

Photography is truly "the people's art." Just as nearly anyone can become a teller of stories with words and voice, a photographer can be defined as someone who owns a camera and knows how to shoot it. The ability to grab any image of the world and call it yours is a heady experience. New ways of sharing images through social media fuel the flames of telling visual stories by bringing an audience to the table.

Our book celebrates the fact that photography seduces us by its accessibility, while illuminating the brilliant minds among us who have carried the art to new heights. While anyone can take a picture, it takes a gift of perspective, patience, and visual acuity to create iconic images that transcend the ordinary. Ansel Adams, Richard Avedon, Irving Penn, and Sally Mann all placed their unique fingerprints on the art and have much to teach us.

The following pages offer information, instruction, and visual storytelling from talented photographers and writers. Through accounts of photography's history as well as its deep power to change public opinion and question social norms, you will discover a new perspective of life around you, whether you are behind the camera or not.

Erika Kotite, *Editor*

PHOTOGRAPHY 101

 Photography can be more than taking pretty pictures. It can be recording a special moment in time and documenting memories important to you and your family. It can be an artistic outlet, an exploration of colors and light. For the luckiest of us, it can be a career.

No matter the purpose, the result will be the same. We'll go over some basic camera instruction without getting too mired down in technical terms and then we'll work on how to capture pleasing, well-composed photographs.

To adequately understand the concepts that will be covered, obtaining a basic 35mm or digital SLR camera is suggested. If you don't own a camera, you'll still be able to understand the concepts, but it may take a bit more effort on your part.

The sophistication level of the camera does not matter for the purposes of Photography 101. Maybe you've inherited grandpa's old trusty Nikon with several confusing dials or have been gifted with a new digital camera with so many bells and whistles you don't know what to touch first. The basic concepts apply fairly evenly to this family of cameras.

Welcome to class! — Christine Walsh-Newton (CWN)

THE DAILY BOOK OF

PHOTOGRAPHY

THIS BOOK BELONGS TO:

Walter Foster Publishing, Inc.
3 Wrigley, Suite A
Irvine, CA 92618
USA
www.walterfoster.com

ISBN-13: 978-1-60058-211-0
ISBN-10: 1-60058-211-7

Authors: Simon Alexander, Grier Cooper, Bill Diller, David Greenberg,
Tom Hauck, Melissa LaRose, Matthew Roharik, David J. Schmidt, and
Christine Walsh-Newton
Project Manager and Editor: Erika Kotite
Associate Publisher: Elizabeth T. Gilbert
Copyeditors: Marla Markman and Emily Smith
Designer: Shelley Baugh
Production Artist: Debbie Aiken
Production Manager: Nicole Szawlowski
International Purchasing Coordinator: Lawrence Marquez

Printed in China.

10 9 8 7 6 5 4 3 2 1

HISTORY OF PHOTOGRAPHY

 Pardon the pun, but photography did not "develop" overnight. The history of photography is long and complicated, filled with fascinating characters from ancient China, Greece, and Arabia; Renaissance Italy; 18th- and 19th-century France, England, and the United States; and 20th-century Germany and Japan. The history of photography involves science, technology, art, and business.

Photography differs from most other ancient art forms because it is a mechanical art. In the way that painters use paint and sculptors use tools, the practice of photography requires a machine: a camera. So evolving technology and mechanical invention is as important in photography history as the trail of images themselves.

From the camera obscura to the camera phone, Daguerreotypes to digital, photograms to Photoshop®, the ways in which we make pictures today differ dramatically from the methods used even a generation ago. But high-tech as it is, modern photography belongs to a rich tradition of innovation, of shutter snapping and image making that mirrors nothing less than our development as human beings.
—David Greenberg (DJG)

FAMOUS PHOTOGRAPHERS

The pages of Famous Photographers will take you on an inspiring journey of creative excellence. Each of the following artists defined and shaped the art of photography into what it is today. There are those who created the mold for others and those who did something completely unprecedented. Regardless of which route was followed, their pioneering, creative brilliance led them to create memorable images. Each of them contributed to the world of photography in a significant way, and forever changed our view of the world.

While it is impossible to address every aspect of the lives of these photographers, it is interesting to note the defining characteristics of their contributions to the field of photography. For some, success came quite easily, while others struggled tirelessly. All, however, share the common denominators of persistence paired with passion, and vision honed with focus. The result is photographs that speak to every human heart.

Each photographer's journey leads somewhere: the peaks of Yosemite, remote deserts, Parisian city streets and cafés, even the underbelly of society. The simple forces of inspiration and desire can lead to some very unusual places. But when an artist is willing to follow these inner promptings, magic ensues. —Grier Cooper (GC)

NATURE & LANDSCAPES

For those who enjoy photography, the natural world provides an almost unlimited supply of subjects. From sunrises and sunsets to flowers and wildlife . . . from snow, fog, and mist to ice-covered trees or vast panoramas stretching to the horizon, the variety is astounding and limited only by imagination. What else beats the satisfaction of preserving a breathtaking natural scene that will bring pleasure for many years to come?

Nature and landscape photography can be enjoyed by everyone, from amateurs to professionals, and is an affordable way to practice photographic arts. The quality of digital cameras is constantly improving, while the price drops. You get both immediate recognition of success or failure when you snap the shutter, and less expense by not having to buy film or pay for processing. If the shot didn't work, delete it and try again. For the traditionalist, this new technology has caused the price of film cameras to drop dramatically. A nature photographer couldn't ask for a better deal.

Whether stalking a wildflower or trophy elk, contemplating an ocean sunset or desert sunrise, trekking through a forest carpeted with fallen leaves or meandering along a snow-covered stream, nature's beauty calls to the photographer "Take my picture. Remember me." —Bill Diller (WTD)

PORTRAITS

Modern portrait photography can be seen everywhere, from your driver's license to your own Facebook page. In terms of a career in photography, portrait photography is still the most popular profession and very much in demand. The best portrait photographers are not only able to make a technically perfect image, they can also make an iconic, dramatic, or even humorous one. They do this while allowing the sitter to enjoy the experience.

The portraits in this book exemplify the varied subgenres within the portrait genre itself, from a simple black and white image to a complicated strobe set up to freeze the motion of a jumping shot. All the subjects shown here represent my collaborators in their portrait photograph, and as such I thank each one for working with me and making my life as a photographer a rich and joyous one.

Some say a great portrait photograph shows a window into the soul of the person being photographed, others argue that a photographer can only hint at the essence of a personality. Make up your own mind and be inspired to try some of the subgenres yourself and see what you can accomplish. —Simon Alexander (SA)

SPORTS & PHOTOJOURNALISM

 Photojournalism is the process of telling stories through photos. Very often, the one thing that draws a reader into an article is a photograph.

Assignments, although sometimes self-generated, are typically initiated and guided by a photo editor. It is not an easy business—obstacles such as location access, time restrictions, other photographers, and the never-ending worry about the weather are always present. Planning the shot and visualizing how it will be used is a good way to temper the challenges and have fun in the process.

The photographer sets out to capture people and events objectively; however it is nearly impossible to not allow your feelings about the subject to be represented in the image. This isn't necessarily a bad thing; essentially it is the human element that distinguishes one photojournalist from another.

Besides sharing the story behind each assignment, the Sports & Photojournalism category explores the mindsets and techniques used in pursuit of the perfect shot. These images are the results of timing, anticipation, and what I call "prepared luck." The reward after all your hard work? A shot that you envisioned in your mind's eye becomes the visual complement to a writer's article. —Tom Hauck (TH)

FASHION & BEAUTY

Fashion and beauty photography is a fast-paced, ever-changing, and thrilling art that almost every aspiring photographer contemplates and is influenced by during his or her career.

Fashion photography is a team effort, in which the photographer is the visionary and leader in executing a concept. As director of the entire image-making process, a photographer must cast models who have the right look and posing ability, convey the image concepts to the makeup artists and hair stylists, and find the right clothing and accessories. The final image ideally is greater than the sum of its parts.

Defining, creating, and capturing that which is aesthetically pleasing to a viewer is the essence of beauty photography. The process is much the same as fashion photography, with less emphasis on the clothing and more on the quality of the model's skin and facial features. Like a Renaissance painter, a beauty photographer uses light as a paintbrush to emphasize and celebrate the sensuality of the body and the unique features, symmetry, and bone structure of the subject's face.

A photographer starts the journey into fashion and beauty photography by mastering each one independently. It's a worthy goal: joining other image-makers who capture the elusive and mercurial beauty of clothing and the human form.
—Matthew Roharik (MR)

PHOTOGRAPHIC CURIOSITIES

Long before the age of digital editing, intrepid individuals had devised clever methods for falsifying and altering photographs, with motives ranging from the benign to the nefarious. Photography often treads the delicate limbo between reality and fantasy—and defies our definition of both. As an art form, it allows the photographer to create images that have never been materially possible. Many of these creations show us deeper dimensions of reality beyond the accidental details of this material plane.

For some, photography is more than a medium for self-expression—it is a tool for shaping the very metaphysics of the world around them. New creations take on a life of their own in the fashion of the Tibetan tulpa or the Jewish golem.

Likewise, the scores of contemporary legends involving photography challenge our concept of verisimilitude. Many of these stories, while never traced to an historical occurrence or actual photographer, express deeper messages that transcend the historicity of an account. Photographic lore, as you will experience in these pages, brings to mind the apocryphal account of the Native American storyteller who used to preface every legend with this prologue: "I don't know if this story ever happened before, but it's still true." —David J. Schmidt (DJS)

GALLERY OF INSPIRATION

Photography has entered a new age, further expanding the definition and result of picture-taking. Our Gallery of Inspiration is where we showcase the work of contemporary photographers who are exploring the medium in new and exciting ways.

There are three places in the evolution of a photographic image where innovation and opportunity converge—before the shot, in composition and subject matter; during the shot, in exposure techniques; and after the shot, using the rich processing tools in the darkroom and through image-editing software.

With techniques ranging from High Dynamic Range (HDR) to tampering with old-school papers and process for new results, nothing is beyond the scope of a photographer whose favorite two words are "What if…?"

Just like a true gallery where the image is the thing, this category is extremely visual in nature, with just a brief description of a technique, an inspiration, or perhaps the story behind the art.

Just be warned: We didn't call it Gallery of Inspiration for nothing. —Walter Foster Publishing

SOCIAL & POLITICAL COMMENTARY

 Photographs centered around social and political commentary afford a moment of reflection about life and the times we live in. Social and political commentary require the same elements of composition found in any other photograph but with an added layer—they are meant to inform, affect, and change the lives of the viewer.

Approaching topics of a social nature with a camera in hand provides a profound opportunity for growth on the part of the photographer. Not only is the photographer examining her own world, she is also investigating the world of her subjects. Figuring out how to do this requires some thought about one's personal beliefs and barriers, both real and perceived.

Political power is fleeting and therefore the photographs may be context-specific—what was an object of political power in one era may not be so in the next. Yet the images can become buried in the minds of a nation and hold power long after they are presented.

How does a photographer step inside a social topic? Where is the entry point? How does a photographer discover the story behind the topic? What compositional techniques might be used for certain political or social issues? How are the photographs presented here affecting you? Will you ever look at photographs the same way again?

Photograph your world and create your own social and political commentary. —Melissa LaRose (MLR)

Camera-derie

USE IT OR LOSE IT

Almost everyone owns at least one camera. It could be a film camera, a cell phone camera, or a digital camera. You may have started by borrowing the camera of your parents to take photographs. During the time I employed this tactic, the common film camera models took 110 film. After years of constantly borrowing her camera, my mother gave into my whim, purchased a SLR (single lens reflex) camera and enrolled me in an adult education course in photography. Thirty years later, I now use digital SLRs (DSLRs) in my photography business.

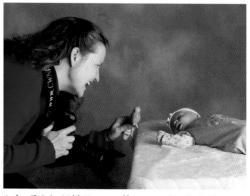

Author Christine Walsh-Newton and her young subject having fun on a photo shoot. Photo © Christine Walsh-Newton.

People have a myriad of reasons for purchasing a camera. For some, it may be to record memories or perhaps to satisfy a wish of pursuing photography as a hobby. For others, it may be for business purposes or because they make their livings as photographers. Whatever the reason, surprisingly, a study conducted in 2007 by the Photo Marketing Association indicates that only 20 percent of camera owners actually use their camera to exercise their artistic skills or to master photography skills.[1]

Let's raise that percentage. Through the "Photography 101" topic series, we will study the basics of camera operations and functions and then address different ways to improve your photography skills using a variety of artistic rules and concepts. Finally, we will review methods in printing, preserving, and displaying the product of your new artistic and improved photography skills.

Let us begin the journey from "camera owners" to "photographers"! —CWN

Ancient Times

GLIMMERS OF LIGHT

Camera obscura (from Latin for "dark room" or "darkened chamber") is a large room or box with a tiny hole in one side, through which light passes through and casts an upside-down image of whatever was directly outside. This principle was one of the major precursors to the development of photography.

While Arab scientist Ibn al-Haytham is credited with building the first camera obscura in or around the year 1021 AD, prior to that Chinese philosopher Mo-Tzu and Greek philosopher Aristotle both wrote of the principles surrounding the images created by light passing through a small opening.

In the 13th century, Roger Bacon described the camera obscura as a safe method with which to observe eclipses. Leonardo da Vinci refers to the camera obscura in "Codex Atlanticus."

Beyond the world of science, the device also found applications in the work of artists, who made use of the precise detail in the images, ultimately using tracing paper to copy them and then using the copies to advance the realism in their work.

By the 18th century, smaller more portable versions emerged and found favor with both professional and amateur artists who could carry them around and choose their subject matter. It was this type of small camera obscura that was later adapted by Louis Daguerre and William Henry Fox Talbot into early versions of what came to be known as a camera. —DJG

Ansel Adams (1902–1984)

CAPTURING THE GREAT OUTDOORS

Ansel Easton Adams, artist and activist, was known for his stunning black and white images of Yosemite National Park and the American West. His images captured the wild beauty of natural landscapes with clarity so acute that he has been called one of the most accomplished technical masters of photography. This clarity of detail was produced with

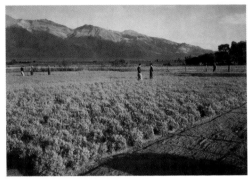

Guayule Field, Manzanar Relocation Center. Photograph by Ansel Adams. Manzanar War Relocation Center photographs LOT 10479-2, no. 3; Library of Congress Prints and Photographs Division.

the use of a large-format camera and the "zone system," developed with Fred Archer, which was a way to determine proper exposure and create flawless finished photographic prints with unparalleled depth.

Committed to promoting photography as a fine art, Adams was a founding member of Group f/64, which was instrumental in creating the first department of photography at the Museum of Modern Art in New York. It was here he met Nancy Newhall, and collaborated on a number of books and exhibitions, including the Sierra Club's *This Is the American Earth* (1960), which was pivotal in inspiring the environmental conservation movement.

A lifelong hiker and explorer, Adams spent a great deal of time in Yosemite. In 1919, he joined the Sierra Club, and was able to combine his love of photography and the pursuit of environmental activism. His photographs were first published in the club's bulletin and he served on the board of directors for 37 years. Adams endlessly traveled the country in pursuit of natural beauty, and fought for the preservation of park and wilderness areas. After his death in 1984, congress named 200,000 acres near Yosemite the Ansel Adams Wilderness area. —GC

Night Photography
FINDING LIGHT IN THE DARKNESS

When the sun goes down, most photographers put their camera away. After all, what's the sense of carrying it around when there's no light to shoot by? But, if you think about it, there is almost always a light source. Even miles away from anything man-made, there's starlight, and on a night with a full moon the landscape can take on ethereal qualities, especially if there's snow on the ground.

Light bouncing off a body of water can produce the same effect. When the lights of a village are reflected in the placid waters of a harbor, they glisten. The effect is eerie but serene. The hustle and bustle of daytime is done, and the peaceful tranquility of the night is apparent.

Taking a shot of a harbor at night requires the use of a tripod or other sturdy mount for your camera. Use a wide-angle lens and set the camera to Program mode. Compose your shot, set the self-timer, and press the shutter. —WTD

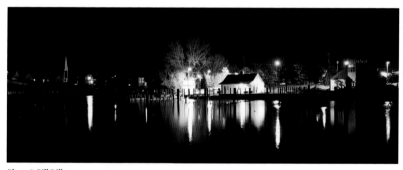

Photo © Bill Diller.

Double Exposure

KUNIE SUGIURA

For this portrait, I very much wanted to collaborate with the subject, who was an artist and made giant photograms. I asked her if could pay homage to her method, using the same shadowed outline of her subject, but this time it would be of her.

I was shooting with strobe light on slide film, thankfully using Polaroids® to check exposure. So I decided to shoot her against a lit white background and effectively silhouette her against it in the exposure. It worked well, and I had made my version of her photogram, but all I had was a shadow of her! Next I shot several rolls of her smiling, standing next to her life-sized photograms pinned to a wall, which I knew was what the editor wanted. I was about to call it a day, when I came up with a great idea of how to get the portrait and the silhouette of her all in one image: I would make a double exposure and shoot her twice on the same piece of film! This is a difficult process, so I discussed it with Kunie, who seemed delighted to work with me on this idea. The result shows her arranging flowers and her face inside her silhouette, which worked out really well. —SA

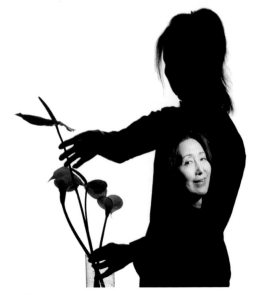

Photo © Simon Alexander.

Life as a Photojournalist

ALWAYS BE READY

As I am walking to an assignment, whether it is a stadium, golf course, or arena, I always keep a compact flash card in my camera and the camera out and ready to go. Sometimes the most interesting things happen unexpectedly right in front of you. If you have to dig through a bag, put on a lens, and insert a flash card, you will very likely miss your shot.

Here I was walking up to the Superdome in New Orleans and stumbled on an infamous fan known as the "Whistle Man." I was able to capture a few shots at a moment's notice. —TH

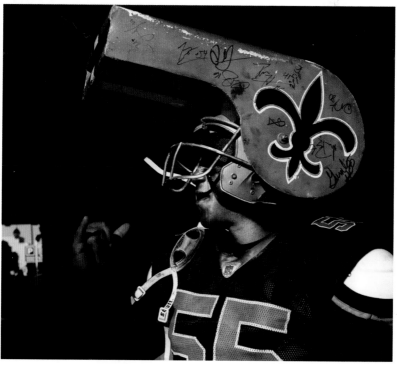

Photo © Tom Hauck.

The Model Test

SHOOTING AGENCY-REPRESENTED MODELS AND TALENT

The model test shoot is a great way to start building your fashion and beauty portfolio. The name "test shoot" is an industry term for testing a model's abilities and look on camera. New talent needs to test with photographers to gain experience and to fill their portfolio book and composite cards. (Composite, or "comp" cards, have several images of the model in various poses, clothing, and backgrounds. These are used to showcase the model's range and submitted by the talent's agency to book assignment work.)

At first as TFP, or trade for print, the model, photographer and makeup artist exchange their services for several finished prints furnished by the photographer from the photo shoot. In most cases, the photographer takes the initiative to set up the shoot and the coordination of the model and stylists. To find models that match your level of skill and experience, try Internet photography and modeling forums and local modeling agencies. When first starting out, approach the model and agencies with the best images possible and offer to work for TFP. Established photographers are often paid by the models for their services and recommended by talent agencies to their talent. At any stage of a photographer's and model's career, paid or unpaid model tests are a great way to test new ideas and keep your skills sharp. —MR

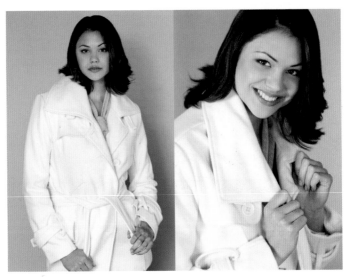

Photo © Matthew Roharik.

World's Smallest Camera

"SWALLOW THIS CAMERA AND CALL ME IN THE MORNING"

In this age of rapid technological developments, any attempt at definitively naming the "world's smallest camera" may very well be obsolete by the time this book goes to print.

Be that as it may, the electronics company Misumi appears to take the cake for now, having created the $^1/_{18}$-inch-wide CMOS camera chip. The chip can be used with a camera attached to a bendable wire, allowing it to be snaked through tracts in the human body or hard-to-reach pipelines; the "snake camera" can be equipped with varying lenses, offering up to a 105-degree field of vision.[1]

The camera chip is reportedly small enough to be swallowed by medical patients, or even injected through a large syringe.[2]

An honorable mention goes to the world's smallest camera plane, the DelFly Micro. Developed by a university in the Netherlands, the tiny dragonfly-shaped aircraft has a wingspan of 10 centimeters, weighing in at only 3 grams.[3]
—DJS

Soul in the Window

BY CHRIS AUSTERBERRY

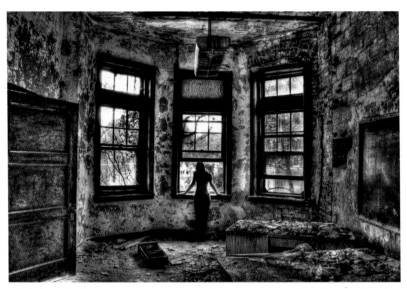

This image came as a result of an exploration of a mental hospital that had been abandoned for 25 years. The amazing textures and contrast in the rooms allowed for dramatic *high dynamic range* (HDR) images. (See box below.) Posing a female subject by a large window added a touch of romanticism to the tragic environment.

Chris Austerberry, Jr. is a freelance photographer and writer near Philadelphia, Pennsylvania. Specializing in HDR techniques, he enjoys photographing his eclectic interests, especially motorsports. http://austerberry.zenfolio.com

HIGH DYNAMIC RANGE (HDR) PHOTOGRAPHY

HDR photography involves combining photographs of varying exposures into a single image. When taking a normal photograph, we use exposure settings that give the photograph a balance of high and low light, compromising between the brightest and darkest elements in the environment. An HDR image blends different exposures of a scene to bring out detail in areas that would either be too bright or too dark in a single exposure.

Families

ROLE OF MOTHER

*M*igrant Mother captures the weariness, concern, and desperation of a woman caught in a personal plight that affects her family and their future. Captured by Dorothea Lange in 1936 as part of the Farm Security Administration's documentation of migrant workers during the Depression Era, the photograph is a time-tested icon of family as the core unit of society.

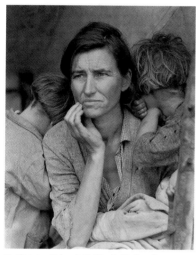

Destitute pea pickers in California. Mother of seven children. Age thirty-two. Nipomo, California, 1936 (Migrant Mother); Library of Congress, Prints & Photographs Division, FSA/OWI Collection, LC-USF34- 009058-C.

The central figure, a mother, is surrounded by her youngest children. The photograph is closely cropped, cutting off part of the figures and creating the visual illusion that the mother is actually more than herself, the whole of her responsibilities so large that they cannot be contained within the confines of the photograph. The use of a compact composition focuses the eye on the mother's face and reveals a hidden determination and strength that is at once worthy of assistance and support.

Lange spoke about taking the photograph, in an article published in *Popular Photography* magazine in February 1960, noting that only five photos were taken as she walked closer to the mother. —MLR

Definition of Photograph/Photography

LET THERE BE LIGHT

Merriam-Webster defines "photograph" as "a picture or likeness obtained by photography"[1] and "photography" as "the art or process of producing images by the action of radiant energy and especially light on a sensitive surface (as film or a CCD chip)."[2]

Whew! Don't worry, there's no test on this later. Let's simplify things a bit and say that photography is artistry with light. Light is the most important ingredient in photography (besides a camera). Without light, you will not be able to produce a photograph.

Many of the settings on a camera are concerned with light. The aperture (f/ stop) manipulates how much light reaches the sensitive surface referred to above, and the shutter speed controls how long the amount of light is allowed to be present. There's also an ISO setting that indicates the degree of sensitivity of the sensitive surface to the light. These three settings work in conjunction with each other to help you produce a well-exposed photograph.

At times, there isn't enough available light to produce a quality photograph. Fortunately, additional light can be introduced through the use of flashes and studio lighting. Most modern cameras come with a built-in flash, and many have additional flashes available that can be added onto the camera. For the majority of the "Photography 101" series, we will be working with available light and how to produce well-exposed photographs with your existing camera equipment. There's no need to purchase more equipment; the sun is free!

—CWN

The First Photograph

"SMILE!"

Frenchman Joseph Nicephore Niepce (1765–1833) is credited with what is widely accepted as the first photograph, that is, a permanent photographic image as opposed to one that deteriorated shortly after creation or upon attempts at duplication.

Beginning in the late 1700s, Niepce experimented with various types of pre-photographic devices to record images, including lithography and an early chemical process known as photo-etching. Some of Niepce's early photo-etchings have survived but are not considered photographs in the conventional sense. Niepce also experimented with the chemical silver chloride, which darkens when exposed to light, and ultimately looked to bitumen, which he used in his first successful attempt to record a permanent image.

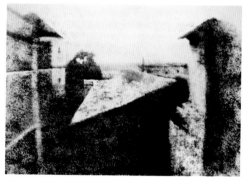

Photo by Niepce.

He dissolved the bitumen in lavender oil, coated a sheet of pewter, and placed the sheet inside a camera obscura to capture the picture. Eight hours later, he removed it and washed it with lavender oil to remove the unexposed bitumen. Niepce placed an engraving onto a metal plate coated in bitumen, and then exposed it to light. The shadowy areas of the engraving blocked light, but the whiter areas permitted light to react with the chemicals on the plate. When Niepce placed the metal plate in a solvent, gradually an image, until then invisible, appeared.

Niepce called the process "heliography" (from "helio" for sun and "graphein" for writing"), "sun prints" or "sun writing," and his first successful, permanent image, a view from his window created in 1825, is widely considered a prototype for the modern photograph. —DJG

Herb Ritts (1952–2002)

OUT OF THE DESERT

A self-taught photographer, Herb Ritts got his start in 1978, when a twist of fate left him stranded in the desert with friend and actor Richard Gere, whom he photographed in front of a jacked-up old Buick in a mechanic's garage.[1] Although he was working as a salesman at the time, the picture gained Ritts notoriety, and his career as a photographer quickly blossomed.

He is known for his black and white images that evoke the classic forms of Greek sculpture, with clean lines and strong forms glorifying the human body, showcasing its sleek, refined beauty juxtaposed with light and shadow. Figures so perfect they are almost surreal often appear against natural textures, such as clay, sand, branches, and desert.

Ritts captured the supermodel era of the 1980s, photographing well-known faces, such as Cindy Crawford, Christy Turlington, and Naomi Campbell. His editorial fashion work appeared in a diverse scope of magazines, including *Interview, GQ, Harper's Bazaar, Rolling Stone, Vogue, Vanity Fair,* and *Elle,* with portraits of celebrities from Madonna to Cher, and Dizzy Gillespie to the Dalai Lama. Additionally, he photographed for leading fashion designers, such as Giorgio Armani, Ralph Lauren, Chanel, Gianni Versace, and Calvin Klein.

In 2008, the Boston Museum of Fine Art opened the Herb Ritts Gallery; it is the museum's first permanent space dedicated to photography. Books of his work include: *Pictures* (1988), *Men/Women* (1989), *Duo* (1991), *Notorious* (1992), *Africa* (1994), *Work* (1996), and *Herb Ritts* (1999). —GC

Filling Shadows
PANACHE IN A FLASH

Photographers come in many sizes, shapes and styles. Some are creative, some aren't. If you want to be a photographer, you simply pick up a camera. The distinction comes after the shutter snaps. Good photographers never stop acquiring knowledge about their craft—tricks of the trade that enhance an image and make it more exciting to look at.

A photographer has the option of using only natural, ambient light, or to try and improve the shot by adding a touch of man-made light, to make the photograph pop.

A flower photo is always pretty, but it will look different depending on which direction the light is coming from. If the major light source is behind the flower, using the on-camera flash to fill in the shadows can greatly improve the picture. —WTD

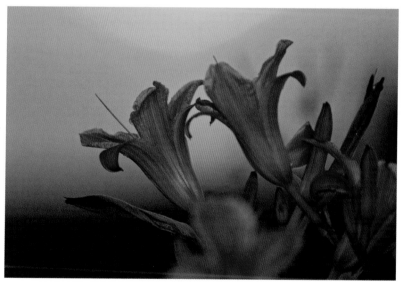

Photo © Bill Diller.

Capturing a Moment

D ROCK, HAIRSTYLIST

This is an extra image shot after a studio fashion shoot had ended. It's actually a shot of the fabulous hairstylist D Rock, who I had not worked with before. He was an amazing hairstylist as well as fun to be around. We had spent a day shooting a variety of beautiful images, beautifully lit and shot with elegance and calm, and I asked D Rock if I could also photograph him with his Elvis glasses on. We put on some groovy music and without me asking he just starting dancing to it, so I shot a few frames, and this was the moment I captured. In a sense this image brings out his essence of being to the fore; he was a star in that moment and was having fun, and it all came together in that split second that I pressed the shutter. —SA

Photo © Simon Alexander.

Toolbox Essentials

SAVING ME ON A RAINY DAY

Weather can present many challenges when photographing outdoors. Keeping you and your gear clean and dry, while important, may not outweigh the opportunity of capturing a unique shot. During a University of Arizona football game in Tucson, half the state's annual rainfall came down in an hour, causing the game to be suspended for more than an hour. Students passed the time by doing push-ups in the flooded stadium. I ventured out of dry cover to get the shot at the expense of getting soaking wet. My equipment fared much better because I have some really durable rain covers for camera bodies and lenses, which help prevent major water damage. —TH

Photo © Tom Hauck.

Fashion Stylist Team

ASSEMBLING YOUR A-TEAM

A makeup artist, hairstylist, and clothing stylist are top priority for fashion and beauty photography. One may have the perfect model in mind for a shoot, but if the makeup and hairstylists are not qualified, then the shot will not be as successful as you envisioned. Flawless makeup artistry is as important in beauty work as the latest clothing is in defining your statement in fashion photography.

Often a qualified makeup artist (MUA) can do both makeup and hairstyling; this is acceptable only when working with a single model or on a tight budget. For more ambitious projects a dedicated hairstylist and MUA is preferable, allowing each to concentrate on what she does best.

Clothing stylists are fewer in numbers than makeup and hairstylists. Some professional clothing stylists own a large collection of clothing and accessories; others have relationships with retailers or designers and can borrow the clothing for credit and/or a fee. Before meeting with a prospective stylist, have all your ideas well-planned so that they can be won over by a great concept.

Plan a one-on-one meeting with each stylist and review your portfolios and discuss your approach to your craft. Share your ideas for your shoots, and it will become evident if each of your working styles and abilities are a good fit. A good stylist team will make work seem like play. —MR

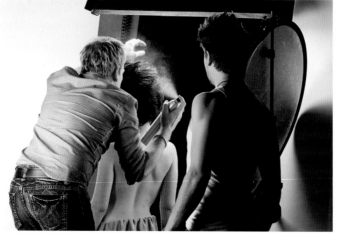

Photo © Matthew Roharik.

A Child's Dream Comes to Life
DRAWING FROM THE WELL OF YOUTHFUL IMAGINATION

For all who find themselves exasperated with the faceless mechanization of modern society, photographer Yeondoo Jung suggests a refreshingly human return to childlike innocence.

The Korean photographer collected several drawings created by kindergarteners in Seoul for the 2005 series, *Wonderland*. He then staged real-life reenactments of the drawings, creating live photographs of each child's fantasy. The scenes were recreated right down to the smallest detail (tailors were even hired to create costumes that mirrored the often mismatched clothing depicted in the children's drawings).

By exploring the fantasies, dreams, and wishes of children and adolescents, the photographer seeks to counteract the modern forces that threaten to hammer down the human soul into flat uniformity.

A similar vein of inspiration lies behind Jung's series, *Bewitched*. The photographer asked adolescents to tell him what their dream was, no matter how seemingly unattainable; he then used props, creative costumes, and scenery to create these scenes around their authors. One high-school student who longed to visit the South Pole was shot wearing fur clothing next to a papier-mâché igloo and two live husky dogs. On at least one occasion, Jung's work bled across the boundary between fantasy and reality—after one young boy from Istanbul was photographed in a portrayal of his dream job as a future math teacher, a local bank donated a grant for the student to attend college.[1] —DJS

Mini Mount of Olives

BY COLIN GILBERT

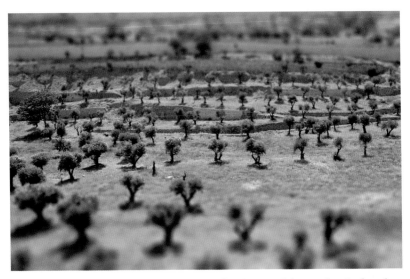

The trees in this picture may appear to be tiny model trees, but in fact they are real, living olive trees in the heart of Jerusalem. Tilt-shift photography tricks the eye into thinking it's looking at a miniature set. These kinds of images get their name from "tilt-shift" lenses, which allow photographers to manipulate the perspective and focus of their images. In digital post-production, the effect can be imitated by strategically blurring certain areas of an image.

Colin Gilbert is a photographer, writer, and educator living in Southern California. He specializes in travel, landscape, and HDR photography. www.colingilbertphoto.com

For a quick and easy way to try this effect with your own photos, check out www.tiltshiftmaker.com. Note that aerial photos are best suited for this kind of virtual shrinking because real model sets are typically viewed from above.

Uncle Sam Wants You

VIEWING THE SOLDIER

Uncle Sam is a personification of the U.S. Government. The phrase "Uncle Sam Wants You" began its life as a military recruiting slogan just prior to World War I and again during World War II.[1] The political power behind the image of the soldier has shifted many times during the last 100 to 150 years. Falling out of favor during the later part of the 1960s and through the 1970s and 1980s, the soldier returned to favor once again during the Gulf War and again with the onset of the Iraq War.

Each generation requires a new image of the soldier, and photography puts a spin on how the soldier is communicated to the public. The image of the soldier is often used to boost nationalism.

Now, the tables have begun to turn. Soldiers take pictures of each other, of their daily activities outside their jobs on the battlefield, and provide an intimate, human side to the age-old job of soldiering. This type of photograph 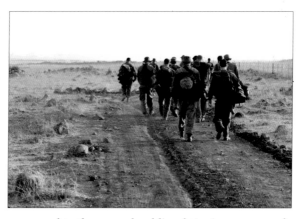 makes the job of war more real to the general public—bringing a new angle on gaining political power through the image of the soldier. —MLR

Types of Cameras

DIFFERENT POINTS OF VIEW

There are a large variety of cameras that have been manufactured during the evolution of photography. Here are a few of the most common:

View Camera. This is the oldest and simplest of camera designs. The scene is observed directly through the lens but is upside-down and backward on a ground-glass viewing plate on the back of the camera.

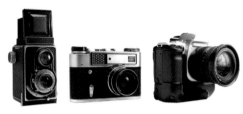

(Left to right) Twin-Lens Reflex (TLR), Rangefinder, Single-Lens Reflex (SLR).

TLR (Twin-Lens Reflex). As its name implies, this camera model has two lenses. The scene is viewed from the top of the camera, so most often, the camera is generally held at waist level while taking photographs.

Rangefinder/Viewfinder. This is a camera that generally has some level of adjustment available to the settings or lens focus. The scene to be photographed is viewed through a viewfinder that does not exactly correspond to the scene that the lens "sees," so the resulting photograph is slightly offset.

Point and Shoot. In recent years, this has become the catch-all term for a digital camera that is not an SLR. However, any camera that is fully automatic and can be operated by simply pointing it at the subject and pressing a button to capture the image falls into this category.

SLR (Single-Lens Reflex). Simply, this type of camera consists of a camera body that has interchangeable lenses. The viewfinder shows the scene to be photographed through the lens, using a mirrored chamber that reflects the scene, called a pentaprism. This style of camera uses 35mm film or is digital. —CWN

FUN FACT

U.S. President Barack Obama was the first president to have his official presidential portrait taken with a digital camera.

Thomas Wedgwood

IMAGE RECORDING PIONEER

Thomas Wedgwood's attempts to record images onto light-sensitive materials are the first such documented experiments in the pre-photographic period. Wedgwood, son of the famous potter Josiah Wedgwood (who had employed a camera obscura in the process of creating the designs for some of his china), had a background in science and was familiar with the study of light-sensitive materials, such as calcium carbonate mixed with silver nitrate and the light-sensitive qualities of silver chloride.

Beginning in 1799, Wedgwood and his colleague, chemist Humphry Davy, began to experiment with recording images on paper that had been treated with light-sensitive substances. Brushing paper with a solution of silver nitrate then setting an object on it and exposing it to the sun resulted in a white silhouette of the object on a black background that they called a "photogram." They later continued their experiments using a type of leather as a surface because they found it to be more sensitive than paper.

They were unsuccessful at their attempts to record a permanent image with a camera obscura, but they continued to have success in recording images using other methods, including placing tiny paintings on glass and then placing them over their treated leather or paper. Unfortunately, their images quickly deteriorated and were best viewed by candlelight in darkened rooms. However, it was their work that greatly contributed to the generally more successful experiments of Joseph Nicephore Niepce nearly 25 years later. —DJG

Richard Avedon (1923-2004)

FASHIONABLY BRILLIANT

Known for photography that pushed the boundaries of what was acceptable, Richard Avedon redefined fashion photography with images that were both elegant and dynamic, yet contained elements of controlled imperfections. His trademark "Avedon blur" captured models sprinting across the page, caught mid-motion with fast shutter speeds. The final images often contained only a portion of the subject, conveying an intimate, loose quality. Avedon was best known for his portraits of notable celebrities, including Marilyn Monroe, Janis Joplin, Bob Dylan, and Andy Warhol; his work for *Vogue* in the 1970s and 1980s was some of the most famous portraits of the time. Avedon's images often include the dark black outline of the film frame, and final prints sometimes measured over three feet in height.

His professional career began in 1944 at *Harper's Bazaar,* shortly after the end of his term as a World War II Merchant Marine photographer. He was soon photographing for many other magazines, including *Look* and *Vogue.* In the 1950s, Avedon created dramatic narrative images that showcased couture fashion against glamorous Parisian street scenes and became one of his most imitated innovations. The expression of character and spirit of his models was what made Twiggy famous in the 1960s.

In 1959, he worked with Truman Capote on *Observations,* a book that showcased some of the most famous people of the century. His work is in the permanent collections at the Metropolitan Museum of Art, Smithsonian Institution, and the Whitney Museum of American Art. (For more about Avedon, turn to page 154.) —GC

Birds of Prey

THE SNOWY OWL

Some birds of prey, such as snowy owls, can frequently be seen in northern climes perched on a utility pole, aware of everything that moves. A native of the Arctic, the owl prefers open vistas, making country roads alongside farm fields a perfect spot to look for this fascinating creature. Although they are sometimes skittish, a snowy owl will often remain on its perch and allow a cautious photographer to approach the pole.

Snowy owls are large, measuring up to two feet from wing tip to wing tip. They rarely let someone get too close, making a telephoto lens mandatory. Shoot at the highest shutter speed conditions will allow in order to capture detail in the feathers, eyes and beak—and be happy you're not a mouse. —WTD

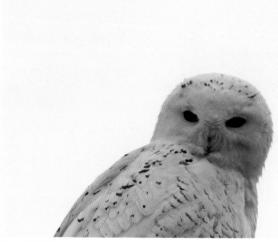

Photo © Bill Diller.

Conceptual

ELI WILNER, MASTER ANTIQUE FRAMER

This was shot on film, without the use of Photoshop, and actually made it to the cover of the magazine that I was shooting for. It's an example of where a concept for an image turns out better than expected; I had simply wanted to make a portrait of him behind the kind of antique frame that he is world renowned for finding and selling. I had Eli's collaboration completely; he loved the idea that he was in a frame on the wall. It was shot in his then-tiny frame shop and studio, using a doorway and a roll of blue paper hanging over it with the frame on top of that, and a hole cut out to match the aperture of the frame. Eli stood behind this, creating the illusion that he was a portrait hanging on the wall (note the wire above the frame). What happened next made the shot: He reached out of the frame to adjust his sleeve. This impromptu gesture made him appear to be coming out of the frame and was now actually adjusting it, referring to his pursuit of perfection and immaculate presentation as a master antique framer and dealer. —SA

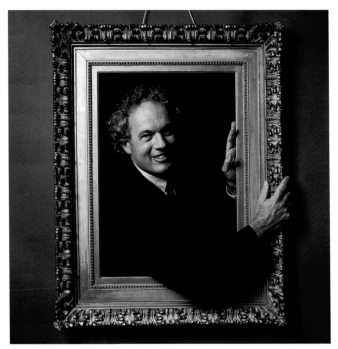

Photo © Simon Alexander.

Serendipity: UC Berkeley Mascot

OSKI HAMS IT UP

What seems like a mundane moment can turn into a unique opportunity. This is Oski, the University of California Golden Bears mascot, at a basketball game. During player warm-ups, most photographers pass the time by catching up on the latest technology and gossip. As we stood and waited for the game to start, Oski laid down on the court in front of us. I seized the opportunity by grabbing a camera and getting down to his level to shoot. He started hamming it up like a supermodel. The photo ran on the cover of *Sports Illustrated.* —TH

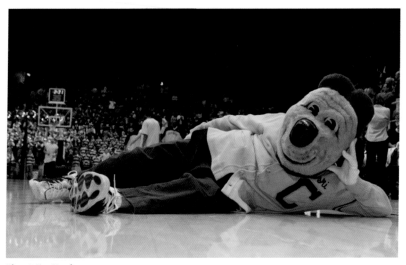

Photo © Tom Hauck.

Shooting Youth with Drama

GETTING A GOOD CRY

The image of a girl with a tear rolling down her cheek was from a series that was created for an assignment for a solo artist's album art. The concept called for the 11-year-old model to portray a painful emotion that would evoke tears.

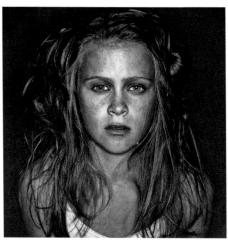

Photo © Matthew Roharik.

The makeup artist aided in the tearing process by administering a viscous liquid eyeliner sealer with an eyedropper to the corner of her eyes. The shutter speed was set at 160^{th} of a second at ISO 100 to freeze the tear rolling down her cheek. A 7-foot octagonal soft box provided the fill light directly behind the camera, about 5 feet from the model. A bare-bulb-ring-light flash without diffusion added the even directional light canceling out the shadows under the nose. This light produces the graphic lighting quality for the painterly look. The lens used was a Nikon 50mm shot at aperture 5.0. Two strobe lights with narrow 9-x-36-inch strip soft boxes were placed equidistant to the left and right side of the model and slightly behind her.

The model sits approximately two feet from a 4-x-8-foot piece of smoothly finished wood that has been painted with chalkboard paint. The background was wiped with white chalk on a damp cloth that created a molted pattern and then misted with a spray bottle of tap water to create additional texture. —MR

Impressionistic Photography

USING SMEAR TACTICS TO GREAT EFFECT

The photographs of Claudia Adeath recall the paintings of impressionist masters such as Van Gogh and Monet. Remarkably, she does not rely on digital editing to alter the images: The distorted effect is created during the shoot itself by nudging the camera with artful precision.

Some images have a rushed feel to them, as those of the series "Remains," which serve as a commentary on modern life. Adeath describes the subject matter as "humans left behind by the frantic flow of time." Other photos present a unique pastoral tranquility.

Photo © Claudia Adeath.

The Mexico City native reports that this technique has taken years to develop and is a work in progress. The idea is to capture an image that is the perfect medium between excessive distortion and a simple clear shot. Adeath states that she achieves the best results with settings illuminated by soft, diluted natural light. She focuses on a fixed point and uses a camera motion that is vertical, horizontal, diagonal, or rotational, depending on her subject, to "smear" the image.

Photo © Claudia Adeath.

The significant divergence from impressionistic painting has to do with technique: Adeath must produce the desired effect with one crucial movement of the camera rather than countless meticulous brushstrokes. Furthermore, the natural light must hit the subject perfectly to create the ideal colors. As such, the photographer captures the precise, fleeting moment at which an object "naturally appears the most impressionistic." —DJS

Sand Jumper

BY CHASE JARVIS

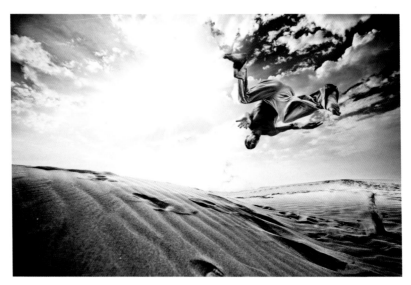

The spontaneous invert of a professional dancer was captured in the desert outside of Dubai. With the camera placed low to the ground, the height of the jump and much of the beautiful foreground could be captured. Early morning light reflecting off the sand compensated for heavy backlighting. In post production the three elements (sky, sand, and model) were each isolated and adjusted to further balance the light levels across the image.

Chase Jarvis, a commercial photographer, always strives to balance technical excellence with absolute spontaneity. He has a studio in Seattle and in Paris. www.chasejarvis.com

Poverty

LIGHTING THE DARKNESS

Poverty (lack) is the extreme opposite of wealth (abundance). Often portrayed as a lack of property, housing, opportunities, and education, defining poverty in a social context falls into the realm of socially acceptable parameters. These are basic parameters centered around an acceptable amount of money and possessions but also communal services like sanitation, water, transportation, and communication. Individual moments of poverty, while disarming and uncomfortable, are quite different from the social issue of poverty.

One of the more interesting definitions of poverty is debility due to a "lack of fertility." This definition conjures a dark, deprived, and dead atmosphere. This aspect of poverty was explored by Jacob Riis, a late-19th-century reporter and photographer. Riis took advantage of the newly developed "flash" cartridge (a mixture of magnesium, potassium chlorate, and antimony sulfide shot from a pistol-like contraption) to light the dark alleys and tenements of New York City. His intention was to inform the public and assist those trapped in the maze of poverty the tenements contained. —MLR

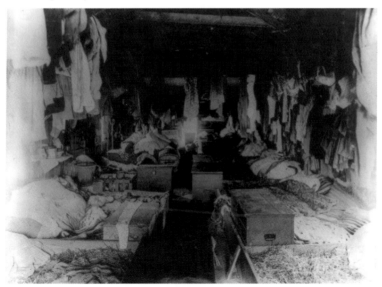

Interior of a shack occupied by berry pickers. Anne Arundel County, Maryland. Courtesy of Maryland Child Labor Committee. Location: Anne Arundel County, Maryland, c. 1909. Photo by Lewis Wickes Hine; courtesy Library of Congress Prints and Photographs Division.

SLR vs. Point and Shoot

WHAT'S THE DIFFERENCE?

The first major difference is that what you see is *not* what you get.

When viewing the scene you are about to photograph through the viewfinder of an SLR camera, the scene is viewed through the lens, and via a reflective mirror in the pentaprism, the view is available in the viewfinder precisely as it will be captured on the film/sensor.

When looking through the viewfinder of a point and shoot, since the viewfinder is slightly above the lens, there is a slight offset in the final photograph. This is called the parallax effect. Parallax becomes even more noticeable the closer the camera is to the subject.

An SLR is an excellent choice for the aspiring photographer or the casual user interested in producing more artistic and technically correct photographs. They most often have extra features such as through-the-lens metering and a built-in flash, and offer a variety of shooting modes, giving the user the ability to control as few or as many of the settings as he wishes. On the downside, an SLR is generally more expensive, bulkier, and heavier than the smaller point and shoot cameras.

Point and shoots are excellent choices for the casual user and have automatic settings that require very little user input. They are small and fit nicely in jacket pockets and are fairly affordable. Unfortunately, they don't offer enough versatility for the serious photographer and the automatic controls can be frustrating for a user wanting to have more control over his photography. —CWN

Louis Jacques Mande Daguerre

BRINGING PHOTOGRAPHY TO THE PEOPLE

Frenchman Louis Jacque Mande Daguerre first unveiled the end result of more than a decade's worth of experiments in 1939 at the Académie des Sciences. The daguerreotypes, as he called them, were unique images on highly polished, silver-coated copper plates. He has since been referred to as the inventor of photography.

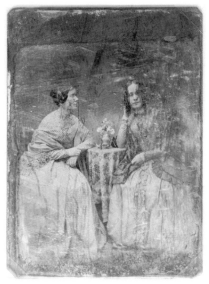

Daguerreotype of two unidentified women full-length portraits, seated at table with tablecloth and bouquet. Created between 1851–1860. Library of Congress, Prints & Photographs Division, Daguerreotype Collection.

Daguerre, an acclaimed painter and theatrical designer, began to experiment with and explore the possibilities of photography. He formed a partnership with Joseph Niepce in 1827 and, over a period of years, they worked together to expand upon Niepce's heliography and develop the ideas both of them had been working on individually.

After Niepce's death in 1833, he continued to experiment with a variety of approaches, using different combinations of materials and chemicals—silver-copper plates, iodine, silver chloride, and even mercury vapors from a broken thermometer—until he finally created a fixed image in 1837. He showed his work to the curator of the Louvre and offered the rights to the process for sale but found no takers. French politician Dominique François Argo, a physicist and astronomer, made the case that Daguerre should receive an annuity and that the government should publish the results of his work. In 1839, his work was publicized, and he was awarded a pension of 6,000 francs a year, as well as 4,000 francs for Niepce's son and heir, Isadore.

Daguerre's instruction manual was translated into every major language, and the daguerreotype was an instant success, spreading throughout Europe and into the United States. —DJG

Annie Leibovitz (1949-)

CELEBRITY SHOOTING CELEBRITIES

Annie Leibovitz is a celebrity photographer who has become a celebrity herself—decorated a Commandeur des Ordres Des Arts et Des Lettres by the French government, designated as a living legend by the Library of Congress, and named one of the 35 Innovators of Our Time by *Smithsonian* magazine. Her images are distinct and mesmerizing: Whoopi Goldberg partially submerged in a bathtub full of milk, Demi Moore naked and pregnant, Bette Midler basking in a sea of roses.

Leibovitz's career began in 1971 with a cover photograph of John Lennon for *Rolling Stone* magazine, where she became chief photographer in 1973. While on assignment in 1980, she photographed Lennon and Yoko Ono hours before his death, creating the famous image of a naked John curled around a fully clothed Yoko.

Her work has appeared in *Vanity Fair, Vogue, New York Times Magazine,* and the *New Yorker.* In addition to her magazine work, Leibovitz has created influential images for American Express, Gap, and the "Got Milk?" campaign.

She is the only woman to have been exhibited at the National Portrait Gallery in Washington, DC. Other exhibits have appeared worldwide in New York, Amsterdam, Paris, and London.

Her books include *Annie Leibovitz: Photographs* (1983); *Photographs: Annie Leibovitz 1970–1990* (1991); *Olympic Portraits* (1996); *Women* (1999); *American Music* (2003); *A Photographer's Life: 1990–2005* (2006); and *Annie Leibovitz at Work* (2008). —GC

Sunrise

FIRST COLORS OF THE DAY

Few things in life rival a colorful sunrise in the American countryside—mist curling up from a farmer's field, early rays of the sun peeking through wispy clouds and illuminating the surroundings with a golden glow, and trees in the foreground and background thrown into silhouette.

Imagination runs wild. What could possibly be in those trees? Are deer hiding under their branches, silently waiting to enter the field for an early-morning snack? You continue to wonder as you watch the fog swirl, changing from red, to gold, to yellow, knowing that in a few minutes those vivid hues will fade.

You rush to set up your camera. Although a tripod isn't a strict necessity, because there's plenty of light to take the shot hand-held, you decide to do it right. You mount the camera on the tripod, take a reading with your in-camera meter, set the self-timer to 10 seconds to prevent camera shake from ruining the shot, press the shutter button, and stand back. —WTD

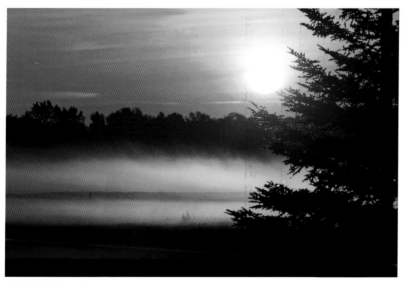

Photo © Bill Diller.

Group

FASCINATING AIDA, MUSICAL COMEDY GROUP

Something to bear in mind when shooting a group portrait: It's generally more difficult than photographing one person, multiplied by how many people there are. Luckily for me, working with Fascinating Aida was not such a challenge, after they had all arrived on stage for the shot.

Getting this shot involved collaboration, trust, and creative thinking, breaking past the bounds of the usual publicity imagery for stage performers. As luck would have it, all of the Fascinating Aida group were hilarious and made for a happy shoot. Their show is very funny, so I built upon their stage show, which I had luckily just seen. We tried a few different compositions and placement of each sitter around the piano, and ended up with this animated image after much laughter and plenty of "How does this look?"

Dillie Keane, the founding member, took apart a hi-hat cymbal and put one on her head, and played it with a drumstick while as I was shooting! —SA

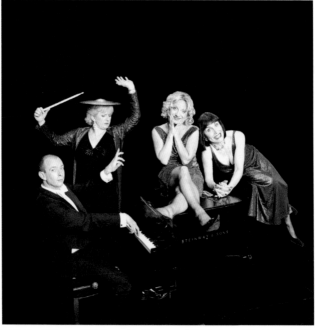

(Left to right: Russell Churney, Dillie Keane, Liza Pulman, and Adèle Anderson.) Photo © Simon Alexander.

Using Your Head, Not Your Gear

A TROPHY SHOT

Getting a celebration shot can be very complicated. After big championship games, photographers seem to revert to a primitive state, running on the field frantically trying to capture the players' emotions. They bump into each other and obstruct one another both physically and visually.

Peyton Manning, quarterback for the Indianapolis Colts, was holding up the Lombardi trophy after winning the Super Bowl. I could not get a clear shot of him in his entirety, so instead I captured a timeless photo by zooming in on the trophy. The reflections and rain gave it a unique feel, and even without a player it still strongly symbolizes the triumph and excitement of winning. —TH

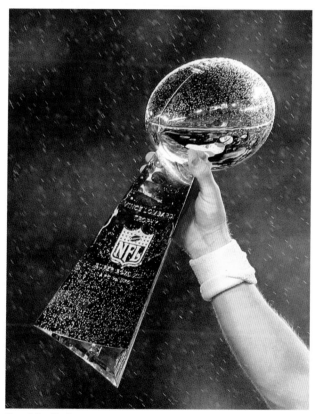

Photo © Tom Hauck.

Working with a Makeup Artist

LESS IS MORE

A makeup artist (often referred to as a MUA) is as essential to shooting beauty as the lens is to the camera for capturing the image. When meeting with a makeup artist for the first time, look through his or her book to see how heavily the makeup is applied. A good makeup artist can create a natural look that looks clean while allowing the pores on the face to show. Bonus points for an esthetician's license, which allows a MUA to do brow shaping and hair removal. Some makeup artists use brushes, an airbrush, or both to apply makeup. Working with a MUA that does both has its advantages. Discuss what kind of makeup they use and the contents of the kit they bring to the shoot.

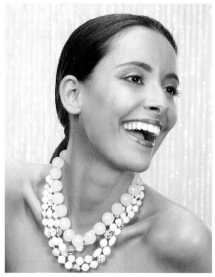

Photo © Matthew Roharik.

On the shoot, a photographer needs to verbally and visually communicate the concept or assignment to the makeup artist. It helps to have tear sheets from magazines ready to show so that your MUA has a visual example of what you want. For best results, allow the makeup artist the creative freedom to explore within the constraints of the assignment.
—MR

FUN FACT:

It's usually best to accentuate one feature at a time. Featuring both dramatic lips and eye shadowing usually is too much and the work competes with itself.

Undressing for Art

THE BRAVE NUDE WORLD OF SPENCER TUNICK

In the uniquely modern phenomenon of a "flash mob," crowds of complete strangers gather in a public place to take part in some bizarre collective activity: riding the subway without pants, faux kung fu fighting, or freezing in place for several minutes. After this odd "performance" has taken place, the participants disperse.

Such happenings are reminiscent of the nude gatherings assembled by New York photographer Spencer Tunick.

In his earlier years, Tunick's shoots had a subversive quality to them, and were planned in a clandestine strategic fashion. According to writer (and former participant) Joe Heaps Nelson, the models would be called to a particular location, given rapid instructions, and rushed to disrobe and assume their position en masse. After shooting, the entire scene would be rapidly dissembled before law enforcement had time to arrive.[1] Thousands of one-time nude models quietly melded back into the milieu of respectable citizens.

Such massive gatherings of nudes take on an abstract quality as the texture of the collective crowd becomes more visible than any individual model.

Given his artistic notoriety, Tunick is no longer forced to evade law enforcement for such shoots; the largest gathering to date took place in the historic center of Mexico City with the blessing of the city's municipal government. Still, the artist continues to describe works such as *Zócalo* as installations of "performance art," in continuity with his early work.[2] —DJS

Succulent

BY BETH SHIBATA

"Succulent" was created with an iteration of low level posterization followed by several iterations of solarization, color adjustment, and reversing the solarization to saturate the colors. The image was then slightly squeezed vertically to lend it a more dynamic, upward feel. The idea was to emphasize the energy radiating from within the plant and raise it to an emotional level.

Los Angeles-based Beth Shibata often draws from elements of her formal education in biology, linguistics, and literature to shape her photographs. She is an exhibiting member of the Photographic and Digital Artists Group, San Pedro Arts Association, and the Henry Fukuhara Workshops.

Religion

PLACING FAITH IN CONTEXT

Religion has a powerful hold on social agendas. Consider its sway on women's health rights, same-sex marriage, and human rights in many countries. Exploration may involve challenging perspectives for a photographer and identifying a process for delving into a culture that may be largely misunderstood, unfamiliar, or reclusive. An introduction from someone directly connected with a particular religion or religious practice may be necessary.

Identify religious imagery within varying contexts—school, work, government, community. Follow a religion through its many iterations by following a series of people claiming the same belief. Examine its many layers with a keen eye and a respectful curiosity for human relationships with the divine. Look at the varying manifestations of religion—object, symbols, dress, relationships, ritual, places of worship, forms of proselytizing. Visually compare beliefs about death, birth, and life.

Establishing visual perspective or a stacking of figures and shapes within a photograph indicates hierarchy and power. The repetitive use of color can be used to make powerful statements about religious belief within a culture. Use light to convey religious concepts or ideas. —MLR

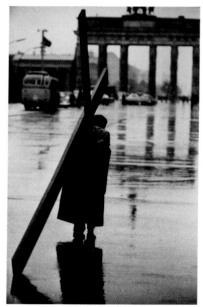

Man carrying cross on street, Berlin, West Germany. Toni Frissell Collection, Library of Congress Prints and Photographs Division.

Camera Modes

AUTO MODES VS. MANUAL MODES

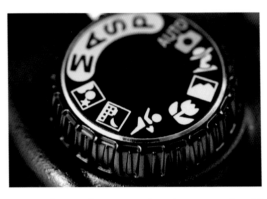

Most consumer-level cameras have a fully automatic mode. The camera will automatically set the shutter speed and the aperture that will result in a properly exposed photograph. This mode generally has the designation "Auto" or a camera icon and is green on the mode dial. Users who prefer maximum control over shutter speed and aperture should choose manual mode, designated by the letter "M" on the mode dial, in conjunction with the camera's internal light meter.

Several additional settings may be available, depending on your camera, that are a combination of automatic and manual:

- Aperture priority allows the user to choose the aperture to be used consistently, and the camera's internal light meter will automatically choose the shutter speed. This generally has the designation of an "A."

- Shutter priority allows the user to choose the shutter speed to be used, and the camera's internal light meter will automatically choose the appropriate aperture. Shutter priority is usually shown as an "S" on the mode dial.

- Program mode, shown as a "P" on the mode dial, means that the camera has synced both the shutter speed and the aperture and manually changing one setting will automatically change the other setting to compensate.

There are sometimes settings available that are fully automatic for specific situations. These are often referred to as program-automatic. This means that the camera will select the proper settings for your situation. Some of these settings are portrait, landscape, close-up, or sports. Your camera manual should specify if these are available and where the settings are located on your camera. They are usually found on the mode dial and are represented by small icons. —CWN

The Calotype
ACCENTUATING THE NEGATIVE

British scholar William Henry Fox Talbot had also been experimenting with the photographic process around the same time as Daguerre and Niepce. In fact, he had demonstrated a method of recording an image on paper in 1833, six years before Daguerre's announcement of a successful process. He created a negative process whereby reverse silhouettes (white lines) were produced when objects were placed on a piece of paper treated with a combination of sodium chloride and silver nitrate and then exposed to the sun. After removing the objects from the paper, an image of them would remain.

He later employed a series of adapted camera obscuras into which he placed his light-sensitive paper. Upon hearing of Daguerre's invention, he quickly rushed to perfect his own, which he called "talbotypes" and later "calotypes," which he presented to the British Royal Society. Talbot felt a degree of competition with Daguerre, although their methods and final results were actually quite different. Daguerreotypes were fragile and had to be kept in glass to avoid deteriorating from too much handling; calotypes were sturdier, essentially printed on paper, foreshadowing the development of photographic prints in the commonly recognized format. The most significant difference, however, was that, because of the negative system (as opposed to the positive system employed by the daguerreotype), calotypes could be duplicated endlessly. —DJG

Anne Geddes (1956-)

BABY LOVE

Babies in flowerpots. Babies dressed as sunflowers, or as a tiny fairies sleeping soundly on a giant branch. These are typical images created by Australian photographer Anne Geddes, who became a worldwide photographic sensation with her colorful, whimsical images of babies and young children dressed in elaborate costumes and placed in fairytale or fantasy settings. Often humorous, her images are a celebration of babies and motherhood. In the past, all of the costumes and props were created by hand, but currently she often shoots the subject and the background separately with a 4 x 5 camera and then fuses them together into one final image using digital technology.

A self-taught photographer, Anne began to work as a photographer in Hong Kong, after moving there with her husband. Her photography business quickly became successful[1] and busy; however, she made sure to set aside one day each month to pursue her own artistic inspirations. During this time, while reading bedtime stories to her young daughters, she began to dream of creating a fairytale told with photographs, an idea which eventually became her first book, *Down in the Garden*.

Her books and calendars have been published in 83 countries and translated into 24 languages. They include: *Down in the Garden* (1996); *Until Now* (1998); *Pure* (2002); *Miracle* (2004); *Cherished Thoughts with Love* (2005); and *Anne Geddes: An Autobiography: A Labor of Love* (2007). Several images have also been used by the French and American postal services for postage stamps.

In 2009, Anne was honored by The Professional Photographers of America (PPA) with the Lifetime Achievement Award. —GC

Sunset

GET IT WHILE IT'S HOT

It's very likely true that most people see sunsets more frequently than sunrises. After a long, tedious day in an office, the sight of that giant orange, yellow, and red ball of fire sinking over the horizon would be just as inspirational, maybe more so. If you're fortunate enough to live near a body of water that faces west, the vivid colors of the setting sun shining on the placid water could make you forget the day's troubles.

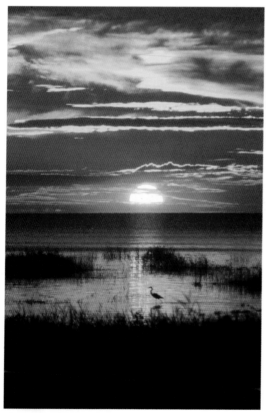

Photo © Bill Diller.

Watching a Great Blue Heron meander across a tranquil marsh in the foreground one day, I was happy to have remembered both camera and telephoto lens. A telephoto lens makes the setting sun look huge. Walking swiftly along the beach, I lined up the heron with the sun, set my camera to Program, and began firing away. When the sun finally dipped below the horizon, a quick check on the LCD monitor showed some real dazzlers. —WTD

Comedians

STEVE COOGAN, COMEDIAN AND ACTOR

Back in 1993, Steve Coogan was already a well-known British stand-up comedian. An agent had advised me to add more recognizable people into my portfolio, so it made sense for me to ask if I could photograph Steve for a book on comedians and actors that I was planning to publish. Photographing comedians, however, can be a hit-and-miss challenge—sometimes they are in a good mood and other times not. Often they are more serious offstage and not at all like their onstage persona. So when you consider that this was one of my first celebrity shoots, it's understandable that I was fairly nervous.

It did not start off well at all. Steve had just discovered that he'd lost his cell phone and was in a bad mood. I managed to cheer him up long enough to get a smile out of him and a few other facial expressions that he was known for at the time, and this was the best image. This along with several other portraits of mine are now in the archives of the National Portrait Gallery, London. It reminds me that while you cannot always have a willing subject, you can learn to be fast and get a shot that works. —SA

Photo © Simon Alexander.

Use of Light: Silhouetting

ROMANCING THE BLACK

Setting the camera to expose for the sunlight causes backlit subjects and objects in the frame to become silhouetted. Here some surfers were walking across the sand in Hermosa Beach, California, after an afternoon in the ocean water. I was able to capture a timeless iconic beach lifestyle image: surfers, volleyball nets, lifeguard tower, pier, sun, and sand. The photo has a warm feeling to it even though it is fall and the surfers are wearing wet suits. —TH

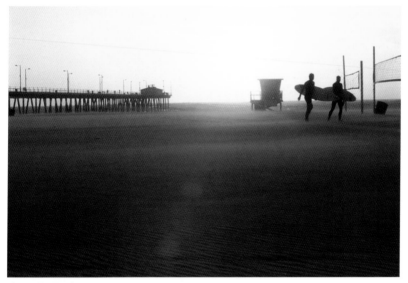

Photo © Tom Hauck.

Working with a Hairstylist

HAIR'S THE THING ...

Having a dedicated hairstylist on a shoot is a wonderful luxury. Hair is one of the hardest aspects to control. Styled hair tends to fall flat within a few minutes of shooting, and the hot lights add to the problem. Controlling flyaway hairs is a constant battle and extremely time consuming in post-production retouching.

When auditioning a perspective hairstylist for a shoot, make sure they have prior experience working on a photo shoot and set. Just like a makeup artist and photographer, a hairstylist will have a print portfolio for viewing. Make sure they have a range of ethnicities in their book, and ask if they have experience with hair extensions. A little trick for shoots where a hairstylist is not available and the hair is just not working for the shoot, go with the hair pulled back or a wet look. —MR

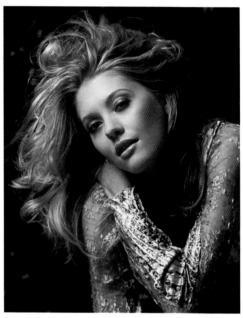

Photo © Matthew Roharik.

Urban Legends I

DYING TO GET THAT FINAL SHOT

Ever since its invention, photography has featured prominently in the annals of contemporary folklore.

"Urban legends" are stories that are told as true accounts, yet cannot be proved to have ever actually taken place. In addition, the same story usually appears across different states, countries, and even continents, yet is always said to have happened in a specific nearby location. The prototypical urban legend is usually attributed to a "friend of a friend."

In spite of their apocryphal nature, however, urban legends bear layers of deeper meaning. Like all legends throughout history, they often contain moral lessons, give voice to collective fears, and are a window into the psyche of a particular generation.

One such tale involves a photographer who supposedly managed to capture a spectacular, close-up shot of a hostile animal seconds before it attacked him or her. In some versions, the unlucky individual was a Japanese journalist camping in the wilderness of Siberia who managed to snap a shot of a bear that was attacking him.[1] Another variant sets the story in Spain, where a tourist captures an image of a bull a moment before being trampled.[2]

How close would a photographer get for that perfect shot?

Needless to say, the idea that any individual (even the most devoted photographer) would spend the last few seconds of their life fiddling with his camera seems highly unlikely. As is the case with many urban legends, however, skeptical disbelief is often suspended when the story taps into such a universal concern as the fear of untimely death. —DJS

Geen Toegang (No Entry)

BY MICHAEL J. SCOTT

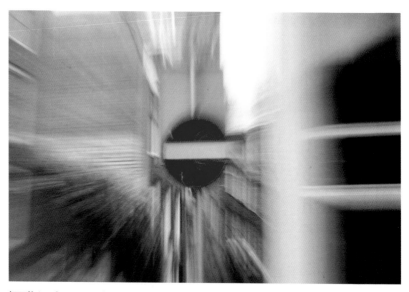

This photograph is a result of the "Zoom Lens Blur Effect" technique. The zoom lens is moved during the exposure, thus creating a blurred rush of the scene, while maintaining a crisp focus on the center. This technique emphasizes a specific subject by leading the viewer's eyes inward to the center, while ignoring the out-of-focus regions. Use ISO 400, f/32, and a 1/30-second exposure.

Michael J. Scott is a student with a passion for photography living in Melbourne, Australia. He specializes in urban landscapes, macro, travel, HDR, infrared, and seascapes. www.scottphotographics.com

Unity
A SIGN OF AGREEMENT

Unity signifies a coming together, a combination of disparate parts and pieces, ingredients, or ideas, to create a whole. The results may continue on as a unit or may separate into different sizes, shapes, or content than they arrived in, only to be turned out into the world at large. Therein lies the curiosity about unity—when does it stop being whole?

In political and social commentary, unity may be temporary, have a purpose that designates its life span or requires a longer existence than expected. Unity can arrive after a disagreement and may indicate a combining of forces, ideas, or some sort of compromise. Symbols of unity in these instances encompass the handshake, photo opportunities with national flags—important statuary and famous buildings are common, too. Photographs of Barack Obama and Hillary Clinton, during the later part of the 2008 presidential campaign, show the mimicking of gestures between them, another common symbol of unity.

Lauri Lyon's photographic essays *Flag: An American Story* and *Flag International* place the ultimate American symbol of unity into the hands of individuals. Each photo shows the momentary unity of human and symbol. The work creates a social narrative for the viewer to examine. —MLR

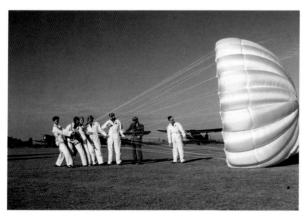

Instructor explaining the operation of a parachute to student pilots, Meacham field, Fort Worth, Texas, 1942. Photo courtesy Library of Congress Prints and Photographs Division.

Camera Settings

FOR A WELL-ADJUSTED SHUTTERBUG

Because so many cameras are different from each other, it's best to read your camera manual's section on settings to see exactly what type of camera you have and what settings are available.

The three main fully adjustable camera settings we will cover are ISO, shutter speed and aperture. These features are always available on SLR cameras and may be available on point and shoots.

ISO refers to how sensitive the film is to light. This designation isn't just for film cameras; many digital cameras also have settings that let you choose how sensitive the sensor will be to light.

Shutter speed is in seconds or fractions of a second. It regulates the length of time that light is allowed to expose the film or fall on a digital camera sensor. It is also the main setting considered if stopping the action of the subject is required. The faster the subject is moving, the faster the shutter speed should be.

Aperture, also referred to as the f/stop, is the setting that controls the size of the opening on the lens that allows light into the camera. The smaller the aperture number, the larger the opening. This is the main setting considered if a large area of the scene needs to be in focus. The smaller the aperture number, the less depth of field, or area of focus. The larger the aperture number, the larger or deeper the area in focus. —CWN

Stereoscopic Photography
A THREE-DIMENSIONAL EFFECT

Beginning in the 1850s and remaining wildly popular into the early 20th century, stereography created an optical illusion that provided the viewer with a three-dimensional image. The method involved using two cameras mounted side by side (roughly 2 ½ inches apart—the average space between human eyes) to simultaneously take "duplicate" exposures of a subject and then printing the two images side by side. When viewed with a device called a stereoscope, the pictures appeared to merge together, resulting in the three-dimensional effect.

Attempts at creating three-dimensional images began in the 1840s using daguerreotypes, but the process proved unwieldy and results were unsuccessful. Not long after, with the advent of the wet process using glass plates, it became much easier to make the dual exposures and the dual prints necessary for the effect. Still, determining the right spacing of the cameras and the most effective distances to shoot from took further years of experimentation and trial and error, but by the mid 1850s the method had been perfected, and it took off. Oliver Wendell Holmes invented a handheld stereoscope in 1861, and millions of

"stereographs" were sold in the coming decades. Much like televisions in the mid-20th century, it was quite common to find a stereoscope and a pile of stereographs in the living rooms of middle- and upper-class families.

While demand waned considerably by the 1920s, development of stereographic cameras continued through into the 1940s. Today there are still a couple of companies making stereographic cameras. —DJG

Diane Arbus (1923–1971)

FREAK PHOTOGRAPHY

The images of Diane Arbus are often unsettling; dark, gritty, and more than a little bit creepy. She used a medium format camera to portray the underbelly of society with vivid clarity and detail, often with flash lighting to further exaggerate the facial expressions and vulnerability of her subjects. She considered herself a visual anthropologist and was known to haunt Coney Island, nightclubs, and the freak show at Hubert's Museum in Times Square in search of subject matter. One of her most famous images, *Identical Twins, Roselle, New Jersey, 1967,* was echoed in Stanley Kubrick's film, *The Shining.*

Arbus began her photographic career in a studio collaboration with her husband, Allan Arbus, with whom she worked for many years. It wasn't until after their separation that she began to scour and study the gritty side of city life and her personal work began to flourish. Her lifelong battle with mental illness created a deep fear of being depressed; she used this fear as a stimulus to power her photographic adventures.

After her photo essay of six "typical" New Yorkers appeared in the July 1960 issue of *Esquire,* Arbus' solo commercial career was born, and she went on to create over 250 pictures for publications, such as *Esquire, Harper's Bazaar, New York, Essence, Sports Illustrated,* and *The Saturday Evening Post.*

Diane Arbus was awarded two Guggenheim Fellowships, in 1963 and 1966. She took her own life in 1971 at age 48. —GC

Low-Light Photograph
BRILLIANT COMPENSATION

This scene inflamed my imagination, but was there enough light to record the image? The sun is rising behind the swing, but it isn't above the horizon yet. The moon is setting over the lake in front of it but too low in the sky to provide any significant light. The result of the sun coming up and the moon going down, along with the 10 below zero temperature and no wind have combined to create a scene that will be tough to duplicate. It will also be tough to photograph.

The full moon is lined up perfectly in the distance, and sunrise colors shimmer off the ice. With the camera on a tripod, a meter reading is taken off the swing itself, exposure is locked in, and the self-timer activated. The shutter button is pressed, and a few seconds later, success: a properly exposed low-light photograph. —WTD

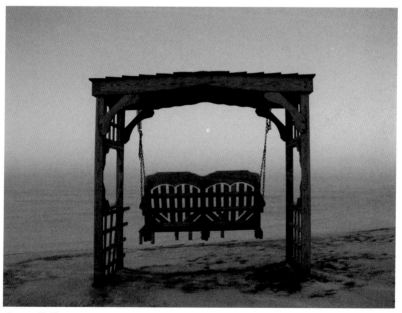

Photo © Bill Diller.

Use of Color

HUNT SLONEM, PAINTER

Hunt Slonem's paintings are so often full of color that you feel that they are jumping out at you, right off the canvas. This commissioned portrait was the result of another successful collaboration with my subject, and my way of incorporating his artwork in the shot with his pet parakeet as well.

When Hunt paints, he lets one of his parakeets sit on his shoulder, and you get the sense that they are helping him choose the palette of colors he applies to the canvas. Hunt chose the green jacket after I pointed out that it would great to see him emerging from his painted jungle, complete with monkeys and birds. I asked if he could also be holding one of his birds, and when he obliged and ventured out of the colorful artwork, the shot was complete. —SA

Photo © Simon Alexander.

Capturing Action

DEVIN HESTER'S SUPER BOWL TOUCHDOWN

No player had ever returned the opening kickoff of a Super Bowl for a touchdown. Devin Hester, #23, the kick returner for the Chicago Bears, was having a career season, and I thought there was a strong probability this could occur.

I positioned myself far downfield of the ball in the event he eluded all 11 players of the Indianapolis Colts. This photo is of Devin jumping over the outstretched arms of the Colts kicker, Adam Vinatieri, the last person who had a chance to stop him from scoring on the opening kickoff of Super Bowl XLI.

Knowledge of the sport, the teams, and the specific strengths of the players helped me make the decision to be in the right place to capture a record-setting event. —TH

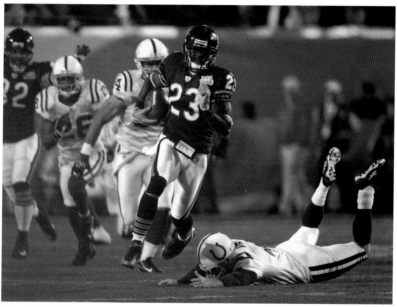

Photo © Tom Hauck.

Casting Your Talent

SHE'S GOT THE LOOK!

A fashion photographer's final image is only as strong as the talent who is selected as the model. The fashion industry has dictated that a model must look good in clothes and caters toward figures that are tall, thin, and beautiful. The goal in fashion photography is to find exotic and stunning people to fill beautiful clothes and pull off the themes in editorial fashion spreads. An appropriate model is necessary in order for the image to belong in the fashion photography genre.

In beauty photography, skin and healthy hair is everything. If the final shot is only head and shoulders, a photographer can open up the modeling field to include people other than 6-foot-tall supermodels. Look for models with exaggerated facial features; they tend to give the makeup artist a more interesting canvas.

Where does one find their supermodel in the rough? Online photography and modeling forums are great resources for amateur and professional photographers and models. As with all things on the Internet, though, exercise caution. Ask for references. Be courageous

Photo © Matthew Roharik. Model credit: Autumn DeSellem.

and ask an attractive friend or person that catches your eye in a public place to model for you. In most cases, she or he will be flattered.

Plan out and create a description of your shoot ideas and concepts to give the model when contacting them for the first time. Be professional and honest in all aspects of your work and people will follow suit. —MR

Ghost Photography

SHOOTING SPECTERS, AVOIDING FALSE APPARITIONS

Those who dismiss the very idea of "ghost photography" as superstitious nonsense would be surprised to learn that devoted paranormal investigators spend most of their time seeking natural explanations and ruling out "false positives."

Some of the most common ones include a person's breath on a cold day, electrical charges from static in the air, lens flares caused by sunlight, motion blur from a jarred camera, or something as simple as cigarette smoke or a finger on a lens. According to ghost photographer Jim Eaton, "very few orbs are true supernatural beings."[1]

After subjecting their work to intense scrutiny, professional ghost photographers have sifted out a small handful of shots featuring ethereal mist, orbs, and humanoid figures that have no apparent natural explanation.

Many hold to the most traditional definition of a ghost as a human spirit that is bound to the earthly realm, producing the phenomenon of a haunting. More innovative paranormal investigators, however, have theorized that when emotionally traumatic events occur in a particular location, the experience itself is recorded, or "imprinted," onto the physical locality through a process that is entirely natural, albeit little understood by modern science.

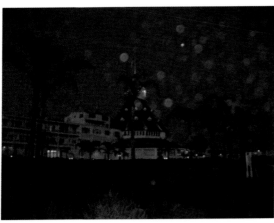

Should this be the case, it suggests the possibility that entire new fields of recording and imaging technology may be uncovered in the future. —DJS

The Hotel del Coronado in San Diego, California, appears surrounded by orbs. Evidence of a ghostly presence or moisture on the camera lens? (Photo by Melanie Stein and Kristen Anthony)

Santa Barbara Mission

BY GREG LAWLER

This shot was taken with an inexpensive, plastic Holga® camera that was modified to accept 35mm film. Using 35mm in the Holga (which is designed for medium format 120 film) results in the large image circle spilling beyond the sprocket holes to the very edge of the film. The Holga also tends to leak light, which caused the cool flares at the top right and bottom left of the image. Essentially this is about as low tech as you can get without using a pinhole camera (which is also a lot of fun).

Santa Barbara-based Greg Lawler shoots images that exude a whimsical sense of joy. He often turns his lens to the brilliant landscapes of central California, drawing inspiration from the vibrant energy and spectacular colors of the Pacific Coast. www.greglawler.com

Financial Disaster

VISUALLY DESCRIBING WHAT WENT WRONG

As far as national financial disasters go, photographing them presents a problem—how many photographs of desperate faces, empty pockets, and "for sale" signs convey the real issue? A photojournalist's job is to illustrate and capture the moment but when the moment is something that happens behind the scenes, internally, and is so deeply rooted and not fully understood by those perpetuating it, much less those being affected, how does one explain it in a photograph? Economic disasters, which financial disasters are, are not a visually ripe topic. They tend toward the dilapidated, the panicked, and the obvious.

Deeply buried subjects push a photographer to dig further and deeper than what is seen on the surface. The everyday and the novelty are up for examination when looking at representing "what went wrong." What went wrong is tied to political power, political power used to push inappropriate, disastrous bills through Congress, push nations into wars, and to lobby and sway Congress toward a desired result that may have nothing to do with prosperity and true nation building, and more to do with greed. —MLR

Cashier handing money out, Riggs Bank, 1938. Photo by Harris & Ewing; courtesy Library of Congress Prints and Photographs Division.

The Shutter and Light

DO THE MATH

The shutter controls the amount of light that that reaches the film or sensor by regulating the length of time the shutter is open.

The shutter speed is generally found on a dial on the top of the camera but may also be controlled by a button or wheel. The shutter speed is also displayed inside the viewfinder and/or in an LCD display on the camera, depending on the model.

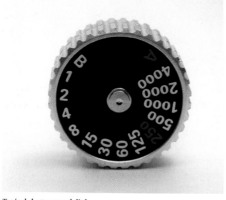

Typical shutter speed dial.

Although the shutter speed is generally a fraction of a second (such as 1/60), for convenience's sake, the "1/" portion of the fraction is generally assumed. So, if your shutter speed is displayed as 100, you can safely assume that it is set at 1/100th of a second.

Shutter speeds range from B (Bulb) to about 1/1000th of a second. The Bulb setting means that the shutter will be open for as long as you depress the shutter button. Sometimes this option is handy when you wish to capture special lighting effects, such as fireworks.

An important concept to remember is that when you double the amount of time the shutter is open, you allow twice as much light to enter the camera. When you half the amount of time the shutter is open, you allow half as much light to enter. For example, 1/125th of a second shutter speed lets in twice as much light as 1/250th of a second, and 1/500th of a second lets in half as much light as 1/250th of a second. —CWN

Photography and the American Civil War

BIRTH OF THE DOCUMENTARY

One of the most significant milestones in the cultural, if not technical, development of photography and war photojournalism was in documenting America's War Between the States. Daguerreotypist Mathew Brady, who was already a successful commercial photographer, acclaimed for, among other things, his portraits of famous Americans, recognized the cultural value of documenting such an important historical event. He assembled a team that included Timothy O'Sullivan and Alexander Gardner and as many as 100 others and set out to record the epic scale of the conflict. Brady and his staff captured images of the encampments, the major personalities, some battles, and, perhaps most significantly, the aftermath of those battles: fields strewn with the bodies of fallen Americans.

While a few daguerreotypes of the 1846 Mexican-American War had been made and the Crimean War in 1855 had been documented with photographs by Roger Fenton and Felice Beato, they paled in scale and scope to the work done by Brady and his staff.

Gardner published the two-volume *Photographic Sketch Book of the War*, which contained 100 photographs and accompanying text. The book caused a great deal of excitement, not so much because it was such a graphic account of the horrors of war and the day-to-day life of the soldiers (in fact many of

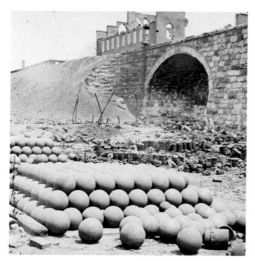

the images had already been readily available to the public), but because publishing a book with original photographs was fairly uncommon at the time. —DJG

Richmond, Virginia, 1865. Piles of solid shot, canister, etc., in the arsenal grounds; Richmond & Petersburg Railroad bridge at right. (Photograph by Alexander Gardner) Selected Civil War photographs, 1861–1865 (Library of Congress). Library of Congress Prints and Photographs Division LC-B811-3276.

Irving Penn (1917–2009)
PRACTICALLY PERFECT IN EVERY WAY

Irving Penn set the standards for fashion photography of the 1940s and 1950s with his signature style of cool, austere elegance created with key elements, including a smooth, neutral background, natural lighting, and minimal props. His images were timeless portraits of fashion and celebrity, where the focus of the image remained solely on his subject. One defining technique he used was a background created by wedging two walls against one another to create a narrow corner. Truman Capote, Spencer Tracy, Pablo Picasso, and Martha Graham were among the list of people squeezed into this narrow corner over the years.

His career began at *Vogue* in 1943, where he became the photographer with the longest tenure, creating more than 150 covers over a 50-year period. In a career that spanned more than six decades, he produced fashion photographs and portraits, as well as carefully detailed still life ensembles, and ethnographic studies of tribesmen around the world.

Penn was known to be a perfectionist and a consummate technician who considered craftsmanship and attention to detail to be his highest priority. His prints were created with a time-consuming, turn-of-the-century darkroom process, using platinum instead of silver to create a lustrous, velvety finish with incredibly rich depth, a process he taught himself and single-handedly brought back into popularity.[1]

Clarity, composition, and care pervade each and every image he created, whether the subject was a bowl of cigarette butts or the Duchess of Windsor. (For more about Penn, see page 154.) —GC

Wind Farms

GIANTS OF THE EARTH

When the word "skyline" is mentioned, people tend to think of big cities and their famous structures, such as the Empire State Building, the Eiffel Tower, or Big Ben.

What all of these structures have in common is their distinctive form, or outline, but you don't have to live in a city to understand the concept of a skyline. Rural areas also boast well-defined shapes that immediately bring recognition, such as a barn or silo, or more recently, the giant wind turbine.

With a push on for a more "green" country, wind farms are popping up, and the distinctive shape of a turbine is unmistakable. They look like giant propellers stuck on a 300-foot pole. You can't miss 'em.

While they might be scary to little kids, wind turbines make excellent photo subjects, especially at sunrise or sunset when they're thrown into silhouette. Set your camera on Program mode, take multiple shots at various focal lengths, and use different areas of the sky to determine exposure. You'll get splendid results. —WTD

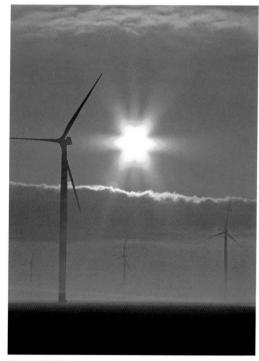

Photo © Bill Diller.

Artists

DONALD SULTAN, ARTIST

On arriving at Donald Sultan's studio, I was greeted and immediately impressed by a large piece of art featuring white dice tumbling out of its black background and frame. In its purist form it was graphic and simply stunning to look at and could not be ignored. I decided against making a portrait with Donald next to it, as it was just too simple and easy.

I set about finding another space to shoot in and ended up making images of Donald at work on some pastel flower pieces. He looked up, and I pressed the shutter. We tried this several times, and it looked good…but it wasn't great. We tried another setup, and I immediately rejected it after looking at the Polaroid, not even shooting a frame of film in camera.

Then I turned around and the dice painting was there again, so we moved a single silver umbrella strobe light, Donald stood in front, and the "too simple" shot turned out to be the best one. Moral: Sometimes you have to trust your initial instincts as a photographer. —SA

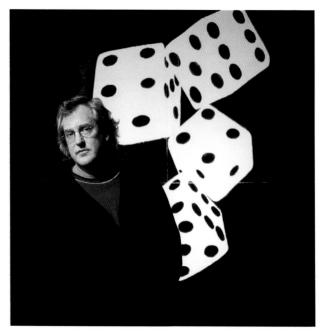

Photo © Simon Alexander.

Celebration

THEIR CUP RUNNETH OVER

Robbie Russell, #3 of Real Salt Lake, is overwhelmed with emotion as he scored the game-winning goal against the Los Angeles Galaxy in the 2009 MLS Cup final at Qwest Field in Seattle. His teammate goalkeeper, Nick Rimando, #18, helps tell the story by running with his hands in the air to celebrate. I was on the Real Salt Lake sidelines, because typically players who have just accomplished fantastic feats look toward their sidelines in solidarity with their teammates. —TH

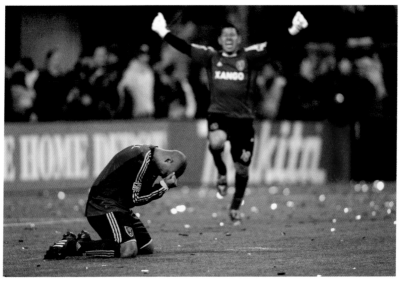

Photo © Tom Hauck.

Lights, Camera ...

DEADWOOD & INK

The concept for this series of images was inspired by the 1874 gold rush in South Dakota. The models were cast as a lady of the evening and a gold prospector. Her motivation to seduce the prospector is to rob him of his pouch of gold.

The series depicts the flirtation that leads to intoxication. The modern twist for the editorial piece was to cast models with current cultural tattoos. The tattoos added a crisp graphic element to an aged and distressed set. A lot of care was given to the props; it included treating all of the surfaces with powdered pigments and matte finishes to the glassware to get the dusty, gritty feel of an Old West saloon. —MR

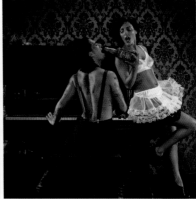

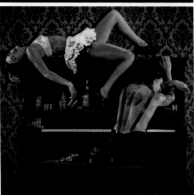

Makeup and styling by
Erica Stewart. Photos
© Matthew Roharik.

Famous Fakes

NESSIE AND FAIRIES APPEAR ON FILM

In 1934, a photograph surfaced that was reported to be an authentic image of the famed Loch Ness Monster.

Twelve years earlier, a photograph had been published that appeared to show a young girl with several real, live fairies dancing in front of her. Known as the "Cottingley Fairies," the image was widely distributed, thanks to support from renowned author Sir Arthur Conan Doyle.[1]

Years later, individuals who had helped to falsify these images came forward with their confessions. The silhouette of "Nessie" turned out to be nothing more than a model attached to a toy submarine; the fairies were simple paper cutouts.[2]

Alice and the Fairies. *July 1917. Glenn Hill / National Media Museum / SSPL.*

Many suggest that their popularity was due to *pareidolia,* a case of people seeing exactly what they wish or expect to see. Centuries of folklore had prepared the collective public consciousness for the idea of the Loch Ness Monster; the Cottingley Fairies were published during the Age of Spiritualism.

According to Finnish folklorist Lauri Honko, individuals who are faced with an extraordinary experience naturally tend to interpret it through the language of existing cultural constructs.[3] Regardless of whether Nessie, Sasquatch, or fairies actually exist, the fact that they haunt the collective imagination increases the likelihood that they will be spotted. —DJS

Poppy Red Cars

BY GARY P. KURNS

This photograph was taken with a Nikon Coolpix SX60 in Oklahoma City during the NSRA Southwest Street Rod Nationals. The cars were masked using Photoshop CS4 so that a motion filter could be applied to the background.

Gary P. Kurns is a retired retail executive with a lifelong passion for photography. His work includes award-winning underwater, close-up, and landscape photography.

Old Age
USING PLACE AND PROPS

Exploring topic and content through the use of location adds additional dimension to a subject. Scout locations during the course of daily transit or make a list of places and areas to investigate. Spend time watching the change of natural light in a location by visiting during the morning, afternoon, and early evening. Consider the possibilities the light changes offer—a focused light source, diffused lighting, dappled or pattern that reflects the nature of the topic. Photograph the location thoroughly by changing perspective, angle, lens, and type of film. The architecture shown in this photograph's location— its plain, utilitarian construction, and flat, undecorated surfaces accompanied by a set of doors—reiterates the idea of exiting physical life and sets the stage for exploring the topic of old age.

Props are another aspect of exploring a topic. In this instance, a cane is used to reinforce the loss of vitality. Notice that the angle and placement of the cane mimics the angles of the architecture. The slumping of the figure away from the architecture further reinforces the idea of aging and the loss of an upright position, and pulls the figure away from the existing structure required of an earthly existence. —MLR

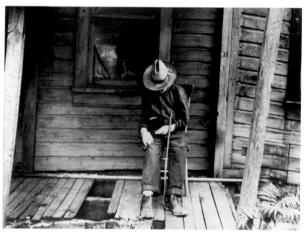

"Old Age" near Washington, Pennsylvania, 1936. Photo by Dorothea Lange; courtesy Library of Congress Prints and Photographs Division.

PHOTO 101

DAY 71

PHOTOGRAPHY 101

The Shutter and Motion

TO BLUR OR NOT TO BLUR...

Shutter speed determines the amount of light that contributes to the exposure. It also enables us to capture motion.

One thing you may notice in some of your photographs is that some of the subjects are blurred from movement. Hands and feet are especially subject to this problem. Normal activity can usually be captured with a setting of 1/60th of a second. Faster movement will require a faster shutter speed to capture it properly.

Sports activities, in particular are a problem, as is dancing. I often shoot events of both of these types and recommend the following settings on your camera to properly capture the following types of activities:

Ballet: 1/125th
Tap Dancing: 1/250th
Basketball and Baseball: 1/400th
Football: 1/800th

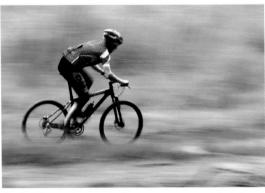

If you're feeling creative, or want to show movement, you can set the shutter speed too low for the situation in order to purposely record blur, as seen in this photograph of a bike race.

Of course, these are subject to individual circumstances. A group of beginning tap dancers, for example, will dance at a slower speed than professionals who have been studying for many years. The best way to determine the proper shutter speed for your particular situation is to change the settings and shoot a few exposures at each setting. Immediately check the screen on the back of your camera if it is digital, and use your zoom feature to take a close look at the hands and feet of your subject. If they are blurry, choose the next fastest speed. Check again until you have reached a speed that adequately stops the movement. —CWN

Motion Studies

TAKING A PHOTOGRAPHIC "GALLOP" POLL

It soon became apparent that photography could be an invaluable tool in the scientific study of the natural world in ways unlike other forms before it, such as sculpture and illustration. Throughout the 1860s, a number of photographers experimented with various ways to capture motion but found only partial success. Oliver Wendell Holmes, who had invented a hand-held stereoscope, captured images of pedestrians in midstride, and the studies of knee, ankle, and foot movement that he conducted later contributed to the advancement of prosthetic limbs for Civil War amputees.

However, the most prominent name in the use of photography for motion studies is Eadweard Muybridge, an Englishman renowned for his images of Yosemite. In order to settle a bet and answer an age-old question, Muybridge set out to determine whether or not, at a full gallop, a horse's legs are ever off the ground simultaneously. After initially trying (but failing) to record a speeding horse by manually opening and closing the shutter of the camera rapidly, he succeeded by ultimately setting up 12 cameras intricately equipped with trip wires so that an individual frame was exposed by a passing horse on a track. (For more on Eadward Muybridge, see page 160.) —DJG

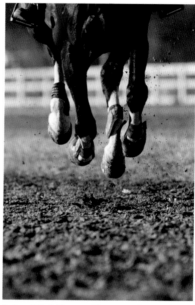

Eadward Muybridge proved in an 1878 photographic experiment that all four legs of a horse are airborne at full gallop.

Henri Cartier-Bresson (1908-2004)

CAPTURING THE "DECISIVE MOMENT"

Henri Cartier-Bresson is known as the father of modern photojournalism, a master of capturing candid moments through his technique of stealth photography and his philosophy of the "decisive moment." An early adopter of 35mm, he painted his Leica camera black to allow for further anonymity, with the ability to capture candid, spontaneous, dynamic moments without being noticed. Photographs were instant drawings in his mind; not surprising, considering his background as a French classical painter.

Although claimed by the world of fine art, he was a magazine photojournalist first, and spent three decades photographing the great political upheavals of his era, including the Spanish Civil War, the assassination of Mahatma Gandhi, the liberation of Indonesia from the Dutch, and China's conversion to Communism. He began working as a photographer during World War II and was captured by the Nazis. After his escape 35 months later, he worked for the underground movement, helping other escapees.

In 1947, Cartier-Bresson joined forces with a group of influential photographers, including Robert Capa, William Vandivert, David "Chim" Seymour, and George Rodger to form the Magnum Photos agency. The cooperative agency split assignments among the members while fulfilling their mission of serving humanity by using photography to feel the pulse of the times.

Although Cartier-Bresson photographed some of the most important political events and public figures of his time, his most renowned images are of seemingly inconsequential moments of ordinary life, flawlessly captured, at the peak of action. —GC

Farm Fields

THEY GO ON FOREVER

Those who live in farm country are accustomed to the sight of plowed fields and crops receding into the distance. For others, a drive through the countryside can be an eye-opening experience.

Those loaves of bread and cans of beans you see on grocery store shelves actually start there, as seeds planted in precisely spaced rows that follow the contour of the land. There is an inherent beauty in farmland; in fact, the line "for amber waves of grain" came from author Katharine Lee Bates seeing fields of wheat swaying in the breeze.

Photographing crops in a field can range from a wide-angle view of the entire field to a close-up of individual plants. For a wide-angle shot you want to get as much of the photo in focus as possible, which you can accomplish by using the highest number aperture possible, such as f/22 or f/32. Include as much of the foreground plants as possible by going right up to edge of the field and keeping the camera close to the ground. —WTD

Photo © Bill Diller.

FUN FACT

On hot, humid days in midsummer, you can actually hear corn grow. Really.

Musicians

MARK KNOPFLER, MUSICIAN AND COMPOSER

Getting to photograph Mark Knopfler, founding member of Dire Straits, was a lucky break early in my career. The shoot took place at my home studio in London, and for six hours I was the happiest photographer with an easygoing houseguest who happened to be one of the world's most famous guitarists.

That said, it could have easily gone wrong, as the music I was playing when Mark arrived was not at all to his liking. Upon asking him what I could get him—a cup of tea, some juice, something to eat—he replied quickly, "Just turn that @#%* off right now!" as he pointed toward my stereo. Quickly, I changed the music to a new jazz CD I had bought and immediately Mark relaxed. We listened to it for the rest of the shoot, putting it on "repeat all" at his request.

It was then I learned one of the most important rules in studio portrait photography: Make your subject comfortable, and you will be too. This portrait was made toward the end of the session, and he obliged my request of holding his guitar in a "Possession" portrait pose that I had shot years before. —SA

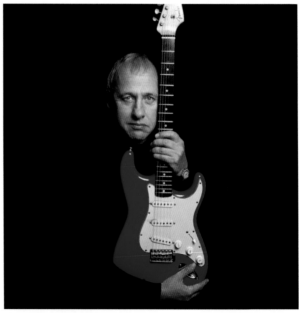

Photo © Simon Alexander.

Right Place at the Right Time

WOMEN'S 1,500 METER RACE

Think beyond the obvious. There were 20-plus photographers at the finish line of the Women's 1,500 Meter Race at the 2005 Prefontaine Classic with their telephoto lenses waiting to get a photo of the winner passing through the ribbon.

I decided to take a chance, and using a 17-35mm wide-angle lens, captured the pack of runners sprinting to the finish from a different position. It was pure luck that this pileup took place directly in front of me. The probability of something like this happening in that exact section of the track was very slim, but my gamble paid off. The photo ran in the double-page "Zoom" section of *ESPN The Magazine.* —TH

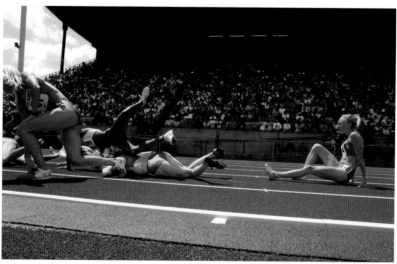

Photo © Tom Hauck.

Essential Light Modifiers

THE UMBRELLA

A photo umbrella is quick to set up and easy to use (see page 218). Incandescent hot lights or strobes can be used with umbrellas. There are two types—shoot-through and reflective—and they range from 32 to 72 inches in width. A shoot-through is made of a transparent nylon that enables the strobe light to flash through the umbrella, creating a large, soft lighting field.

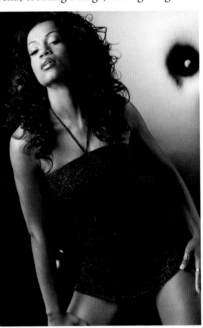

The interiors of reflective umbrellas are lined with either a white nylon or silver-reflective Mylar. The white creates a soft, low-contrast light and the silver a high-contrast sharp light. The umbrellas can be used in pair on each side of a model with a 2-to-1 lighting ratio. The fill umbrella light is set at half the power or intensity of the key-light umbrella.

A 60-inch reflective umbrella with a white interior was placed to the right side and 5 feet in front of this model. We raised it about 3 feet from the ground and aimed it slightly downward. A large silver reflector was placed on the opposite side of the light to fill the shadow with light to reduce the contrast of using one large key light. —MR

Photo © Matthew Roharik.

FUN FACT

A single large umbrella can effectively light an entire body.

Tampering with History

THE DOCTORED PHOTOS OF JOSEPH STALIN

"A document stuffed in the memory hole would be conveniently whisked away…" —George Orwell, *1984*

Joseph Stalin took the idea of making political undesirables "disappear" to the ultimate extreme. Not satisfied with merely imprisoning or executing those perceived as a threat to his authority, the Soviet Premier often attempted to erase people from photographic history, enlisting the help of experts who likely would have marveled at the modern wonder of Photoshop.

Many of the fathers of the Russian Revolution and former Bolshevik Party members were snubbed from history by Stalin's crack team of photo manipulators. Along with the preeminent revolutionary Leon Trotsky, the regime deleted Nikolai Yezhov, Lev Kamenev, and Alexander Malchenko from the annals of history after they became "threats to national security."

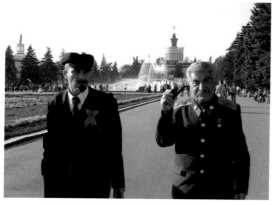

In some cases, a single photograph would be edited multiple times, as more and more individuals fell prey to Stalin's paranoia. In one instance, the details of a revolution-era political rally were changed and signs rewritten to fit the political orthodoxy of Stalinist Marxism. (One placard that had formerly read "Watches for Sale, Gold and Silver" was changed to read "Fight for Your Rights.")

It can be easy to ascribe such historical revisionism to only the most brutal dictators of the past. I would dare suggest, however, that for those endowed with authority, the temptation to erase "inconvenient" facts is an ever-present reality. The leadership style described by Lao Tzu in the Tao Te Ching, rooted in humility and flexibility, has historically been the exception rather than the rule. —DJS

As One

BY MARK TANNER

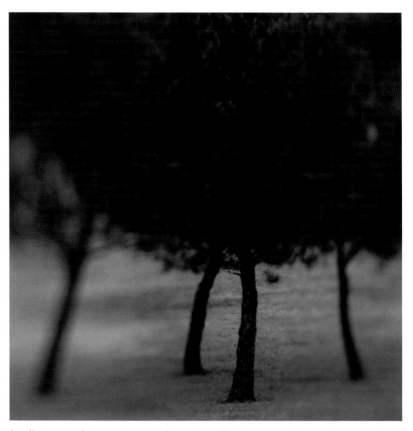

T his surreal image is part of a series called *Form and Atmosphere,* in which a very fine line of focus achieves a sense of depth and atmosphere. Using the shift and tilt functions on a 4 x 5 view camera, you can tilt the lens and the film planes in opposite directions to gain a very narrow line of focus and blur the rest of the image.

Mark Tanner is a photographer in the Los Angeles area. While he earns a living shooting advertising and editorial assignments, his passion lies in creating conceptual fine art images. www.marktannerphotography.com

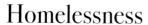

Homelessness

THE DEEPER TRUTH

Humans collect, they nest, they gather the practical, the sentimental, and the essential objects they need to make it through a day. What they choose to place around them, to laboriously carry and to hold dear reveals a deeper requirement of "home." No matter whether we own, rent, or lease, live with family and friends, live in a shelter, or any place that provides safety for the night—we always re-create around us our basic understanding of home.

Homelessness is a condition involving a person and a story. Convey this condition with visual observations about possessions, living environments, and interpersonal interactions. Document where the homeless fit within a community and how that community responds to them. Look at different levels of community—local, state, federal, international.

Find a level of personal connection, and make the photographs about a personal journey. Consider for a moment that connecting with the underpinnings and objects of being homeless allows for a deeper investigation of the topic. —MLR

The Aperture and Light

COME TO A FULL, COMPLETE F/STOP

The aperture is also referred to as the f/stop. A stop is a measurement of light. Shutter speeds, ISO, and aperture can all be talked about in "stops." However, that is just a bit too technical for what we will be learning in Photography 101, so for now, you only need to remember that aperture and f/stop are the same thing.

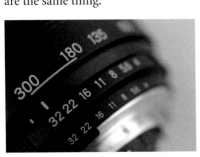

Close-up of lens aperture scale.

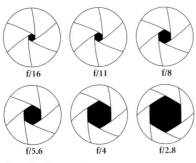

Examples of lens apertures.

The aperture is the opening of the camera lens that allows light to enter the camera. This opening can be changed to allow more or less light into the camera.

Standard aperture openings are f/2, f/2.8, f/4, f/5.6, f/8, f/11, f/16, f/22, and f/32. Your lens may have extra apertures, such as f/1.2 or f/1.4. Additionally, digital camera readouts may also show measurements of numbers that fall in between these standard measurements. For example, f/6.3 is on my camera, and it measures a partial "stop" of light.

Apertures can be a little confusing. The main thing to remember is that the lower the f/stop number, the bigger the opening and the more light that will be let into the camera. F/2 is the largest opening for the lens example discussed above, while f/32 is the smallest opening.

Each of these standard measurements also interrelate. Each f/stop lets in twice as much light as the next higher number but half as much light as the next lower number. For example, f/2.8 lets in twice as much light as f/4 but half as much light as f/2. —CWN

Eastman Kodak

SNAPSHOTS FOR THE MASSES

A photography enthusiast in his teens, George Eastman of Rochester, New York, employed the popular wet-plate process and later, gelatin emulsions in his work but began to experiment and eventually discovered ways to improve upon this method. In 1881, at age 24, he formed the Eastman Dry Plate Company, which became enormously successful.

Despite the success of his company, Eastman continued to look for ways to create a new type of negative that would be cheaper and easier to use than glass plates. His research and development resulted in significant practical and commercial advances in photography.

Among Eastman's contributions were film that came on a roll of paper coated with a gelatin emulsion and celluloid based film. Then came the blockbuster: In 1888, the company tapped into the budding amateur interest in photography, introducing a small, hand-held camera called a Kodak. The camera came preloaded with enough film for 100 pictures and offered a service where, for an additional fee, it could be sent back to Eastman, the 100 pictures could be printed, mounted on a paper backing, and the camera would be reloaded with another roll of film and sent back to the customer. The advertising slogan "You press the button, we do the rest" was absolutely accurate, and, despite some technical shortcomings, amateur photography took off around the world. What is now known as the "snapshot," an informal image of everyday life, was born. —DJG

Edward Curtis (1868–1952)

SHADOWCATCHER

Edward Curtis, photographer of the American West, spent 30 years documenting the traditional life of Native Americans. His life's work, *The North American Indian,* led him to create over 40,000 images in a 20-volume set, with 20 large-format portfolios, amassed from visits to over 80 tribes, ranging from the Inuit to the Hopi of the Southwest. His beautiful, gold-toned sepia prints, also known as "Curt-Tones," captured the likenesses of notable figures, such as Geronimo, Chief Joseph, Red Cloud, and Medicine Crow.

In 1898, while photographing on Mount Rainier, he discovered a party of lost scientists, including George Bird Grinnell, a renowned expert on Native Americans. Grinnell soon invited him on an expedition to photograph the Blackfoot Indians, where he taught Curtis systematic methods of acquiring scientifically valid information. Two weeks later, Curtis began his own project, with the goal of covering all aspects of Native American life and lore, most importantly mythology and spiritual practices.

Curtis painstakingly researched his subjects; his efforts to achieve immense depth of understanding earned him the name of "shadow-catcher," and tribal leaders began to invite him to visit their tribes, so as not to be left out of his historical documentation.[1] The work often meant grueling travel and inhospitable conditions, but Curtis felt strongly about photographing in natural settings, although some critics argue that he may have staged some of his images. In many cases, his material is the only recorded history in existence. —GC

Coming for the Bride by Edward Curtis, 1906.

Autumn Color

HARD TO BLOW THIS ONE

The lush greens of summer, soft white snow in the winter, spring skies with billowing clouds—they're all sublime but nothing can compare to autumn color.

The vibrant hues of red, yellow and orange standard at sunrise or sunset are rivaled by the intense blaze of a sugar maple tree with its saturated elegance. When autumn color is at its peak, even mundane objects like a tree house take on an air of grandeur.

Recording the scene with a camera needn't be difficult. Simply pick the desired view, and wait until the scene is properly illuminated. Make sure there isn't anything in the background, then with the camera on a sturdy tripod, set it to a high number f/stop in Aperture Priority mode. This will ensure detailed depth of field, and with a 10-second delay, capture the color. —WTD

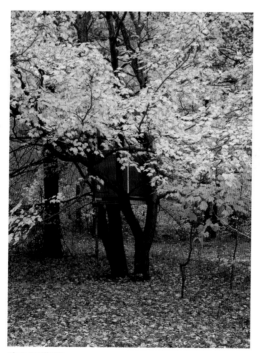

Photo © Bill Diller.

Drawing with Light

HELEN, DJ

Early on, my portraits were simple black and white images showing my subjects emerging from a black background. I started to play around with long and double exposures on film with some friends, and the result was a series of portraits called "Light Works," from which this is taken. In complete darkness, the subject draws with a flashlight and then looks toward my camera, and I fire off the strobe afterward (this was done before the use of Photoshop in my work).

In this image, Helen has drawn what I like to think are two rockets blasting off and is looking right at you, challenging you to decipher the drawing and to make up your mind as to what the light drawing could be. —SA

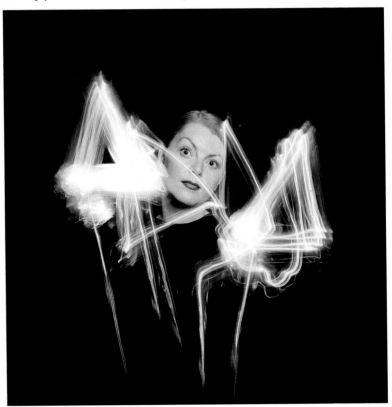

Photo © Simon Alexander.

Specificity vs. Serendipity

AN ONSTAGE UNSTAGED MOMENT

Sometimes an accidental moment becomes the most meaningful image in a series of photos. This photograph was taken during a studio shoot in San Francisco for the Smuin Ballet company. I had a seamless backdrop and studio lights set up to take photos of the dancers in their stage attire. Michael Smuin, the company director, stepped in to demonstrate his vision of the shot for the dancers, and I snapped a few photos to test the light. The image captures Michael's enthusiasm and flair, and respect among his dancers. Michael passed away soon after, and this photo was used at an event in his honor since it was such a strong representation of his character. —TH

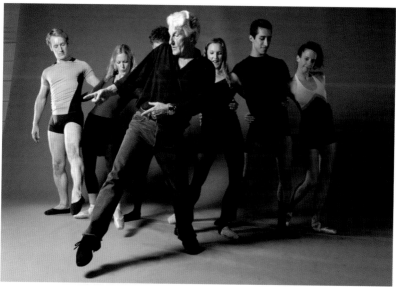

Photo © Tom Hauck.

Essential Light Modifiers

THE BEAUTY DISH

When shooting close-up beauty work, a photographer can make a stunning image by using a single beauty dish as the key light.

This shallow reflector is unique in the fact that a small circular disk is suspended in the center of the reflector so that the bulb is unseen from the front view. The light from the bulb is reflected back to the main reflector and then to the subject. This type of light modifier is most effective when used close to the subject's face, attached to a boom arm so the light can be lowered into place out of the camera's view.

A beauty dish attaches to a strobe light with a collar and is available with either a white or silver reflective surface, in widths from 16 inches to 32 inches. The light can be further softened with an optional diffusion sock.

To create this image, the beauty dish was placed to the model's right, with the front of the dish perpendicular to her face. The 16-inch-diameter beauty dish had a silver interior reflector with a diffusion sock. A parabolic reflector was used as a hair light directly over top of the model, and a strip box was placed to her left for additional highlights and to outline her form. A small 16-x-22-inch soft box was placed in front of her to fill in a bit of detail in the shadowed areas. —MR

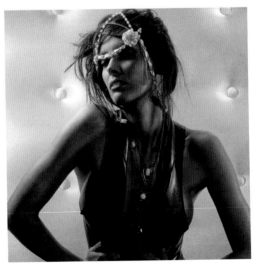

Photo © Matthew Roharik.

Revolver Camera

GIVING NEW MEANING TO THE TERM "PHOTO SHOOT"

Beginning in the mid-19th century, a variety of cameras appeared that were made to resemble walking canes, pocket watches, hats, and handbags. Perhaps the most peculiar permutation was the camera that looked similar to a revolver. Initially developed in Paris in 1862, Thompson's Revolver Photographique was later copied by other manufacturers. These cameras functioned in the same manner as a pistol would: The shutter release was a trigger, the cylinder would rotate the plates of film, and, in lieu of a viewfinder, the camera had sights on top of it to be lined up for careful aiming.[1]

The concept is not necessarily as morbid or as violent as it may initially seem, given the commonplace nature of sport shooting during the historical period. Be that as it may, it is not difficult to imagine the sticky situations that might face a curious tourist who pointed a revolver at strangers while on vacation.

Given its potential for such dangerous misunderstandings, the revolver camera is (thankfully, perhaps) a thing of the past. Still, one can imagine that, for some, it would have been cathartic to use this unique apparatus to draw a bead on certain in-laws while taking the family Christmas photo. —DJS

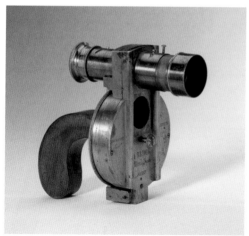

Thompson's revolver camera; photo courtesy George Eastman House, International Museum of Photography and Film.

Vanitas

BY KATHRYN OSGOOD

This photograph is part of a series of images that interpret the still-life *vanitas* paintings of the late 16th- and 17th-century Flemish artists. Typical elements used were skulls, clocks, decaying food or flowers, books, maps and luxurious items such as gold and goblets. Dark, moody light conveys their detail and texture. While this work is derived from the genre, the interpretation focuses on objects, composition, light, and precision rather than a message of mortality or impermanence.

Kathryn Osgood, a San Francisco-based freelance photographer, has always had a strong interest in photographing the natural landscape. Her fascination with the technological developments of photography has led to her current exploration of digital montage.

Greed

CAN EXCESSIVE DESIRE BE PHOTOGRAPHED?

In the Merriam-Webster dictionary, greed is defined as "a selfish and excessive desire for more of something than is needed." In a social context, greed can eventually lead to an imbalance in resources and in extreme cases place humanity in a position of devastating shortages, pollution, or awash in a sea of unneeded, unwanted, and unusable objects. Apathy and ignorance feed greed and build upon the unnecessary accumulation of "stuff."

Social and political greed pits community against community, individual against individual, country against country, and corporations against community. Recent revelations about corporate greed, Ponzi schemes, and the irresponsible game mortgage lenders and financial institutions have played, provide fodder for symbols of greed. Placing a photograph of the more notorious offenders next to the word greed in the dictionary may speak to the moment, but universal symbols of greed may ultimately have more impact as a photographic subject.

Is greed a byproduct of progress? Can it be spotted in a crowd of people? What exactly does it resemble? —MLR

Houses and Factories, c. 1941. Courtesy Library of Congress Prints and Photographs Division.

PHOTO 101

DAY 91

PHOTOGRAPHY 101

The Aperture and Depth of Field

HOW DEEP WAS MY VALLEY

So do you have the whole aperture thing figured out? Hang on because it gets just a little more involved.

The aperture of the camera, in addition to controlling the light that enters the camera, also influences how much of your scene is in focus. The area that is in focus is called the "depth of field."

A stalk of wheat in focus with the background out of focus (a small depth of field) indicates a large aperture setting was used in creating this photograph.

The larger the aperture is opened, the less the depth of field. If you are taking a photograph of a person with an aperture setting of f/2 and you focus on your subject's eyes, you will more than likely discover that your subject's ears are out of focus.

The smaller the aperture, the greater the depth of field. For landscape photos, you will want to make sure that your aperture is quite small, with a setting of f/22 or f/32. In the middle of this fall groups of people or a scene that is smaller or more close-up. An aperture setting of f/5.6 or f/8 will probably work for these situations.

The next time you are working with your camera, try a few different f/stop settings and check your photograph specifically for areas that are out of focus due to how far away they are from the camera. For a creative change of pace, try your hand at manipulating your f/stop to limit the area in focus as well.

Most lenses come with a chart showing depth of field guidelines. —CWN

The Study of Photography

ALFRED STIEGLITZ PROMOTES PHOTOGRAPHY AS ART FORM

An acclaimed giant in the world of photography for his impressive body of work, Alfred Stieglitz is also enormously important in the context of the history of photography because of his efforts to have the relatively new form elevated to the same status as other fine art disciplines, such as painting and sculpture. In addition to frequently exhibiting his own work and promoting the work of other artists, Stieglitz wrote extensive scholarly criticism, examining and, in fact, establishing some of the initial serious theories and aesthetics of photography.

In 1902, he formed a group called The Photo-Secession and opened the first of his several New York City galleries, exhibiting the work of fellow photographers who shared a similar approach to and philosophy about photography. In the same year, he also began to publish the quarterly journal, *Camera Work,* which featured high-quality reproductions and highlighted the work of contemporary progressive masters in the field. In 1905, he opened a new gallery known as 291, where, in addition to photography, he also exhibited work by radical painters Henri Mattise, Paul Cezanne, and Georgia O'Keefe (who would later become his wife), sculptor/painter Georges Braque, and sculptor Auguste Rodin as well as the work of African craftspeople.

After 291 closed and *Camera Work* printed its last issue, he opened The Intimate Gallery (1925–1929) and another, An American Place, in 1929, where he continued to exhibit paintings, sculpture, and photography until his death in 1946. —DJG

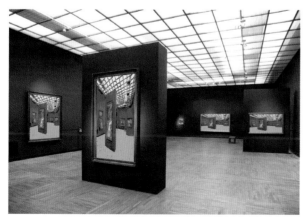

Margaret Bourke–White (1904–1971)

BRIGHT, BOLD, AND BRAVE

Margaret Bourke-White was known for her tenacity and fearlessness, two traits an early female photojournalist and first female war photographer had to have. A trailblazer in many respects, her career required her to work in dangerous conditions while covering wars and major events all over the world. Whether hanging out of bombers, climbing the Chrysler Building, or witnessing the atrocities during the opening of the gates of Nazi Germany's Buchenwald Concentration Camp, Bourke-White boldly moved where no woman had ever gone before.[1]

Her career began in Cleveland, Ohio, where her early photographs captured the bold, clean lines of American industry with a crisp aesthetic. These photographs brought her to the attention of Henry Luce, who hired her as the first photographer for *Fortune* magazine in 1929, and later hired her as the first female photojournalist for *Life* magazine.[2]

Bourke-White was both a celebrated artist and a successful businesswoman. Her studio in the new Chrysler Building also hummed with work for advertising clients, including the creation of the biggest photographic mural in America for NBC Studios in Rockefeller Center. However, during the Depression, she began to focus more on social issues, collaborating with Erskine Caldwell on her best-known book, *You Have Seen Their Faces.* —GC

Tranquility

YOU CAN SEE THE QUIET

Tranquility is defined as the state of being tranquil, being free from agitation of mind or spirit. There may be no more accurate photographic representation of a tranquil scene as undisturbed, new-fallen snow blanketing the trees and ground along the banks of a slow-moving stream. You can almost hear the peace.

Once a stream has frozen over and becomes covered with snow, it's no different from a road or trail—it's merely a wide snow-covered expanse between trees. There is nothing to make it stand out. It has no character. But if you come upon that same scene with stretches of open water flowing, it takes on a totally different personality.

A scene like this should be photographed using as much depth of field as possible, which means using a tripod or some other sturdy method of keeping the camera still. Shoot at the highest number aperture you can manage. —WTD

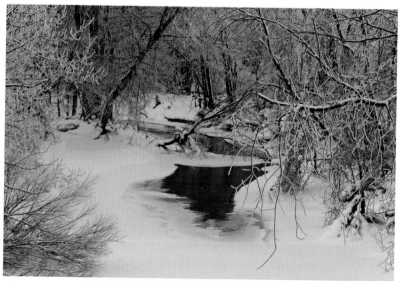

Photo © Bill Diller.

Color Cross-Processed

DAVID BYRNE, MUSICIAN, COMPOSER, AND ARTIST

For this portrait to happen, I had to be in the right place at the right time, which luckily for me I was. Shortly after photographing Mark Knopfler, I was in a bar in London with some friends and met one of my favorite musicians, David Byrne, who started a band at art school called Talking Heads. He was hanging out with some other musician friends of mine who were in a new band and about to release their first album.

After saying "hi" to my friends, I went up and introduced myself, and asked him flat out if I could make a portrait of him. He agreed, and I tried my new "Light Works" technique with him, but this time using color-slide film, cross-processed in color-negative developer, resulting in this cool and saturated image. I also knew that he would enjoy the process, and this image is the result of a great collaboration during an afternoon using two rear-cycling flashlights and some ambidextrous hand movements. —SA

Photo © Simon Alexander.

Off-Field Score

WINNERS ON THE BLEACHERS

College football fans are the most exuberant of fans. It is often just as exciting to shoot the crowd as it is the game itself. I was covering a late-fall battle of undefeated teams, the Wisconsin Badgers at the Purdue Boilermakers in West Lafayette, Indiana. The home team's quarterback Kyle Orton was a Heisman Trophy candidate, and the students took it upon themselves to creatively lobby for their classmate. Even though the temperature was in the low 40s, as you can see, they were still giving it their all. —TH

Photo © Tom Hauck.

Essential Light Modifiers

OCTAGONAL SOFT BOXES

Octagonal soft boxes resemble umbrellas but use rods that are supported by a rigid, metal collar designed to fit specific manufacturers of strobe lights. Boxes range from 30 inches to 80 inches in width. The box is placed over the strobe and the light shoots forward through a white diffusion panel that is on the front of the box. Some boxes have an internal diffuser, or baffle, that softens the light even further (see page 218).

Each diffusion panel decreases the intensity and power of the light by at least one f/stop. Each panel also lowers the color balance from the daylight balance 5500 Kelvin by a few hundred degrees. The shift toward the warmer color spectrum causes a yellowing effect. It is subtle when using one diffusion panel.

A 60-inch octagonal soft box with two diffusion panels was placed to the right side of the model about 3 feet from her face. A large white reflector was placed on the opposite side of the light to fill the shadow with light to reduce the contrast of using one large key light. A small strip light was placed on the floor pointing upward, centered on the eyes and illuminating under the neck. A 150mm lens at 4.0 was used to achieve the limited depth of field so that only the face is in sharp focus. —MR

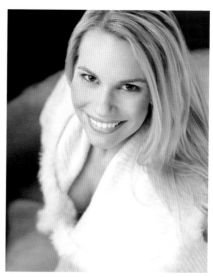

Photo © Matthew Roharik.

The Victorian Dead

A FINAL KEEPSAKE

A boy is posed holding a stringed instrument in his lap, seated on the edge of a large, upholstered chair.

An infant sits upright beneath an arch of white flowers. Her eyes stare ambiguously into the camera.

Girl with Scissors. Cabinet card, ca. 1890. Image courtesy of The Thanatos Archive.

A young girl sits in a small rocking chair wearing her finest dress; her doll and other playthings appear on the floor nearby.

All of these children were dead when they were photographed.

During the Victorian era, it was common for families to take elaborate photographs of their loved ones who had passed on. Many of these photos were taken to preserve the last memory of deceased children; often the mother would pose alongside the child's body. In a dark predecessor to the modern Christmas card, copies of these images were sometimes mailed out to loved ones.

Curiously enough, many of the post-mortem scenes were staged to appear as lifelike as possible: The corpse was often posed with its eyes propped open or with pupils painted on its eyelids. In almost contradictory fashion, the photographs announce tragedy even as they seem to simultaneously deny the finality of death. —DJS

Hong Kong from The Peak on a Summer Night

BY TREY RATCLIFF

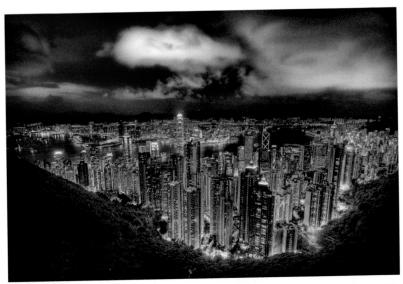

HDR photography is an ideal way to capture the warm glow and metallic shine of a metropolis skyline at twilight. This spectacular image demonstrates how the tone mapping process (done in Photomatix®) can work wonders in a city scene, giving the buildings a stunning three-dimensional vibrancy. Additional software programs, such as Topaz Adjust® or LucisArt®, are often employed in scenes like this to enhance detail and really make the picture "pop."

Trey Ratcliff is a world-famous travel photographer known for his pioneering contributions to the world of HDR photography. You can view his work at www.stuckincustoms.com and learn more about his technique at his HDR tutorial (www.stuckincustoms.com/hdr-tutorial).

Mighty Transportation
POWER ON WHEELS

Transportation enables products to be delivered across continents and within nations, quickly delivers people from one location to the next, and until e-mail, had control over simple communication, such as documents and letters.

Dependence upon a petroleum-based transportation system generates power and places it in the hands of those who manage the industry and the political powers who support its growth. Whole sectors of the economy are founded on the use of transportation—the auto industry, insurance, and airlines. Others are expanded through the use of transportation—trucking of food and products across state lines and region to region, and the exporting and importing of the same products overseas. The more money made, the bigger the political power game.

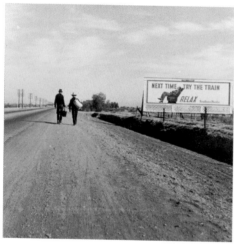

Toward Los Angeles, California, 1937. Photo by Dorothea Lange. Courtesy Library of Congress Prints and Photographs Division.

Capturing the mighty power of transportation in a photograph can succeed from several angles—the industry, the commuter, the habitual passenger, the lobbyists, the politicians, a business establishment. A photographer's foray into a crowd of commuters reveals the stress of traveling daily. A visit to a rail yard, a cargo container company, a shipping port, a freeway during rush hour—each contains a piece of information about the political power of transportation. —MLR

Change One, Change Them Both

USING SHUTTER SPEED AND APERTURE TOGETHER

Since both the shutter speed and the aperture control the amount of light, it is important to use them in conjunction with each other.

First, you must find the proper exposure for the scene. The easiest way to do this is to check your in-camera light meter. Generally, when you look through the viewfinder of your camera, you will see something like this:

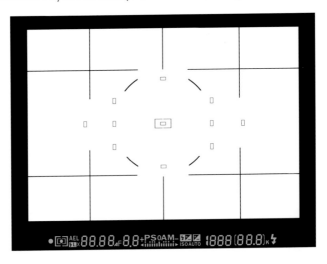

Part of the display shown above is the in-camera light meter, which will indicate if your camera settings are allowing in enough light.

Change your aperture and shutter speed settings until the in-camera light meter shows a proper light balance for your scene. If your shutter speed is too slow, you can increase the shutter speed. The important thing to remember here is that for every change to the shutter speed setting, you must compensate by changing the aperture setting in the opposite direction.

For example, if your settings are 1/30th of a second and f/5.6, but you would prefer a 1/60th of a second shutter speed, you must change your aperture to f/4. To break this down even further, you have decreased the amount of light entering your camera by half when you changed the shutter speed from 1/30th to 1/60th of a second. To compensate, you needed to double the light entering the camera by changing the aperture from f/5.6 to f/4. —CWN

Oskar Barnack and the Leica

CAMERAS GET REALLY HANDY

German Oskar Barnack set out to become a painter, but after an apprenticeship to a maker of mechanical devices, he became fascinated with technical instruments and, eventually, photography. He worked as a toolmaker, specializing in precision mechanics and optical equipment before going to work for a maker of scientific instruments. He worked in the experimental department of the firm of E. Leitz, where he developed highly precise machines for use in complex manufacturing.

In 1905, Barnack created a way to put 15 to 20 pictures on a single negative with the idea that they could be enlarged into photographs at a later time. In 1914 his idea came full circle when he created a tiny, single-shutter speed camera that used 35mm motion-picture film. This camera was the Ur-Leica— the first successful small-format camera. The pictures it took were of the highest quality of any camera yet.

World War I hampered the commercial development of the Leica, but Barnack continued to tinker with and improve upon his original design. The Leica was formally introduced to the public in 1925, and by the outbreak of World War II it was the camera of choice for professionals and amateurs alike. Andre Kertesz and Henri Cartier-Bresson were Leica users, and it remained wildly popular for decades. Barnack spent the rest of his life further refining and improving the original camera, ultimately creating numerous models and thousands of accessories. —DJG

Imogen Cunningham (1883-1976)

BEAUTY IN THE DETAILS

Vivid, swirling botanical images and intimate, sensual studies of both plants and people define Imogen Cunningham's work during her many decades as a photographer. Her attention to clarity of form, pattern, and design is a common denominator through all of her work. However, she was a technical master first and foremost; a chemistry major in college, she spent several years as an apprentice to Edward Curtis, where she learned his special technique for making platinum prints.

Cunningham loved to experiment, both in and out of the darkroom. She even developed her own chemical process, adding lead salts during the printing process to produce sepia tones in her prints. Sandwiching two negatives together to create double exposure prints was another area of fascination. To her, photography was a means of exploration, play, and creativity.

One of the first female professional photographers, she opened her first studio in Seattle and was quite successful, but her vision and circle of friends blossomed dramatically when she moved to San Francisco in 1917 with her husband, artist Roi Partridge. It was there that she met influential photographers, such as Edward Weston and Ansel Adams, and went on to cofound Group f/64, which was short-lived yet legendary in its pursuit of technical purity and prowess.

Whether photographing magnolias, morning glories, the industrial landscapes of Oakland, or portraits of celebrities for *Vanity Fair,* Cunningham strove for perfection and joy of creation. She photographed actively until weeks before her death at the age of 93. —GC

The Tree

AN EVERGREEN SUBJECT

Sometimes the most simple of subjects make the best photographs. Less is more, or to paraphrase a Joyce Kilmer poem: I think that I shall never see a photograph as lovely as a tree.

One particularly beautiful tree stands near my home and has become one of my favorite subjects to photograph. Trees are generally taken for granted, and in a place where lofty forests once stood there is something heroic about a lone tree, standing as a sentinel against the elements. With sweeping branches, the tree presents a visage that is unique. Whether covered with the green leaves of summer or frost in winter, barely visible on a foggy day or lit by the failing rays of a setting sun, it always photographs well.

It may seem foolish to go on about a simple tree, but to again borrow (and again, butcher) Joyce Kilmer: Photographs are made by fools like me, but only God can make a tree. —WTD

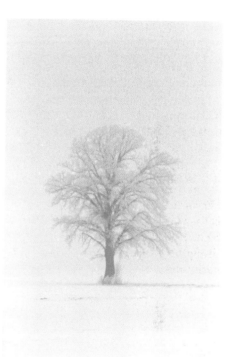

Photo © Bill Diller.

Use of Sunlight

ROBERTO CORTAZAR, PAINTER

As I turned up to the gallery, where I was commissioned to photograph Roberto Cortazar for a magazine, I had no idea that luck would shine on me again. The dimly lit gallery in an old Manhattan house was small and long, and, after arriving early to set up with my assistant, I simply did not know where to shoot. The space was tight, but there was one small painting with a huge frame that caught my eye. As always I had brought my strobe lights and was not too worried that this lack of light would present an issue.

Roberto arrived and we chatted briefly about some ideas. We shot some frames and they looked okay, but something was missing. I needed another dynamic element to bring it all together. Then the sun came flooding into the gallery, and cast a shadow of Roberto onto the wall and frame. He was actually looking down and waiting for me to decide what to shoot next, so I asked him to look into the lens, and I pressed the shutter, capturing his shadowed profile on the white frame. The balance of light and dark worked well, and thanks to my trusty light meter, I was able to recalculate the contrast range and exposure and make the shot. —SA

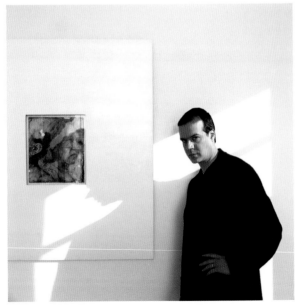

Photo © Simon Alexander.

Use of Light: Front Lighting

MAKE HASTE WHILE THE SUN'S LOW

Front light on a subject can create images filled with brilliant colors. Using a wide aperture as well, allows the background to be blurred creating isolation of the subject. Not only is this technique difficult for the subject, causing them to squint, but the direct light can cause unwanted harsh shadows. The best time of day to use front light is when the sun is close to the horizon, typically within an hour of the sun setting or just rising. —TH

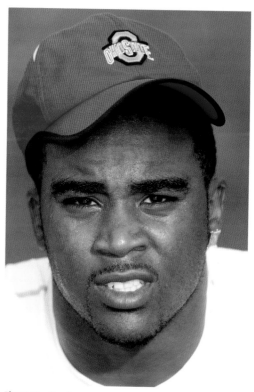

Photo © Tom Hauck.

Secret Garden

DON'T HAVE A FOREST? MAKE ONE!

To create the feel for the Secret Garden–themed photo shoot, we rounded up about 50 large branches and placed them on gray muslin that covered 15 feet of floor. Dried leaves and grasses were added for texture. Several branches with dried leaves intact were hung from the ceiling in a 10 to 15 foot range from the model.

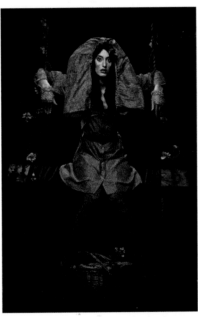

*Makeup: Tim Maurer; model: Laura Itzkowitz. Photo ©
Matthew Roharik.*

The 200mm lens shot at f/8 about 30 feet from the model, compressed the appearance of the space and created a forest look. Hemp rope aged with wood stain and wrapped in dried grapevines supported the swing from a steel girder. A 22-inch beauty dish provided the key light off to the right of the model. The other front fill light was a 72-inch octagonal soft box placed 10 feet away to the left and powered near its lowest setting. A 16-inch diffused beauty dish was directly overhead. Directly behind, two strip boxes with no diffusion against the back wall provided the rim lighting for the model. Two strobe lights with barn doors were aimed at the canopy from behind to outline their shape. —MR

Urban Legends II
THE CURSED ADVERTISEMENT

Is it possible for a person to be cursed as a result of being photographed? Many have smugly attributed this superstition to primitive tribesmen from some remote location. The best documented occurrence of said belief, however, has occurred in modern folklore in the form of the urban legend, "The Cursed Advertisement."

The story involves a famous recurring ad campaign, either the cover of *Sports Illustrated* magazine, Campbell's Chunky Soup television commercials, or, most recently, the video game "Madden NFL." According to the legend, every athlete who has posed for the advertisement was plagued with bad luck following the photo shoot, suffering sports injuries, a waning career, or trouble in their personal life.[1]

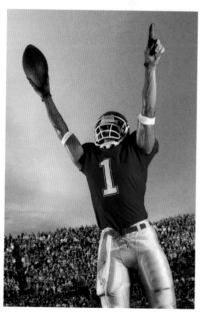

While it is true that many of the athletes featured in these endorsements experienced misfortune shortly thereafter, this should come as no surprise. Most spectator sports, by their very nature, entail injury at some point, and selection for an illustrious ad campaign often marks a high point in an athlete's career, after which a decline is not uncommon.

Could it be, however, that the deeper meaning of this story has to do with the act of being photographed itself?

In this age of reality television shows and increasingly elaborate popularity contests, the scramble for stardom seems to have reached a fevered pitch. Considered in this context, the urban legend in question may serve as a modern cautionary tale: Regardless of whether any particular publication is actually "cursed," it cannot be denied that notoriety often brings unexpected negative consequences. —DJS

Bay Bridge

BY RICK SZCZECHOWSKI

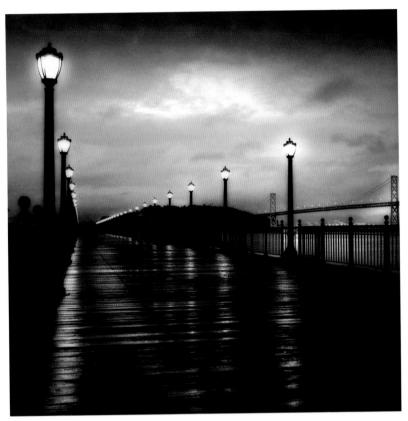

This image started out as a traditional darkroom print, incorporating many techniques. The image was intentionally printed one stop dark. All the highlight areas were then bleached back to give a luminous effect. The sky was burned in even more, gradating from dark at the top to increasing lightness. The lower portion was also burned in. These techniques help give the scene a dimensional quality.

Los Angeles-based Rick Szczechowski is a commercial photographer. He is particularly interested in the art of polymer photogravures. His can be seen at Island Weiss Gallery in New York City and at Hunsaker/Schlesinger Fine Art in Santa Monica.

Employment

THE VISUAL IMPACT OF UNEMPLOYMENT

Like a small hole found in the material of a well-loved jacket, a continually growing rate of unemployment can pull and tear and eventually rip apart the fabric of community. Conveying the social impact of unemployment begins with an understanding of the threads of community, the result of a few weak fibers, and how that might be interpreted visually. Weak fibers are linked to loose, curvy and frayed threads. Groups of weak threads suggest a progressing breakdown in the fabric.

The weaving, snaking lines of the unemployed waiting for food, jobs, and training, or parades of hungry, angry, jobless protesters are hallmarks of visually portraying unemployment. Simple, handcrafted signs of explanation, desperate attempts to obtain a job, the faces of skilled and highly educated individuals working at low paying, often menial jobs invoke empathy, recognition, and fear from the viewer. Think of each person within the photograph as a worn thread. Eventually, the fabric needs repairing, reinvention, or repurposing. Now, the snaking lines, the parade of protesters, becomes a positive force. —MLR

Overview of Lenses

THE LONG AND THE SHORT AND THE ZOOM OF IT

If you own a SLR or DSLR, you have probably had to choose a lens to go along with your camera body. Usually a basic lens comes with the body, but there may be a time when this lens doesn't meet your needs. Let's review the most common types of lenses: normal, long, short, and zoom.

The most important difference between lenses is their focal length. Focal length is the distance between the optic center of the lens and the film/sensor.

A normal or standard lens captures almost exactly what is seen by the human eye. What is considered normal varies, depending on the film size; for a SLR/DSLR, it would be 50mm.

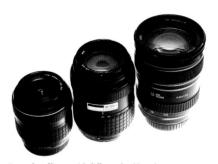

Examples of lenses with different focal lengths.

A long lens is used when you do not want to get close to a subject or are not able to. Some standard long lens sizes are 85mm, 105mm, or 200mm. The higher the number, the farther away from your subject you can be, or the greater the magnification of your subject.

A short lens has a shorter focal length than a standard lens and provides a wider angle of view, which explains why they're also known as wide-angle lenses.

A zoom lens covers a range of focal lengths, and the lens can be adjusted anywhere within that range. My favorite zoom lens is a 28-105mm lens, which is perfect for everyday shooting, but if I am going to photograph distant objects, I tend to use my 80-200mm lens. —CWN

FUN FACT

The longest lens is a 1700mm telephoto lens manufactured by Carl Zeiss and developed specifically for the Hasselblad 203 FE for use in long distance wildlife photography.

Nikon

JAPAN GETS CAMERA-READY

Nippon Kogaku Kogyo Kabushiki Kaisha (loosely translated as "Japan Optics") of Tokyo was formed in 1917 when the three leading producers of optical materials (one of which had been in business since 1881) merged to form one company. Much like the German companies Leitz and Zeis, they initially produced well-regarded microscopes, telescopes, surveying equipment, and other instruments for science and industry, not cameras.

In the 1930s Nippon Kogaku Kogyo Kabushiki Kaisha was producing photographic lenses for other companies, such as Canon, when the Japanese government selected them to be their largest supplier of military optics, producing binoculars, periscopes, bomb sights, and aerial lenses. It was during this time that, partially in response to demand from the Japanese navy, the company began to do more research into cameras, and they soon began to manufacture cameras for reconnaissance airplanes as well as naval vessels.

At the end of World War II, the occupation, eager to reestablish the Japanese economy, reorganized the company to make products for civilian use only. In the mid-1940s, the company decided to enter the camera market after years of supplying their products to other manufacturers. After a couple of years of development, studying, and improving upon the designs of the Leica and the Contax, they introduced their first product, the Nikon I, under the brand name Nikon, in 1948. U.S. Occupation forces discovered the high-quality products while stationed there and brought them home, eventually creating demand, popularity, and the rise of an industry giant. —DJG

Dorothea Lange (1895–1965)

SHOWING WHAT WE DID NOT SEE

Dorothea Lange made photographic history with her Depression Era work for the Farm Security Administration (FSA), bringing the tragic circumstance of migrant workers, displaced farm families, and sharecroppers to the attention of the government and the nation at large.

For many years, it was her mission to follow the exodus of farm families as they left the Dust Bowl and headed west to find work. She and her husband, labor economist Paul Schuster Taylor, collaborated on this project that documented rural poverty and human suffering; he provided the text, and she provided the photographs. The images were distributed in free newspapers across the country and became powerful icons of the era.

Lange was trained as a photographer in New York City but moved to San Francisco in 1918, where she opened her studio. When the Depression hit, she turned her lens toward the streets of San Francisco, documenting homelessness. This work led to her employment with the FSA. Later, she was again hired by the government (this time, the War Relocation Authority) to photograph the forced evacuation and relocation of Japanese Americans to internment camps following the attack on Pearl Harbor. Her images were so haunting, critical, and controversial that the government censored and impounded them.[1]

Her empathy and compassion drove her to persist in her work of documenting the poor and the forgotten. She continued to travel the world and produce vivid documentary photo essays during the final years of her life. —GC

Flowers

YOU CAN'T IMPROVE UPON 'EM

For a photographer, there are no limits, no end to subjects begging to be recorded. A flower garden is a prime example. It's full of colorful plants just waiting to fill the viewfinder. Flowers come in different sizes and shapes, and in every color of the rainbow. They're the perfect objects to photograph, because they don't move fast and won't bite. Flowers aren't shy but rather boastfully display their petals.

Photo © Bill Diller.

Photographing them need not be difficult. A tripod isn't required, and in the confines of a crowded garden may be more of a hindrance than a help. Take advantage of the sweet light at the beginning and end of the day, compose carefully, and shoot at a high shutter speed in order to blur the background. If everything's done correctly, you will have immortalized a beautiful flower—the perfect picture.

—WTD

Environmental

ELIZABETH PEYTON, PAINTER

Elizabeth Peyton's studio was small at the time, and so were her paintings, so when I showed up to make an environmental artist's studio portrait for a magazine, I was not sure I had enough space to do it.

In the end, her inspiration wall above her desk proved an intriguing environmental backdrop—the orange fluorescent masking tape she had used to stick pictures up jumped out and caught your eye. This image spoke most to me about her and her paintings, the quiet observation of a moment or a person, and a keen eye for detail.

Since this image was made, she has become a very successful painter, and I am glad that I got the chance to meet her and make her portrait. —SA

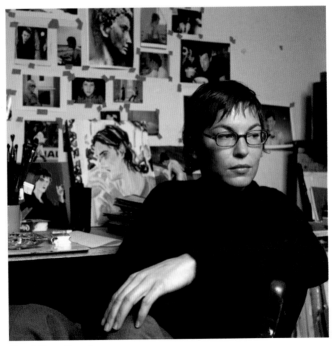

Photo © Simon Alexander.

Back Lighting
TURNING A REBEL INTO AN ANGEL

During a portrait session of Heisman Trophy candidate Eli Manning, of the University of Mississippi Rebels, I took advantage of the position of the sun to backlight my subject.

I positioned myself so the sun was directly behind his head, making sure to shade my lens to prevent direct light from refracting in it, which causes lens flare. I used one fill light to balance the light on the front of the subject, giving it a three-dimensional feel.

The backlight of the sun created an almost angelic halo behind Eli, which is consistent with his character. —TH

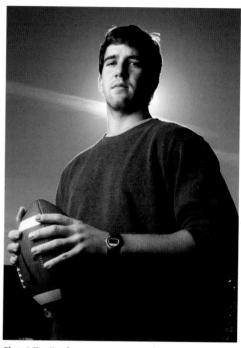

Photo © Tom Hauck.

Setting the Mood of the Shoot

THE PERFECT MUSIC PLAYLIST

Music played during a photo shoot can greatly aid and inspire the photographer, talent, and crew. A carefully crafted playlist will help put the model at ease. While in a studio or on location, music is an essential part of the image-making process.

Make two 40-song playlists. The first consists of music for the time up to the shoot, with ambient and house music, and the second consisting of high-energy pop, techno, and rap music for the actual photo session. Order the songs in the first playlist so that the music starts mellow and chill. Increase the tempo of each song, and end it with an upbeat song that will transition into your second high-energy mix. The first mix is to be played while participants are arriving and the talent is receiving their makeup and hair is being styled.

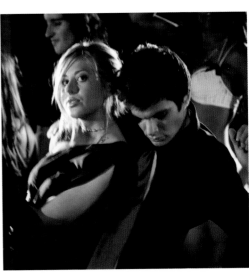

Photo © Matthew Roharik.

The second list should start fast and end even faster! Have fun with this list. Songs from any genre will work as long as they share a pulsating beat and are up-tempo. Fashion and beauty photography is often about capturing movement and emotion, so explore songs with sensual base lines and rhythm that motivate people to move. This mix is meant to be played at a high volume as long as it does not drown out your direction to the model. Think of yourself as a club DJ that has to please a crowd of diverse people while enticing them to dance and keeping them moving. Stay with current music, and choose songs for your playlist as carefully as you choose your equipment. —MR

The Human Soul

WHAT DOES IT LOOK LIKE? HOW MUCH DOES IT WEIGH?

In 1911, Dr. Duncan MacDougall conducted a series of experiments with patients who were at the brink of death. One of his goals was to photograph the human soul.

The Massachusetts physician theorized that the "soul substance" produced light as it exited the human body, creating an image "resembling that of interstellar ether." While most of his experiments involved analog photography, the doctor suggested that X-ray images might also show evidence of the soul, should it become "agitated" at the moment of death.[1]

Dr. MacDougall conducted similar experiments with tuberculosis patients to see if the human soul had a physical weight. By weighing patients on their deathbed, he determined that the body lost 21 grams of weight at the exact moment of death.

The physician's research raises an immediate philosophical question: Can the human soul really be limited to a quantifiable physical substance?

The crux of Dr. MacDougall's research may have hinged on a false premise, after all. The idea of photographing or weighing the human soul presupposes that the essence of a human being—whether called "soul," "spirit," or "life force"—is a material separate from the sum of that person's parts.

According to theologian B. O. Banwell, in contrast, the ancient Jewish concept of the soul was much more holistic. Drawing from Biblical references to the soul, Banwell states, "It was essentially the whole man, with all his attributes, physical, intellectual, and psychological, of which the Hebrew thought and spoke."[2]

Sounds considerably more relevant than a 21-gram blob of mist. —DJS

Victoria Beach Tower

BY COLIN GILBERT

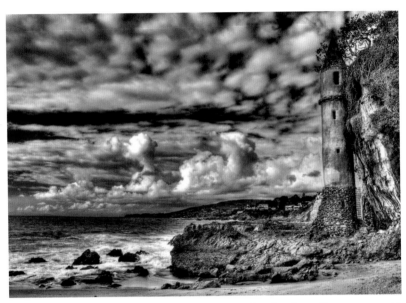

This dreamy scene is an HDR photograph that has been "tone-mapped," enhancing local contrast to create a vividly detailed look. Often when people first view an HDR image they say it "looks like a painting." The dazzling clarity that results from tone mapping gives photographs like this a surreal yet hyperrealistic quality. HDR tone mapping is quite effective in scenes like the one here, where rustic textures meet dramatic skies.

Colin Gilbert is a photographer, writer, and educator living in Southern California. He specializes in travel, landscape, and HDR photography. www.colingilbertphoto.com

Daily Routines

FAMILY DINNER AS VISUAL FOCUS

Ordinary topics allow for extraordinary framing and visual interest if the photographer is aware of his or her surroundings. A photograph by Russell Lee conveys the concept of a daily routine—preparing a small meal—by simply moving away from the task at hand and viewing the larger setting. Incorporating the whole kitchen in this instance reiterates the idea of routine through repetition of hinges, tiles, and drawer pulls.

The utter simplicity of the workspace allows the task of the woman to retain its place as a focal point. A kitchen filled with items would be distracting against such a repetitive background, causing the photographer to choose another angle or point of view to convey the visual message.

The patterns of the woman's clothing further support the concept of routine and repetition, and her place within a very human and familial need—sustenance. The viewer would be completely unaware of these details if not for the forethought of the photographer and his ability to notice the total enclosure available for the photograph. —MLR

Kitchen of tenant purchase client. Hidalgo County, Texas, 1939; Library of Congress, Prints and Photographs Division.

Focusing Your Lens

I CAN SEE CLEARLY NOW

There are two ways to focus a lens; manually and automatically.

Some lenses have a button, switch or slide on them for you to choose automatic or manual, so make sure that you have chosen the proper mode. Some cameras also have a corresponding switch that will need to be set as well.

Manual focusing can be a little tricky. The best method is to rotate the focusing ring on the barrel of the lens until the subject is in focus. Then rotate the lens some more to take the subject out of focus and then back in focus so that you are sure that your focus will be perfect.

An example of a manual/automatic focus switch on a lens.

A camera with an autofocus capability sends out a beam of infrared rays that will bounce back from your subject, providing a measurement of the distance between the camera and the subject and will adjust the focusing ring on the lens barrel accordingly.

Lenses that focus automatically can be set in several ways. It's time to pull out that manual again to find out the specific methods available on your particular camera. Generally, there is an overall scene-automatic mode that adjusts the focus so that most of the scene is clear. You may also have the ability to select certain areas (or brackets) of the frame to focus on.

An added feature is a focusing lock, where you can prefocus on a certain area so that when your subject enters that area, she will be in focus. —CWN

FUN FACT

The only camera that did not use a lens to focus was the pinhole camera.

Photograms

WRITING WITH LIGHT

Photograms are photographs in perhaps the truest sense because they are images created with exposure to light, but they are not considered photographs in the conventional sense because they are not created using a camera.

When objects are arranged on photographic film or photosensitive paper, exposed to light and then developed, all but the areas of the paper where objects had been placed are rendered black, leaving a pattern in the shape of the objects. Different effects are achieved when objects of varying degrees of solidity are used, either laid directly on the surface or just over it.

In the development of photography, many of the early inventors experimented with what would later be named photograms, but, around 1918, cutting-edge artists—such as Christian Schad and soon after Man Ray and Laszlo Moholy-Nagy—who were working with photography began presenting abstract art in the form of photograms.

Man Ray, an established painter, sculptor, filmmaker, and photographer, came upon photograms as a result of a darkroom mishap and soon became entranced with the form, which he called "rayographs." His work in the form produced increasingly more complex, sophisticated images as he continued to experiment with the effects of light and motion during his exposures. Throughout the 1920s and 1930s Man Ray was at the forefront of the surrealist and dadaist movements, exhibiting in major galleries and, in 1935, as part of a show at the Museum of Modern Art in New York City. —DJG

"Different Moods" photogram. © Les Rudnick 2010.

Helmut Newton (1920-2004)

THE KING OF KINK

Helmut Newton built his reputation on his capacity to shock. Indeed, his images were rife with plenty of isms: fetishism, sadomasochism, and voyeurism, and one must not overlook the themes of pornography, bondage, prostitution, and aggressive cat fights. The models in his photographs appear pristine and aloof, with perfect hair and makeup, often either nude or semi-nude, clad in neck braces, casts, dog collars, heels, or perhaps in a wheelchair. Because he went to such great lengths to depict his female models in the most unusual ways possible, it should come as no surprise that his birthday was on Halloween.

Although he was born in Germany, Newton fled to Singapore in 1938 to escape the Nazis.

He settled in Paris in 1961 and began to develop his signature style of erotically charged, unsettling imagery. His work appeared in British *Vogue* and *Jardin Des Modes*, followed by French *Vogue*. However, his work did not appear in American *Vogue* until 1971, after Dianna Vreeland was fired (apparently, she was not a fan).

He has been honored with The Tokyo Art Director's Club Prize, The Life Legend Award for Lifetime Achievement in Magazine Photography (*Life* magazine, 1999), and recognized by the French and German governments.

Helmut died in a car accident in Los Angeles in 2004. His final spread in *Vogue* depicted a model eating grass and another lying on a bed of nails.[1] —GC

Woodland Paths

CROOKED, TWISTED—AND WE LIKE THEM THAT WAY

We've all heard the expression, "follow the path of least resistance." In the natural world, people have been following the path of least resistance for thousands of years. Rather than go directly through a marsh or over a mountain, they follow the most convenient route. That's why a woodland path meanders along, following the contours of the land instead of brazenly traversing a straight line. The path of least resistance also creates, in the eyes of some, a beauty that a more direct route lacks.

Photographing such a scene calls for a wide depth of field, so the camera should be mounted on a sturdy tripod, and set to the highest number f/stop. After the shutter is snapped, the mystery created by following the path of least resistance is preserved. —WTD

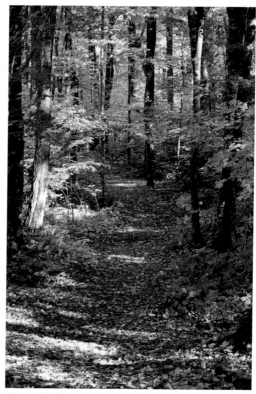

Photo © Bill Diller.

Use of Shadow

DONALD DEAL, FASHION DESIGNER

Donald Deal's fashion design and sense of style is classic, timeless, and beautiful, and he has dressed many for the red carpet over the years. When he commissioned me to make his portrait, I was very happy to oblige.

Our inspiration was the cinema portraits of the 1930s and '40s. We shot a variety of setups, using old Fresnel tungsten light, and even an old 4 x 5 format film camera, shooting only on black and white film and Polaroid. In some shots he was seated, standing in others, and always wearing a variety of elegant clothing. This portrait was the final choice and actually comes from a Polaroid 669 proofing negative.

What I like most of all is that the dramatic lighting technique I used here creates a lot of shadow, which adds depth and dynamism to the final image. —SA

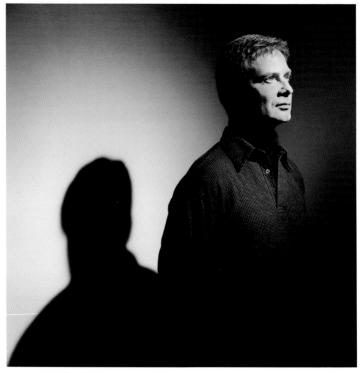

Photo © Simon Alexander.

Backlit

OVERSPRAY IN A WHOLE NEW LIGHT

When taking a photo, light behind a subject allows people not to squint from light in their face. It also provides the ability to bring out details that are not readily visible to the eye. Translucent materials such as water and smoke look remarkably different with backlight shining through. It adds almost a three-dimensional look. —TH

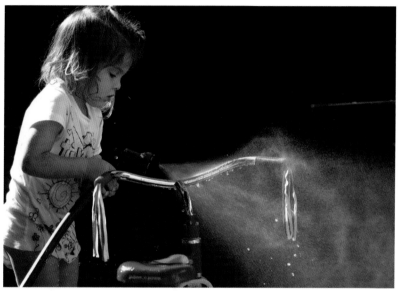

Photo © Tom Hauck.

The Ring Flash

CIRCLE OF LIGHT

Originally designed for the dental field, the ring flash was attached to a camera by Clifford Coffin in the mid-20th century and entered the fashion photography world with blinding speed. The flash produces shadowless light from a ring-shaped strobe that fits over and around the lens of the camera. The lens actually shoots through the ring light, allowing the light source to be on the same axis as the lens. It produces an unmistakable stylized lighting quality that has been used in countless editorial fashion spreads and advertising campaigns. It also produces a signature outlining shadow around the model when he or she is within close proximity to a background.

Ring flashes are manufactured in many sizes and mounting styles; prices typically begin at $300. A few models are battery-operated, but the higher-end models must to be connected to an AC outlet to power the flash and modeling lamp. Most ring flashes offer accessories, such as diffuser covers and color gels.

One of the greatest advantages of the ring flash is its ability to shoot in tight spaces that cannot fit lights or large soft boxes. Even as the sole light source, properly balanced with available light, the ring flash has enough character to be the only key light. In other lighting situations it can be used as a fill flash when shooting with large soft boxes. —MR

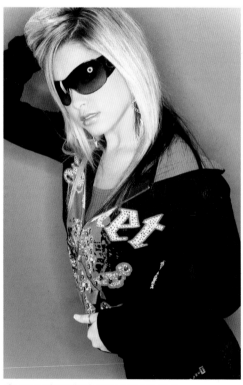

Photo © Matthew Roharik. Model credit: Makahla Ross.

World's Largest Camera
AIRCRAFT HANGARS AND CAMERA TRUCKS

If the category of "world's smallest camera" involves cutting-edge techno-logical innovations, the largest cameras are still grounded in continuity with time-tested techniques.

In June 2006, an entire aircraft hangar in El Toro, California, was transformed into an enormous pinhole camera, based on the same principle as the 14th-century camera obscura (see page 9). Measuring 215 x 160 x 80 feet, the darkened hangar created a photograph on a muslin canvas three stories high and 10 stories wide; the image was developed in a "tray" the size of a swimming pool.[1]

Shaun Irving lays claim to a very different sort of giant camera, however—one that he continues to use on a regular basis. Irving has modified a delivery truck to function as a camera large enough for the photographer to stand inside it. Having light-proofed the truck's bed, Irving cut a hole in one wall of the vehicle large enough to fit a lens the size of a bathtub stopper. Massive sheets of photographic paper are hung from the opposite wall; when the lens is uncovered, an upside down image is projected onto the wall of the truck.

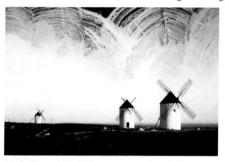

Windmills near Mota del Cuervo; courtesy Shaun Irving.

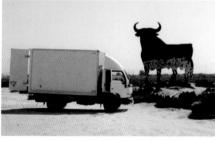

The camera truck near Santa Pola, Valencia, Spain; courtesy Shaun Irving.

Irving has displayed the photos created by his "camera truck" in galleries across the world. He describes the images as "living, breathing pieces of work"; indeed, some of his photographs continue to develop even days after they have been hung on display in the gallery. —DJS

Still Life with Nail Polish

BY STUART TYSON

This image is what is known in the trade as a "blob." The perfect blob is somewhat of a Holy Grail. When three perfect blobs came together, using just bit of nudging, it became a trifecta. The highlight was the icing on the cake—although unplanned, everything fell into place. If only life mimicked art.

Stuart Tyson, a native of North Yorkshire, UK, arrived in New York in 1994. He specializes in still life, art exhibition catalogs, landscape, and portrait photography.

The War Machine

CENSORSHIP IN THE NAME OF "GOOD TASTE"

Sydney Schanberg, a journalist and war correspondent during the Vietnam War, recently sat on a panel titled 'The Power of Wartime Photography," sponsored by the Museum of Jewish Heritage and cosponsored by the National September 11 Memorial & Museum. His comments indicated his belief that photographs "were a superior way to explain what was happening..." but he also expressed that as a war photographer, "you come away knowing that you never did enough. That you escaped because of a lot of things—luck, you're American, you have a passport, you have money, and, of course, if you are in a third world country, there is the accident of birth."

Svetlana Mintcheva, the Director of Programs for the National Coalition Against Censorship, also sat on the panel. She is quoted as saying "atrocity images can make enormous political power, and that's why they're always subject to censorship." She also added that "censorship masquerades very frequently as good taste..."[1]

War photography affords the public a way of looking at a topic they otherwise do not have access to, allowing us to see the story behind the event and to draw our own conclusions. —MLR

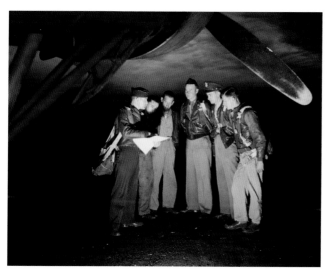

Here's our mission. A combat crew receives final instructions just before taking off in a mighty YB-17 bomber from a bombardment squadron base at Langley Field, Virginia, 1942. Photo by Alfred T. Palmer; courtesy Library of Congress Prints and Photographs Division.

Focus and Depth of Field

MAPPING WITH CLARITY

Earlier articles reviewed the depth of field as it relates to your aperture setting and the art of focusing; now we'll cover the finer points of focusing as it relates to the depth of field.

When you focus on a subject, that subject is in the "plane of critical focus." It is a very tight area that is in perfect focus.

There is also an area in front and behind the area in focus that are in reasonable focus. This is the area that is referred to as the depth of field. The further an object is away from the plane of critical focus, the more out-of-focus it will appear.

Most often, the areas to the front and the back are not equal. Generally, the area of reasonable focus is about one-third in front of the subject and two-thirds behind, except when you are focusing very close to a subject, perhaps with a macro lens. In this case, the areas in reasonable focus in front of and behind the subject are about evenly divided.

Depth of field can also be different for different focal length lenses. The shorter and wider the lens (or the lower the number of its focal length), the greater depth of field available.

The distance you are from your subject also affects depth of field. The further away you are, the more depth of field is available to you than if you were using the same lens at a closer distance. —CWN

Stroboscopic Photography
A FLASHY NEW TECHNIQUE

While "flash" photography had existed in an evolving series of forms since the 1880s, the use of it was limited to the illumination of still subjects. Just before 1900, Ernest Mach was able to capture images of quickly moving objects like bullets by using repeated flashes or a pulsing light source. In the 1930s, Harold "Doc" Edgerton, a professor of engineering at MIT, developed the high-intensity, gas-discharge tube stroboscope, which eventually became the foundation for all electronic flash units.

A woman's hands are captured photographically using stroboscopic techniques.

With stroboscopic light, Edgerton's method—intermittent flashes of light at extremely short intervals—allowed him to capture the motion and direction of things normally too fast to observe with the naked eye. Using this method, Edgerton photographed countless subjects—from a hummingbird in flight to a bullet fired from a gun—and was able to capture the minute details of their movement through space. In stroboscopic photography, it is possible to produce either a single image of an object in rapid motion or, with adjustments to the strobe, a series of separate progressive images of the object as it moves.

While Edgerton employed stroboscopic photography for scientific research, his colleague at MIT, Gjon Mili, used it creatively to record and reveal the patterns of movement in athletes, dancers, musicians, and actors. His work with Edgerton captured the attention of *Life* magazine, and in 1939, he was hired as a freelance photographer. Among his notable works was a photographic re-creation of Marcel Duchamp's famous painting *Nude Descending a Staircase.* —DJG

Patrick Demarchelier (1943-)

NICE WORK IF YOU CAN GET IT

Since the late 1970s, French fashion photographer Patrick Demarchelier has built a career out of capturing hundreds of sensual, revealing photographs of some of the most beautiful women in the world, from top models such as Claudia Schiffer and Naomi Campbell to world-famous entertainers like Madonna. His work has graced the pages of scores of fashion magazines and used in advertising campaigns for an illustrious lineup of international designers.

However, Demarchelier made photographic history when he became the first non-British, official photographer of the Royal Family, after his photographs of Princess Diana appeared in *Harper's Bazaar,* which lead her to request him as her personal photographer. The photos show a side of Diana that had not been previously revealed; her usual public façade is replaced by a woman who is relaxed and laughing but with a hint of sadness.

Demarchelier is known for his ability to put his models at ease, making them forget the camera, then capturing them during moments that reveal their true natures. An almost-nude, yet very relaxed, image of Janet Jackson with a man cupping her breasts from behind is a perfect example of the success of his methodology. Anthony Hopkins, Tom Cruise, Bill Clinton, and Robert De Niro have all been subjects of this same method of scrutiny.

In 2007, he was honored by the French Minister of Culture as an Officier dans l'ordre des Arts et des Lettres, the most prestigious French award for an artist.[1]
—GC

Nature Centers

TAKE NOTHING BUT PICTURES

American explorers of the 19th century, like John Muir, saw the need to protect parcels of land from exploitation and to ensure the area remained in a natural state. That's where our National Park system came from. On a smaller scale, many locales are home to modest preserves that carry on the National Park tradition of preserving our natural heritage.

Frequently called "nature centers," these tracts are kept free of motorized traffic, providing trails designed for hiking. In such places, people are encouraged to leave nothing but footprints and take nothing but pictures.

Photographing in a nature center can be as simple or complex as desired. The ubiquitous point and shoot camera may record terrific images, but in order to capture the essence of a wilderness arboretum, a digital SLR system would undoubtedly work better. A camera, a couple of lenses, and shoe leather could produce wondrous results. —WTD

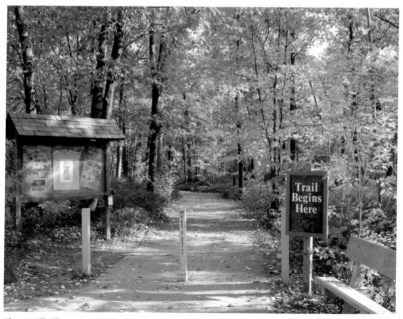

Photo © Bill Diller.

Use of Location

THELMA GOLDEN, MUSEUM CURATOR/DIRECTOR

When you are asked by a client to go on location to shoot a portrait, you never know what you may end up finding. In many ways it's exciting, and in many others it's daunting.

This particular shoot location left me with too many options, but after I looked around the museum interior, I felt that the outside courtyard would provide a colorful, simple background that I felt I needed. Despite having my strobe lights with me, I opted to use daylight, which was softly filtering through a cloudy overcast day in New York.

After meeting Thelma, I realized we had very little time to make the shot, so outside we went. This location's blue-green glass and white-wall background, shot out of focus, provides a backdrop that balances beautifully against Thelma's skin and clothing. To cap it all off, she gave me a subtle smile and her eyes smiled too, making the portrait very successful, despite the short time frame. —SA

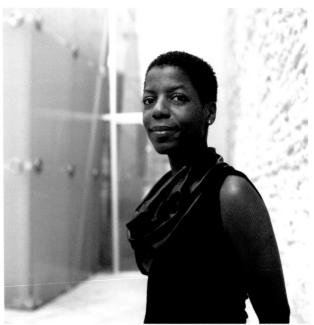

Photo © Simon Alexander.

Perspective

DEION BRANCH STRETCHING

Deion Branch, #83 of the Seattle Seahawks, was returning to the active roster from an injury, so he spent some extra time stretching before their game against the Chicago Bears at Qwest Field in Seattle. I wanted to show the grand scale of the stadium relative to a player in an isolated moment. I used a 17-35mm lens to get wide enough to include the whole stadium as a backdrop. —TH

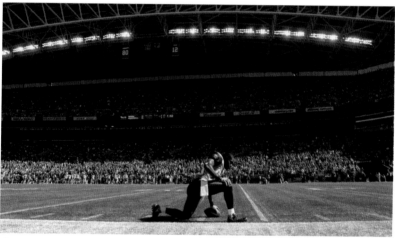

Photo © Tom Hauck.

Wardrobing Your Subjects

TEXTURES AND TONES THAT WORK

The right assemblage of beautiful clothing is crucial in fashion photography, and a good balance must be struck between the clothing and the model. Choose your print, color, and fabrics carefully. The texture and sheen of materials reflect and refract light in unique and various ways and should be evaluated when formulating the wardrobe options for a photo shoot. Color harmonies and tones can be experimented with to create added depth to an image.

Try working with fabric tones that are close in hue to your background. If the background has a reflective surface, then a dress with similar visual properties, like satin, can create a complimentary texture palette throughout the image. The lighting should be used as a tool to bring out the dynamic intricacies of the details of the clothing.

The model should be encouraged to interact with the clothing in inventive ways. Encouraging the model to tug on a belt or the lapels of a jacket brings motion to the image and can accentuate the lines of the clothing. Fashion photography is about selling clothing, so think about how to make every inch of materials luxurious and visually stimulating. —MR

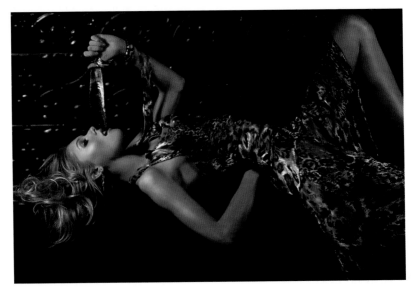

Photo © Matthew Roharik.

Performance Art Meets Photography

CUTTING-EDGE CONCEPTUAL PHOTOGRAPHY

It's a typical day in Beijing. Pedestrians go about their daily business, strolling along a city sidewalk…until they come across the figure of a man who appears to have crash-landed head first into the pavement. His body is ramrod straight and motionless. Onlookers seem mildly perplexed. This is an example of the self-styled performance art that Li Wei photographs.

Li Wei Falls to the Earth, 2002. Photo © Li Wei.

Wei states that he was a performance artist before he was a photographer, and this experience continues to influence his photography. Even in pieces depicting only the artist or elaborately orchestrated gravity-defying scenes, the viewer has a feeling that they are stumbling into the middle of a performance piece.

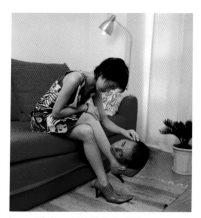

Dream-Like Love, 2003. Photo © Li Wei.

There is a tongue-in-cheek humility to Wei's appearance in many of his works. While covered with paint and extravagantly groomed to depict the "Green Man," he presents a matter-of-fact, deadpan stoicism. In other scenes, he appears overwhelmed, as when a companion is throwing the artist like a javelin from a moving vehicle.

The series "Dream-Like Love" serves as a poignant commentary on romantic relationships. Through the use of mirrors, custom backdrops, and other "low-tech" special effects, the artist creates a series of images in which a woman caustically carries his head around like an accessory, even standing on it.

While many in the West have lauded Wei as a "political demonstrator," he has consistently described his work as an expression of universal human themes, rather than issues specific to 21st-century China. —DJS

Watching Sunrise

BY JONATHAN HEY

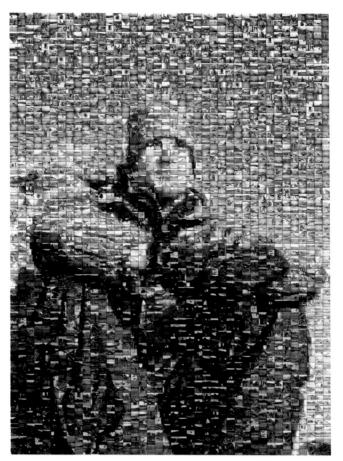

The photo mosaic images featured on many posters are surprisingly easy to create. Forming a second image from a cluster of initial images lets you add another level of meaning to a standard photograph. Besides, it looks great when you blow it up to a larger size. Programs such as AndreaMosaic will recreate an image you choose from a library of others and will color the photograph correctly. As in the example shown here, you can recreate you, the photographer.

Jonathan Hey is a designer and freelance photographer based in England. www.palojono.com/photos

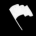

Humility

WHAT DOES HUMILITY LOOK LIKE?

Humility is the act of being humble, of deferring to another without showing any superiority or self-assertive behavior. Its opposite would be greed and the sense of entitlement that accompanies a state of excessive desire—the belief that a person is entitled to have something for nothing. Entitlement brings with it a sense of superiority and assertiveness that an act of humility can disperse. Humbleness and humility are often placed low in the social hierarchy, a characteristic that is not coveted or cultivated yet expected of those laboring at menial tasks.

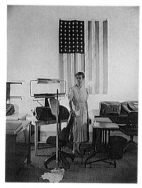

Washington, D.C. Government Charwoman, 1942. Photo by Gordon Parks. Courtesy Library of Congress Prints and Photographs Division.

Gordon Parks, a photographer hired by the Farm Security Administration (FSA), created a photograph during his time with the FSA that is called *American Gothic.* Its subject is Ella Watson, a cleaning woman working during the 1940s in the FSA building in Washington, D.C. Ella stands before the American flag, the tools of her daily work in hand. She looks directly at the camera, perseverance, peace, and a sense of honor surround her—signs of humility in the face of adversity. —MLR

How Lenses Affect Perspective

DEPENDS ON HOW YOU LOOK AT IT

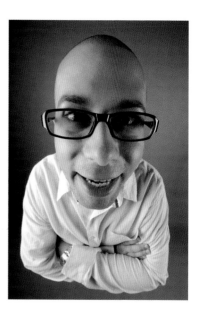

Perspective is the way that we perceive depth, distance, and size.

Shortening the distance between the camera and the subject causes the closest objects to the lens to appear larger. A good example of this is a photograph of someone sitting on the floor with their legs and feet stretched out in front of them toward the camera. The resulting photograph will appear as though the subject's feet are extremely large in proportion to the rest of his body.

Wide-angle lenses exaggerate this phenomenon even further. Since wide-angle lenses can be focused at a shorter distance, it is easy to get too close to the subject, resulting in a photograph similar to the one on this page.

If you were to hold the camera the same distance from your subject and use a short lens, a medium-length lens, and then a long lens to take three separate exposures, each photograph would show progressively smaller portions of the subject.

Perspective can also be exaggerated by the *way* we hold the camera. The next time you are outside, find a fairly tall tree and stand close to it and take a photo while aiming up at the top of the tree. By doing this, you will be purposely distorting the appearance of the tree to look taller than it actually is because you tipped the camera back and the film plane or sensor was no longer parallel to the subject. The same effect can be used on buildings. —CWN

FOR FURTHER RESEARCH

If you love architectural photography, research "perspective control lenses," developed specifically to avoid the perspective distortions caused by wide-angle lenses.

Group f/64

DON'T MESS WITH MY PHOTOGRAPH

Group f/64 was formed by a group of photographers from the San Francisco area in 1932 to practice and promote an aesthetic philosophy and technical approach to their art. At the time, the advent of smaller, more portable cameras was seen by many as a major breakthrough as a form of communication, or even art, for the masses. However, the members of f/64 eschewed the use of these newer cameras and instead dedicated themselves to using large-format cameras with small apertures, f/64 being the smallest. Members of the group included founders Ansel Adams and Edward Weston as well as a handful of others, including Willard Van Dyke and Imogen Cunningham.

Born in the midst of the Great Depression, the group sought to promote a new vision of the country by presenting the best contemporary photography of the American West; exhibit extremely clear, well-defined images; and adhere to what they called "Pure Photography," which they described as "…possessing no qualities of technique, composition or idea, derivative of any other art form." This was a direct response against movements such as Pictorialism, promoted by Alfred Stieglitz, which aimed to achieve a graphic arts quality, like painting.

Much of the better-known work created by artists in the group had nature as its subject—landscape or abstract details of elements from the natural world.
—DJG

Baron Wolman (1937–)

OFFICIAL PHOTOGRAPHER OF THE 1960s MUSIC REVOLUTION

When the first issue of *Rolling Stone* magazine came out in October 1967, it defined the rock and roll revolution of the 1960s in print and photographs. Baron Wolman, as the magazine's first chief photographer, captured the famous and the soon-to-be-famous cultural icons of the era, including Janis Joplin, the Rolling Stones, Jimi Hendrix, The Who, Iggy Pop, Pink Floyd, Jim Morrison, and the Grateful Dead.

Wolman was living in the center of San Francisco's Haight-Ashbury district, a few doors down from Janis Joplin, and just around the corner from the Grateful Dead when he met Jann Wenner, founder of *Rolling Stone*.[1] Although Wolman agreed to work for free for the fledgling magazine, he wisely retained the rights to all of his images and developed an illustrious collection over the course of several years. Wolman was best known for his informal portrait style, disdaining the studio and on-camera strobes. He preferred to photograph quite close to his subjects and use available light.

After leaving *Rolling Stone*, Wolman went on to create his own magazine, *Rags*, with a focus on street fashion and culture. A few years later, he spent a year documenting the Oakland Raiders during their 1974 season. After he got his pilot's license, he became enamored with aerial photography, which resulted in two books: *California from the Air: The Golden Coast*, and *The Holy Land: Israel from the Air*, which were released through his publishing company, Squarebooks. —GC

Abstracts in Nature

ANIMAL, VEGETABLE, OR MINERAL?

Reviewing pictures from a nature walk usually reveals identifiable icons, such as a trophy buck, a blooming flower, or a stream flowing through snow-covered banks. Some photographers, however, opt for a different approach. They look for abstracts in nature, pieces and parts of a scene that catch their eye, and may not be easily recognized. A close-up of the inside of a flower, leaves scattered on a path, or reflections of the sky and marsh grasses in a rippling stream are examples of photos that are pleasing to the eye but slightly offbeat.

Shooting abstracts in nature is no different from any other type of outdoor photography. Use the basic skills of exposure and composition—but most of all, use your imagination. —WTD

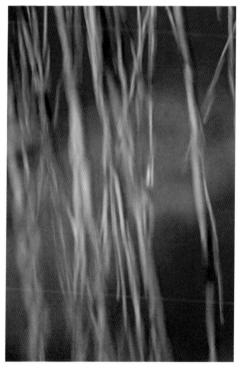

Photo © Bill Diller.

Black and White

CATHRYN HARRISON, ACTRESS

Black and white photography is still my first love, and this simple portrait from a shoot that Cathryn had commissioned me to do exemplifies it succinctly. She needed a head shot, but we ended up producing something much more than that, and this image was my favorite. Her beautiful long, blond hair contrasts brilliantly against the black clothing and background that had become my signature style early on in my photography career. Without color, your eye is drawn to form in photography, and the play between light and dark. The camera framing and composition become even more important without the distraction of color.

Even in these days of digital photography, you can still produce beautiful black and white images, and it's so much easier than shooting film and processing. Now you can see your images in color instantly, and then at the mere click of a mouse in your software, it's black and white. –SA

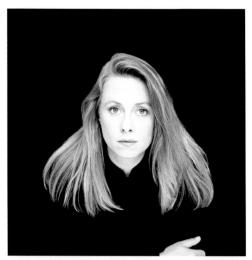

Photo © Simon Alexander.

FUN FACT

When a shot is not working, convert it to black and white.
That way, your eye can really focus on the form and composition, and you can fix it.

Negative Space

PACK OF WOLVES

This snowy photo was captured at a Green Bay Packers NFL playoff game. This is a quintessential shot of legendary Lambeau Field's frozen tundra in the middle of winter. The players look like a pack of wolves amidst the falling snow. I used a 70-200mm lens to make sure the photo was not zoomed in too much. I chose to offset the offensive huddle to the right, which creates visual negative space to the left. This space isolates the players and gives a sense of perspective. As well, it provides an area for magazines or advertisements to overlay text. The weather was so cold that I kept hand warmers in my pockets to heat up the batteries, which had to be constantly rotated because the cold reduces their performance by half. —TH

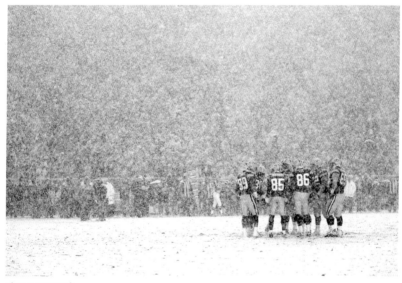

Photo © Tom Hauck.

Influential Fashion Photographers—Past

RICHARD AVEDON (1923-2004) AND IRVING PENN (1917-2009)

"If a day goes by without my doing something related to photography, it's as though I've neglected something essential to my existence, as though I had forgotten to wake up." —Richard Avedon

Avedon began his career in advertising and quickly moved to a 50-year reign as *Vogue* and *Harper's Bazaar's* fashion and celebrity portrait photographer. His minimalistic style of brightly lighted subjects in studio, squarely facing the camera on white backgrounds, defines his early work. His contribution to the fashion industry came with his ability to put a subject at ease and evoke emotions that seemed candid and truthful. His subjects were photographed laughing and in the moment. He produced black and white images, revealing aspects of his subject's character and personality that were not typically captured.

"A good photograph is one that communicates a fact, touches the heart, and leaves the viewer a changed person for having seen it. It is, in a word, effective." —Irving Penn

Irving Penn began his schooling as a painter; at the age of 26, he began designing photographic covers for *Vogue*. Penn's work was defined by images with compositional clarity and exhaustingly complex arrangements of groups of figures. He also experimented in the dark room, moving away from traditional silver printing, and using platinum, which produces dense, velvety saturation, with skin tones that are dark and lush. His body of work was embraced by the fashion and fine art world. —MR

Contemporary Daguerreotypes
FAR FROM A LOST ART

There are currently more artists creating daguerreotypes than during any period in history since the medium was invented.

A daguerreotype is an image created on polished silver by the direct reflection of light off of the subject; the end result is encased in glass for preservation. Common from 1840 through about 1855, the daguerreotype was followed by easier and less expensive forms of photography, including the tintype, ambrotype, and the glass negative with paper print.

To be sure, most contemporary daguerreotypists are drawn to the history of the technique; some have used the process to re-create images from the past. In addition to historical interest, however, many 21st-century daguerreotypists have described a metaphysical attraction to the medium.

Creating an image is challenging and process-intensive, from preparing the materials to safely handling the toxic chemicals that are involved. The inherently unpredictable and fickle process has been compared to baking bread: Beyond simply following a recipe by rote, a certain amount of instinct and feel for the medium are required. Daguerreotypist Charlie Schreiner personifies this element of chance as the "hidden force," stating that it "loves to pop inflated egos, and returns to instill chaos and replace predictability with uncertainty." —DJS

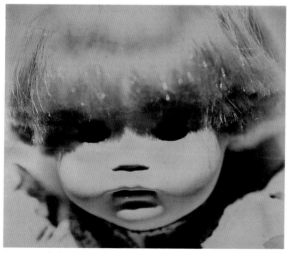

Daguerreotypes by Charlie Schreiner.

Dark Versus Light, Day Versus Night

BY GARRY SCHLATTER

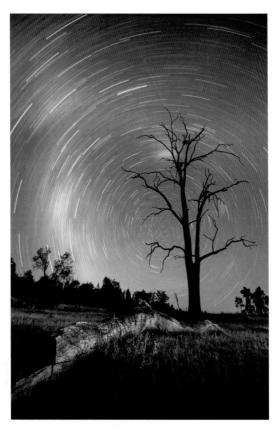

W orking at night is what I love most—and star trails are fascinating. This image was taken on private property one hour south of Brisbane, Australia, shooting into the southern sky with the Southern Cross. The star field that we see in our night sky rotates around the polar axis in a complete circle.

Garry Schlatter is an Australia-based photographer who enjoys the wilderness of his country. He specializes in landscape, nightscape, and architectural photography. www.visionandimagination.com

Urban Decay

FINDING A POINT OF VIEW

Documenting urban decay sends photographers into cities searching for areas that have become disenfranchised, separated, and cut off from the flow of prosperity. Urban decay begins to look the same, no matter what city or state it is found in, unless the photographer begins to probe its causes.

Capturing causes reveals the history behind the decay. Causes are myriad—changes in modes of transportation; the building of highways, road and rail lines that divide populations; the closing of industrial facilities or failed attempts to create jobs; contaminated parcels of land, failed infrastructures.

Consider the pattern of decay in a community—cities may be surrounded by decay or find their wealthier communities circling the decay. There may be "players" (groups or individuals) that have caused or initiat-

ed the decay, or there may be other social issues that added to the decay (economic conditions, plant closings) that are worth exploring. As a social subject, urban decay requires the photographer to take a step further into the decline. The photographer must find a point of view from which to begin. Identifying the causes of the decay may serve to stir the instinctive, visual nature of the photographer. —MLR

What Is ISO?

SETTING THE STANDARD

ISO stands for "International Standards Organization" and is an official way to classify the speed of a film. This refers to how sensitive the film is to light. This designation isn't just for film cameras, though; many digital cameras also have settings that let you choose how sensitive the sensor will be to light.

When choosing your ISO film or setting, the important thing to remember is that the lower the number ISO designation, the more light your scene needs to have. In a photography studio with controllable lights, you will probably want to choose 100 ISO or lower. In a dimly lit setting, perhaps an outdoor evening scene, you may need to choose an ISO of 1000 or above. Remember that the higher the ISO setting of the film or camera, the more "grain" or "noise" your final photograph will contain. For the highest quality photograph, choose the lowest ISO film or setting available.

Film speeds, or ISO settings, are generally 50, 100, 200, 400, etc. A 100 ISO setting, or film speed, requires half as much light as a 50 ISO setting, and twice as much as a 200 ISO setting.

Now that you understand how to manipulate aperture and shutter speed together, you may add in the ISO variable to compensate. Just remember that if you change the shutter speed or aperture by one setting, you must offset it by changing the ISO or film speed one setting in the opposite direction. —CWN

DSLR cameras have ISO settings while modern SLR film cameras will read the DX coding on the film canister and automatically set the camera. Older film cameras have a dial setting that must be changed to match the film speed shown on the canister. In this example, the setting would be at 200.

Kodachrome

THE WORLD SEES IN COLOR

The first examples of practical color photography, Autochrome and Dufaycolor, were produced using a process called an "additive method" but it had some drawbacks, such as problems with enlargements and projection, which required the use of extremely bright lights.

Kodak's Kodachrome film, invented by Leopold Godowsky Jr. and Leopold Mannes in 1935, used a completely different process called the "subtractive method." It was initially introduced as 16mm motion picture film in 1935 and, in 1936, as 8mm movie film and 35mm slide film. However, it would eventually be mass-marketed in a wide variety of still photography formats (35mm, 110, 120, 126, 828, and 4 x 5 and ISO/ASA that ranged from 8 to 200) and really take off as the first successful color reversal film.

With its rich, durable images, fast emulsion rate, and availability in roll form, it was ideal for 35mm "hand cameras" and quickly became the color film of choice among photojournalists and commercial photographers.

Because processing of the film was too complicated for the average amateur photographer, the purchase price of the film included developing—except in the United States, where, for legal reasons, the cost is divided.

Kodachrome was the first widely successful, mass-market color film. Today, even after Kodak, citing a decrease in demand due to the rise of digital technology, announced the discontinuation of the product in 2009, it is still considered the standard by which all other color film is measured. —DJG

Eadweard J. Muybridge (1830–1904)

PICTURES THAT MOVE AND MOVING PICTURES

In his efforts to settle a bet made by race-horse owner Leland Stanford, as to whether or not a horse's hooves simultaneously leave the ground, Eadweard Muybridge created and used a photographic setup that allowed him to capture movements that were imperceptible to the human eye. The photographs ultimately showed an airborne horse with all four hooves off the ground and proved

Eadweard Muybridge, bust, facing right - frontisp. In Animal Locomotion (Phila., 1888) LC-USZ62-49712; Library of Congress Prints and Photographs Division.

that Stanford was indeed correct. By using a battery of multiple cameras and a special shutter, Muybridge was able to capture motion from start to finish.

Muybridge was born in England but made his way to the United States, where he gained fame for his landscape photographs of Yosemite. He gained further notoriety in 1874, when he shot and killed his wife's lover. Although he was acquitted for "justifiable homicide," he found it prudent to travel abroad in Central America for a few years, taking pictures for the Union Pacific Railroad (owned by Stanford).

Upon returning to the country, he continued his experiments, notably at the University of Pennsylvania, where he made thousands of images in his studies of the locomotion of humans and animals. The volumes of this work, which showed humans performing a tremendous variety of activities, from walking downstairs to throwing water, are still used today as scientific and artistic reference.

At the 1893 World's Columbian Exposition in Chicago, Muybridge used his zoopraxiscope (considered the first movie projector) during a series of lectures, making history by showing moving pictures to a paying audience for the first time. —GC

Creating a Mood

HOW DOES THIS MAKE YOU FEEL?

Photography is an art form that, if done well, is certain to elicit emotions in a viewer and create a mood. Looking at a properly composed picture of palm trees along a tropical beach beside a crystal clear, aquamarine ocean as the sky shimmers under the reds and oranges of a spectacular sunset is sure to take a person's breath away. But what if you're not in a position to witness such events? The next best thing is to be on the lookout for just the right combination of subject and lighting conditions that will produce similar feelings.

Look for what nature offers you, like a full moon behind tree branches as they're illuminated by the sunrise. The image can be surreal, looking almost eerie as the moon is framed by branches slithering through the sky.

Photographing the scene can be tricky, due to low light levels. Use a long telephoto lens with image stabilization, and crop in the viewfinder to eliminate the tree trunk. The result is an image guaranteed to create a mood. —WTD

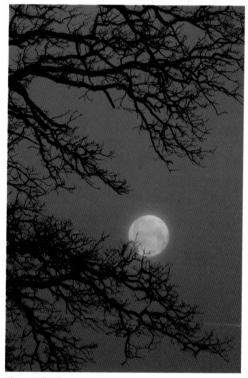

Photo © Bill Diller.

Colorful

TOBY STEPHENS, ACTOR

After receiving a call from a local London magazine to photograph an up-and-coming actor, I did some research and found out that Toby Stephens was actually the son of Dame Maggie Smith and Robert Stephens, who had become famous in the BBC show *Upstairs Downstairs*. He was playing the lead in *Coriolanus* in The Royal Shakespeare Company's production at the Barbican Theatre. My first instinct was to shoot him in character after the play, then I found out I only had 10 minutes and was not allowed on stage or in the theatre for some reason.

As I walked around the Barbican looking for a location to shoot, I saw him on posters that were all over the place with him in character, screaming and wearing a white shirt saturated with blood from a scene in the play

So what was I going to do to make an interesting portrait? Luckily, I found some planters with bright red flowers and small palm foliage. When Toby arrived I asked him to sit on the edge of the planter, and we made this image. His calm spirit and intense gaze struck me as the opposite of his character, and the blue of his jean jacket complemented his skin tone, and the red flowers behind added the drama. This composition just worked and was later purchased by the National Portrait Gallery. —SA

Photo © Simon Alexander.

Framing

NIKE® TEAM CROSS COUNTRY NATIONALS

The Nike Team Cross Country Nationals (later called the Nike Cross Nationals) in Portland, Oregon, provided a wonderful opportunity to photograph packs of athletes competing. I placed the camera on a small tripod and connected it to a wireless transmitter so I could fire the camera remotely as the runners passed. Because I was not able access the camera during the race, I set it to time value mode. This allowed me to stop the action and accommodate any changes in sunlight. I chose a 15mm fish-eye lens to accentuate the curves of the man made hills of the course. —TH

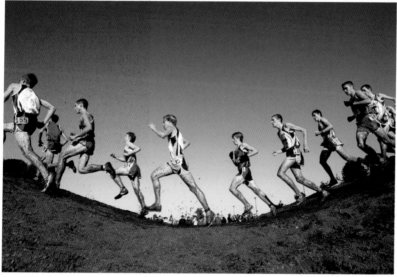

Photo © Tom Hauck.

Lights, Camera ...

LARGE-FORMAT FILM STILL ROCKS

This image of a girl with a lipstick necklace was created for a custom cosmetic line for an advertising campaign. The image was captured with a Horseman large-format (or 4 x 5) camera. Film sheets are loaded into a holder with dark slides that are removed during the actual exposure. The large format camera is a very flexible system. The lens board and the film back are fastened to a rail and joined by an accordion bellow bag. The construction allows for the front and back to shift, tilt, and rise, creating amazing effects in depth of field. The detail and quality of 4 x 5 film is unparalleled. Even in a digital world, many professional photographers and film schools still work with this format.

After the pose was struck, the model had to remain perfectly still while the film was loaded in front of the viewing glass on the camera. Adding to the difficulty, the model could not be seen when the transparency film was being exposed. A limited depth of field was chosen to draw the viewer's attention to the product. The aperture was set to f/5.6, which also enabled a fast shutter speed to compensate for any body movement (in general, a shutter speed below 1/8 will cause image blur from a model). —MR

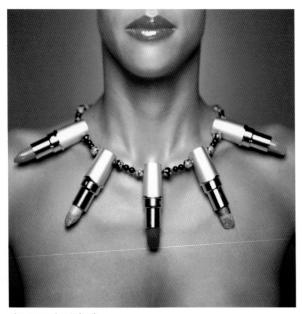

Photo © Matthew Roharik.

The Last First Contact

WORLDS COLLIDE

"The white man came from there. We'd never seen such a thing. Did he come from the ground? Did he come from the sky? The water? We were confused…" —*Papua New Guinea highlander[1]*

In the early 1930s, the Leahy brothers of Australia led an expedition of explorers into the highlands of Papua New Guinea in search of gold. They were the first Europeans to penetrate the interior of the island—and happened to bring along filming equipment and cameras. The images they captured provide a firsthand view of the native population's initial perceptions of the outsiders.

The indigenous highlanders would later tell journalists that, at the time, they had assumed that the explorers were the spirits of the dead. The only time anybody had seen another human look so pale was after the body had already begun to decompose. Some of the Leahys' photographs show crowds of people weeping with joy, believing that their deceased loved ones had finally returned to the land of the living.

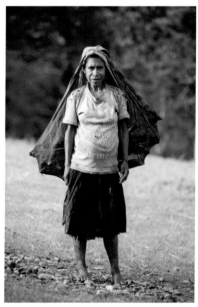

The native peoples of Papua New Guinea's highlands lived isolated from the outside world for centuries before the Leahy brothers' expedition.

Barring some Hollywoodesque arrival of extraterrestrial visitors, a first encounter of such magnitude will likely never again be documented. Similar experiences are possible on a smaller scale, however. Years ago, this author visited a remote village in the Sierra Madre Occidental of northern Mexico, home to the reclusive *Rarámuri* indigenous people. Many of the local children had never seen a person of European descent in their lives; their reactions to my appearance ranged from confusion to outright terror. —DJS

The End of the Line

BY JEROME MUNGAPEN

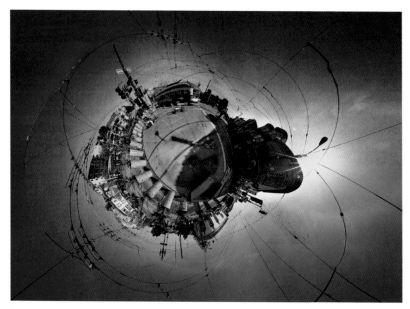

This image is a stereographic "PanoPlanet" of the intersection of Market Street and Castro Street in San Francisco, California. The technique involves taking multiple photographs to form a complete 360° panorama of a particular scene. The set is then warped into a "planet" using a mathematical transformation. This type of image is characterized by a circular planet surface, with structures (such as buildings) breaking free of the planet's surface and into the sky.

Jerome Mungapen is a photographer in San Francisco, California. His passion is landscape and still life photography, specializing in PanoPlanets. www.panoplanets.com

Marketing Political Ideas

"WE WOULD NEVER DO THAT"

Although most political parties and those desiring political power deny the use of marketing techniques in pushing political agendas, marketing techniques are indeed used all the time. Photojournalists and documentary photographers often aid and abet the marketing of political agendas without meaning to—the simple act of reporting on a topic can generate its infiltration into the minds of the public.

Once the tool of television and newspapers, photographs are used on the Internet to embed and market political ideas into the minds of viewers. Our first digital president—Barack Obama—used photographs to connect with the public throughout his campaign and continues to do so during his presidency. Presidents have released marketing photos since photography became an available tool during the mid-19th century.

A study released just after the 2008 presidential campaign revealed the sway a photograph can have on a campaign. Stanford University morphed the photographs of citizens with those of presidential candidates during the 2004 campaign. A marked difference in the voting (the morphed candidate received many more votes) occurred when the participants viewed a morphed photo of the candidate that made it appear the candidate had the viewer's features.[1] —MLR

President Gerald Ford at a farmers' market in Philadelphia, Pennsylvania, 1976. Photo by Marion S. Trikosko; courtesy Library of Congress Prints and Photographs Division.

Overview of Exposure

TOO LIGHT, TOO DARK, JUST RIGHT

Your camera's built-in light meter measures the amount of light available in the scene and indicates if the scene will be overexposed or underexposed.

By now you may have made adjustments to your camera settings so that the indicator in the camera points to or lights up in the exact middle of the exposure meter readout. If the indicator is to the right of center, it is indicating an underexposed scene while an overexposure is indicated when it is left of center.

The light meter in the camera measures the amount of light reflected into it by the subject. Most often, it is an average reading of the light in the entire scene, not just the subject. This is called center-weighted metering. In most situations, this works adequately enough, but if you have large dark or light areas, the meter may give you an incorrect reading.

Check your camera manual to see if "spot metering" is available on your camera. This function will allow you to select a bracketed area and take a light reading from a specific area of your scene instead of the entire scene.

If this option is not available, the best way to compensate while relying on the in-camera meter would be to let the reading show a slight under-exposure for brightly-lit scenes and a slight over-exposure for darker scenes. —CWN

Sometimes overexposure or underexposure is used as an artistic element.

Exakta and the Single-Lens Reflex

A WHOLE NEW WAY TO SEE THE BIG PICTURE

In 1912, Johan Steenbergen of the Netherlands founded the company Industrie und Handelsgesellschaft (also known as Ihagee and later, IHG) in Dresden, Germany. In 1933, the company introduced the Exakta, one of the first compact Single-Lens Reflex (SLR) cameras designed to use roll film. In 1936, the company introduced the Kine-Exakta, which was the first SLR that produced a 24x35mm picture using 35mm film. IHG subsequently manufactured a number of other models.

SLRs differed from the standard viewfinder cameras because light from the subject being shot was reflected up into an attached (in some cases removable) eyepiece through which the photographer could see a more accurate image, unlike viewfinder cameras where the photographer viewed the subject through a separate lens. So the real advantage over viewfinder cameras is that the photographer and the camera are actually seeing the same thing, as opposed to the slight variations that occur with the other method. Another benefit of SLR technology is that interchangeable lenses could be employed without dramatically altering what the photographer was seeing as opposed to viewfinder cameras, which basically had the one, fixed lens. IHG products were, however, on the expensive side and, for this reason, used primarily by professionals.

Interestingly, where several other camera manufacturers got into the business as a result of their optical-glass operations, IHG never produced its own lenses, purchasing them instead from the leading companies of the day. The company did produce accessories like flashes and processing equipment, such as enlargers.[1] —DJG

Edward Henry Weston (1886–1958)

PHOTOGRAPHIC PIONEER

Edward Henry Weston was one of the most influential fathers of modern photography, known for his direct approach that relied solely on purity of form, carefully considered compositions, and impeccably sharp prints. Using an 8 x 10 view camera, he was able to capture the heart of his subjects with stunning detail, from his well-known studies of seashells and vegetables (which he typically ate after photographing them), to nudes and landscapes.[1]

Weston enjoyed success almost immediately after receiving his first camera at age 16, beginning with his first exhibit at the Chicago Art Institute. He worked out of his studio in Glendale, California, for two decades, and then moved to Mexico City in his late 30s, where he was enthralled with a lively art scene and met artists, such as Diego Rivera. After his return to the States a few years later, he settled in Carmel, California, and opened a studio with his son, Brett.

Weston shared a vision of technical perfection and expertise with fellow members of Group f/64. He applied these principles to all of his work, even the infamous collection of abstract images of a ceramic toilet, where he sought to find art in the details while simultaneously challenging mental associations. He was the first photographer to be awarded the Guggenheim Fellowship, a grant that he used to travel the country while photographing landscapes. Yet it was the scenes right outside his doorstep in Carmel that became his passion at the end. —GC

Monarch Migration
A VISUAL FEAST ON WINGS

Poetry in motion. Fluidity. Nonstop action. These terms could describe many different things. An athlete going high to catch a pass along the sidelines, dragging his toes at the last second to complete the pass. A skater flawlessly executing a pirouette that scores a 10 at the Olympic Games. In the natural world, they could describe a cheetah galloping across the savannah in pursuit of a gazelle or millions of gallons of water flowing over the rapids of a raging river.

Or it might just be a bunch of butterflies flittering around. Observing a monarch butterfly migration gives you a feast of colorful plumage moving so constantly you're not sure where one stops and another one starts. These orange and black beauties gather in tremendous numbers and can be seen whirling and darting in an orgy of motion.

A photograph of a monarch butterfly migration can include anything from a stop-action shot of an individual butterfly, using a high shutter speed, to a group shot that gives the perception of motion. For the latter, you need to shoot at around 1/30th of a second, which will provide an impressionist-type portrait. —WTD

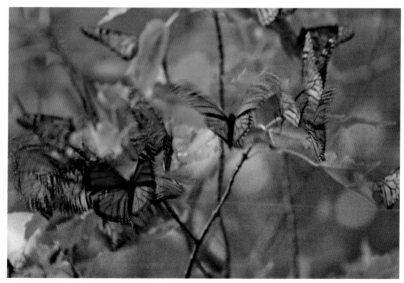

Photo © Bill Diller.

Actors

BILL NIGHY, ACTOR

Bill Nighy is a world-famous film actor these days, but back in 1995, he was still treading the boards of West End Theatre and playing the love interest in many TV dramas. I had the great luck to meet him when I photographed his wife, Diana Quick, the year before (see page 302). He commissioned me to make some new photos of him for Equity (an actor's union) and some upcoming casting interviews.

He has a great sense of humor, and we had a few laughs during the private session, which lasted a couple of hours. This shot is a simple yet effective portrait made in black and white, using my signature style of a black background and showing Bill's inquisitive expression and direct gaze. I like to think that the subsequent portraits helped him garner the roles that he has become so famous for playing over the last 15 years, adding to the fact that he's an incredibly talented actor and all-round lovely chap. —SA

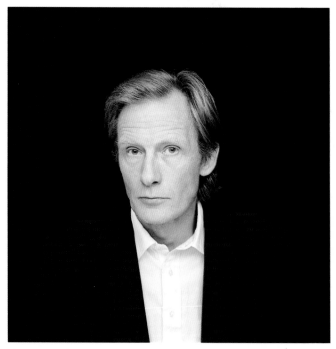

Photo © Simon Alexander.

Being Patient

BALLET WARMUP

This is backstage at the Smuin Ballet in San Francisco. Just before each performance, the dancers put on shoes, warm up, and rehearse their pieces one last time. As I was taking photos of a dancer adjusting her shoe, another inadvertently jumped into my background. I decided to reframe the picture to include both dancers in order to give a better feel for the activity behind the curtains. I had to be patient and wait for the dancer in the background to work her way into the shot doing something visually exciting. —TH

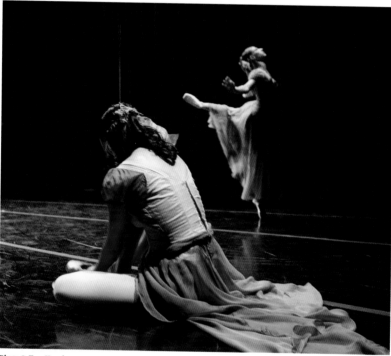

Photo © Tom Hauck.

Influential Fashion Photographers— Present

ANNIE LEIBOVITZ (1949–) AND STEVEN MEISEL (1954–)

In the male-dominated field of photography, Annie Leibovitz, born in Waterbury, Connecticut, has deservedly risen to superstar status as a fashion and celebrity portrait photographer. In 1970, she received her first assignment from *Rolling Stone* magazine to shoot John Lennon; within two years, she was named chief photographer. She would spend a decade creating some of the most fascinating and poignant portraits of the world's greatest musical artists.

In the '80s, she was named *Vanity Fair's* first contributing photographer. Here she showcases her painterly masterpieces of immaculate lighting and staged portraits of celebrities. Keeping true to her love affair with film, she shoots with medium-format film.

Since the '80s, Steven Meisel has enjoyed a rare relationship with Italian *Vogue*—he has created every cover for every issue. He has also composed images for the advertising campaigns of fashion's biggest designers, such as Prada, Dolce & Gabbana, Versace, and Valentino. In 1991, Meisel worked with Madonna to create her infamous book, *Sex,* and several of her iconic album covers.

Born in New York, Meisel majored in fashion illustration and began his career working for fashion designers. His work draws from cinema as he casts his models as actors. He scripts storylines that reflect current culture, creating images that stay with you long after seeing them in print. He supports the true essence of the person he shoots, giving them the opportunity to see themselves as he does. —MR

Urban Legends III
VACATIONING LAWN GNOMES

A family wakes up one morning to find that a decorative gnome is missing from their front lawn. The suburbanites chalk it up to petty thieves and go along with their lives…until one day they receive a postcard. The card reads, "I just needed some time away. Signed, your loving lawn gnome," and features a photograph of the gnome standing in some faraway tourist destination. Over the course of several months, the family receives a series of postcards from around the world, all of which include a different photograph of their missing lawn ornament.

According to this urban legend, a group of young international businessmen or flight attendants had decided to add some spice to their frequent travels by pulling the prank. Eventually, the gnome returns from his "vacation" and appears back on the front lawn, safe and sound. In some versions, he has been smeared with shoe polish to simulate a suntan.

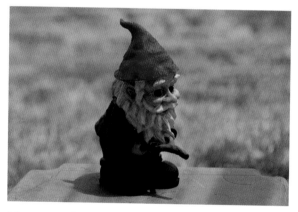

One notable aspect of this legend is that it has been documented as actually taking place on multiple occasions. The story presents folklorists with a "chicken and egg" situation—none have been able to definitively determine whether it began as a fictitious tale and subsequently inspired copycat pranksters to act it out, or whether the original accounts of a real-life prank eventually evolved into the far-reaching legend.

Regardless of its origin, the phenomenon of travelling lawn gnomes has continued to spread in both lore and practice across England, Australia, and North America.[1] —DJS

Tulip

BY GARY P. KURNS

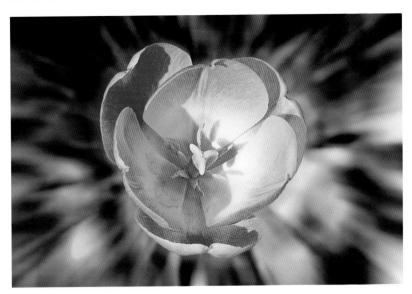

Built in 1886, the historic Crescent Hotel in Eureka Springs, Arkansas, has beautiful flower gardens in the spring. This tulip was shot using a Nikon D3 with an 105 macro lens. Then, using Photoshop CS4, a mask was applied followed by a radial blur filter on the background.

Gary P. Kurns is a retired retail executive with a lifelong passion for photography. His work includes award-winning underwater, close-up, and landscape photography.

Power

MOUNTAINS OUT OF MOLEHILLS

Power is movement, action, energy. Power is active even when it appears to stand still. Power is the force behind change yet it can also become an obstacle to change. Mountains are symbols of power as are trains, automobiles, weaponry, and machinery. Power exists in nature as a force that can constrain or enable—weather, rivers, and fire are all examples. We (society, people, governments, religions) define who or what has power to constrain or enable us. Our personal perspective informs the definition of power.

Worker inspecting a locomotive on a pit in the roundhouse at the C&NW RR's Proviso Yard, Chicago, Illinois, 1942. Photo by Jack Delano; courtesy Library of Congress Prints and Photographs Division.

Photographs convey power through the use of a particular set of visual tools. Simply filling the greater portion of the image with a figure or object creates a sense of power—the figure visually overtakes or controls the rest of the composition. Placing a particular figure in the forefront imparts a sense of power, ability, and importance while the figures or objects in the background become visually smaller and less capable of controlling their environment. The photographer can create a story where there is none, and often the choice of cropping and framing creates the story when one does not exist. —MLR

Light Meters

NO MORE RESHOOTS REQUIRED

Light meters measure the amount of light falling on the subject. If you desire a certain ISO, shutter speed, or aperture setting, you can input this information into a light meter, take a "reading," and the light meter will calculate the appropriate corresponding settings for your camera. When using a light meter, your camera should be in manual mode.

Light meters average the amount of light in the scene, taking into calculation the light and dark areas, and provide a reading that would be appropriate if the entire scene was an average of the two, or a medium gray. For brightly lit scenes or dark scenes, you will want to take into consideration methods that were discussed on page 168.

In-camera light meters measure the light reflected from the subject and are referred to as reflected-light meters. Any meter that is held from the camera location and aimed at the subject is called a reflected-light meter.

Incident-light meters measure the amount of light falling on the subject and are held near the subject and pointed toward the camera. This is the most common type of hand-held meter and produces a much more accurate reading.

Spot meters measure the light falling in a very precise area, where light measurement is critical. —CWN

A typical light meter. The white domed area is the place that light must fall on to provide an accurate reading.

Gelatin Dry-Plate Process

A NEGATIVE BECOMES A POSITIVE

Creating a device to capture realistic images of the world was one thing, but finding a way to print permanent reproductions of those images was an almost equally epic adventure. Early photographers spent years experimenting with a variety of processes that employed different combinations of chemicals and materials, each of which had its virtues and drawbacks.

A major breakthrough emerged with the advent of the gelatin dry-plate process. Though formally introduced in 1871 by a doctor, Richard Leach Maddox, in a letter to the *British Journal of Photography*, the method was still a few years away from being practical. When it was ultimately modified and perfected toward the middle of the 1870s, it represented a revolution in photography.

Gelatin, a substance created by the processing of animal horns, hoofs, bones, organ linings, tendons, and cartilage, has a number of scientific and industrial uses. When it was applied to the photographic process, the gelatin, which contains elements that make it conducive to holding or "fixing" certain chemicals, was liquefied and then used to coat "plates" well in advance of shooting. Before long, gelatin dry plates were being mass-produced, and photographers no longer had to travel with a mobile darkroom full of chemicals. Also, because of the high sensitivity of the gelatin plates, faster exposures became possible. —DJG

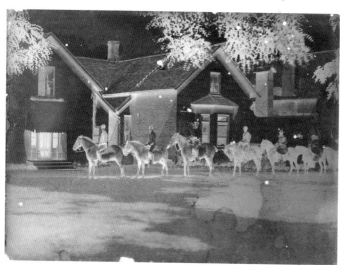

Glass negatives produced with the gelatin dry-plate technique. Photo courtesy Trent University Archives.

Julia Margaret Cameron (1815–1879)

THE POETRY OF PHOTOGRAPHY

As a photographer, Julia Margaret Cameron had the goal of capturing the beauty she saw and securing a place for photography as a fine art. Her photographs resembled oil paintings, with her signature poetic and painterly style, created with long exposures, soft focus, and dramatic lighting. These qualities carried through her portraits and her more imaginative, illustrative photographs, which were staged scenes influenced by literary, religious, and historical works.

She was easily one of the most prolific and well-known photographers of her time, recognized as particularly experimental and influential. However, her career only spanned 11 years and did not begin until her daughter gave her a camera for her 48th birthday. She quickly became obsessed and was soon coercing her circle of friends, family, and servants to model for her.

The wife of a retired judge, Cameron moved in the highest circles of Victorian society, photographing the most famous intellectuals and artists of her time, including Charles Darwin, Robert Browning, Edward Burne-Jones, and her neighbor, Alfred Lord Tennyson, for whom she illustrated *Idylls of the King*.

Although she was an artist first, Cameron was also a shrewd businesswoman, and catalogued and copyrighted every one of her images, which is why they are still in existence today. Additionally, she used the newer, wet collodion process, which was quite labor-intensive and dangerous, and produced a sharp negative from which multiple prints could be made. Because photography was still quite a new art form, her photographs are often the only existing photographs of these important historical figures. —GC

Cute Baby Animals

CATCH 'EM WHILE THEY'RE YOUNG

From infancy, wild animals learn how to survive within their environment, using their natural talents. Everything a baby animal learns as it matures serves a purpose later in life. A red fox will run from danger, disappearing into a forest or into the nearest hole. It's a natural instinct learned by observing how their parents responded to a perceived danger. From the time they're old enough to run, a baby red fox bounds away but may take shelter in the nearest hole, even if it's a drainpipe. However, baby red foxes are naturally curious, so if you're patient and prepared, you may be able to grab a shot of one these cute, little bundles of energy.

Keep your telephoto lens handy, and remain as still as possible. You may be rewarded with that once-in-a-lifetime shot of a baby red fox as it sticks its head out to watch you watching him. —WTD

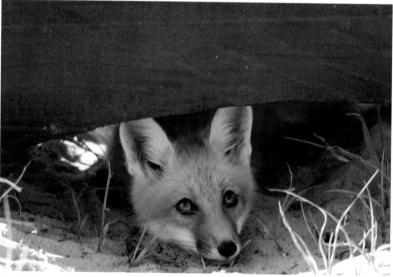

Photo © Bill Diller.

Polaroid

BRUCE WOOLLEY, MUSICIAN

For a while my brother and I joined creative forces as photographers in London, calling ourselves "The Other Brothers." This is a portrait we made as part of our collaboration with Bruce Woolley and his Radio Science Orchestra. We offered our photographic services to him backstage after a performance, and we later got a call from him to produce the album-cover photography for the next CD the band was recording.

This shot from a Polaroid 669 black and white proofing negative ended up as my favorite from the session, and quite elegantly shows the eccentric nature of Bruce, who cowrote the first song to ever be played on MTV (*Video Killed the Radio Star* by the Buggles). I printed the negative onto bromide paper using a lith developer and also a process of "bleaching back" the print and then redeveloping the print again to achieve the wonderful color and rich yellowy warmth to the midtones and whites. The background is actually a partially painted brick wall that I shot out of focus and lit brightly, contrasting against the dark foreground and shadowed portraits. —SA

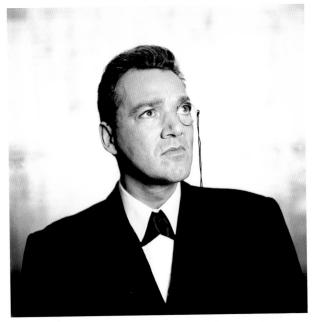

Photo © Simon Alexander.

Being Patient

LOSING THE CROWD, GAINING THE IMPACT

I had been trying to capture a unique lifestyle image on a trip to Cuba. During a tour through a small town, I noticed a young boy walking down a crowded street waving a plastic plane as if it was flying. Instead of shooting with the distractingly busy street as a background, I waited until he passed and was isolated in front of a colorful nondescript wall. This image is a timeless vision representing children around the world lost in play. —TH

Photo © Tom Hauck.

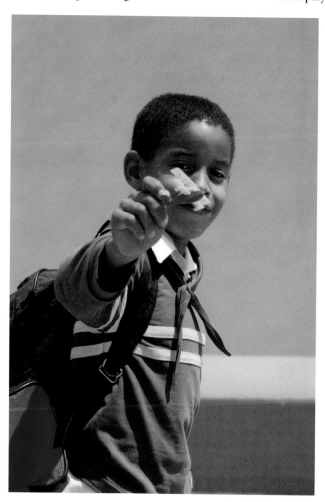

Developing Theme and Concept

EDITORIAL FASHION THEMES

A solid, well-planned concept leads to strong work. In an editorial fashion spread, a recurring theme or narrative is present in each photograph in the series. The theme allows disparate things to be presented together and gives continuity to the series of images. The most obvious themes are driven by props, clothing, locations, and extreme lighting techniques.

Inventing and imaging concepts is rewarding work. Often narratives are borrowed or parodied from well-known stories and events. Try as a point of reference basing an element of the shoot on a fairy tale, novel, or movie. Inspiration for a shoot could be ripped from today's headlines. It could even be based on a dream or nightmare. Approach an editorial spread as a short story. Sketch out your ideas in a storyboard so you can present it to makeup artists and clothing stylists for feedback.

A theme can be as simple as a season, time, or place or as complicated as a circus sideshow where the models act out parts. A successful editorial fashion theme does not have to cost a lot of money; it just needs to be smartly presented and flawless in its execution.

Start with a single model, a theme, and five final images as a goal. Strip the concept to the bare essence of the idea and plan it out so the narrative or story element is present and obvious in each frame. Successful editorial themes come from planning and concessive communication between the photographer, the talent, and the crew. —MR

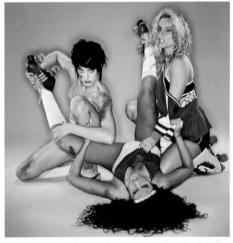

Photo © Matthew Roharik. Makeup and wardrobe styling by Erika Stewart.

Pigeon Photographers
YES, THE FLYING KIND

The depicted photographer was, unfortunately, not available for an interview, as he has been deceased for quite some time.

And he is a bird.

For years, pigeons had been used to carry messages and mail; the German pharmacist Julius Neubronner is credited with having been the first person to draw a connection between the bird and photography. Other inventors followed him in developing various versions of a camera that could be securely strapped to a trained pigeon. The cameras were equipped with a timer mechanism that would automatically take pictures at regular intervals. (Evidently, nobody trusted the birds' judgment in deciding when and what to photograph.)

Pigeon camera Oberländer. © Swiss Camera Museum.

As with many technological developments throughout history, a potential military application provided a significant impetus for advances in research. The use of bird cameras was to be explored by civilian and military researchers throughout World Wars I and II in Germany, France, and Switzerland, in what some might consider a predecessor to the unmanned spy planes of the 21st century.

Animal rights advocates will doubtless be glad that modern technology has evolved more sophisticated methods of surveillance that do not risk the lives of innocent animals, providing us with a marginally more humane way of conducting international warfare and espionage. —DJS

Barbie Figure Study #2

BY MARK TANNER

This image is part of a series of fine-art figure studies on America's favorite doll, Barbie™. The photograph was made using Polaroid type 55 positive/negative film. The texture is achieved by sandwiching the processed negative between two pieces of paper and then peeling the paper away, which clears away a portion of the processing chemistry. The processing chemicals that remain create the textured pattern. The negative is then set out to dry completely before printing.

Mark Tanner is a photographer in the Los Angeles area. While making a living shooting advertising and editorial assignments, his passion lies in creating conceptual fine art images. www.marktannerphotography.com

Family Structure
PYRAMID OF LIFE

A cotton sharecropper family snapped by Dorothea Lange in Cleveland, Mississippi, June 1937, reveals a portrait of a family struggling with poverty and the needs of a growing family. What the future holds for this family is unknown but clues are exposed in its composition.

The arrangement of the family members speaks to the social structure of a traditional family unit. The rectangular format of the photograph implies perspective or direction and, in this instance, pinpoints a moment on the trajectory of family life. Framed inside the construction of the home and porch, the dominant figure, a father, leans against the porch post, reflecting his position in the family at one glance as a means of support and at another the downfall of the family if removed. The father's young children spill out next to him, falling into a pyramid arrangement. The mother figure sits at the pinnacle of the pyramid appearing to be far away, but because of her placement in the pyramid she becomes the actual perspective point to the whole arrangement.

The future metamorphosis of family life is revealed in the squirming children whose feet and bodies begin to break out of the pyramid shape and dangle away from the frame of the porch. Their movement indicates the perpetual motion available to enter the social and political fabric of life.
—MLR

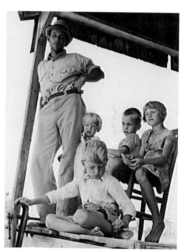

Cotton sharecropper family near Cleveland, Mississippi, 1937; Library of Congress, Prints & Photographs Division, FSA/OWI Collection.

Filters

SPECIAL EFFECTS FOR UNDER $20

Filters are thin pieces of glass with a metal or plastic rim that screw onto the front of your lens. Your lens should have a designation printed on it in millimeters that indicates the size of filter needed.

The most common usage of filters is as a protective covering for the lens. An ultraviolet (UV) filter is used for this purpose.

Other filters are used to change the quality of light that reaches the film or digital sensor. Filters block some of the light waves entering the camera and most often will affect the lightness or darkness of an image, so some exposure adjustment will be necessary.

Colored filters are most often employed when using black and white film and keep certain colored light rays from entering the lens, thereby affecting the balance of colors in the film. Objects that are of a certain color will appear darker or lighter in response.

A star filter causes rays to appear to emit from any light source, like the sun or a lamp. Another popular one is a polarizing filter, which will darken blue skies and remove reflections from glass or water.

A variety of colored filters.

With the introduction of digital photography, filters are less commonly used. Special effects produced by filters are now easily created with photo-editing software, such as Photoshop. —CWN

FUN FACT

For an inexpensive way to experiment with macrophotography,
purchase a set of close-up macrofilters.

Cyanotypes
PHOTOGRAPHY SINGS THE BLUES

English Scientist Sir John Herschel, while conducting experiments with iron, discovered that a number of iron compounds are light sensitive. Many iron printing processes were developed as a result of this finding, with the most popular being the cyanotype, which is also known as the blueprint, or ferroprussiate process, because the resulting images have a blue tint.

A botanist, Anna Atkins, who knew Herschel and his work through her scientist father, had learned about making photograms from none other than calotype inventor William Henry Fox Talbot, a friend of her husband. Atkins saw the potential benefits of using photography as an aid to her studies of plants. She combined the two processes by placing plant samples onto cyanotype-treated paper and exposing them to sunlight, which resulted in cyanotype photograms of algae, seaweed, ferns, and other plants. The resulting images were later published in the 1843 book *Photographs of British Algae: Cyanotype Impressions.*

Atkins is widely considered to be the first female photographer, and her book, while published privately rather than commercially, is thought to be the first that combined photographs and text. Atkins eventually produced three volumes of the book. Though she is reported to have owned a camera, it seems as if she worked exclusively in noncamera-based photography. —DJG

FUN FACT

Besides photography, the relatively inexpensive and simple chemical process also found a place in the worlds of engineering and architecture where the white images on a background of blue became known by the more familiar name: blueprints.

Robert Capa (1913-1954)

PHOTOGRAPHY FROM THE TRENCHES

Known to say, "If your picture isn't good enough, you're not close enough," Robert Capa, the 20th-century combat photojournalist, took tremendous risks in the trenches to get the most powerful shots he could. He captured moment after dramatic moment in his coverage of five wars: the Spanish Civil War, the Second Sino-Japanese War, the 1948 Arab-Israeli War, the First Indochina War, and World War II, where he took his most famous shots on D-Day while swimming ashore with the second assault wave, armed with two Contax II cameras mounted with 50mm lenses. These gripping war images earned him the Medal of Freedom Citation from General Eisenhower.

Capa was born in Budapest, and later moved to Germany, then France. While photographing the Spanish Civil War in the late 1930s, he shot a photograph titled "Falling Soldier," which shows a militiaman falling mere moments after being fatally shot. (The authenticity of this photo is still the subject of hot debate.) His work for *Life* magazine brought him around the world, as did his involvement with the Magnum agency, a photographic cooperative that he co-founded with Henri Cartier-Bresson. He toured Russia with John Steinbeck, who used Capa's photos to illustrate *A Russian Journal*. Photos of the birth of Israel were used in Irwin Shaw's *Report on Israel*.

Robert Capa redefined wartime photojournalism with his hands-on approach, which was both his defining characteristic and the source of his demise. On May 25, 1954, he was killed on assignment in Vietnam when he stepped on a landmine.[1] —GC

Lovable But Homely Babies
SOMETIMES UGLY IS BETTER

It's interesting to observe the young of a species as they get used to their new world. You soon realize that youngsters at play are entertaining and cute, no matter what the species.

With some exceptions.

Some species aren't blessed with good looks when they're very young. A baby bird is a prime example. They don't get their feathers for a while after birth, and it's the feathers that make a bird beautiful. If you've ever seen a nest of baby robins or a young American Goldfinch, you'd agree they aren't examples of nature's most attractive creatures. In fact, some people think they're downright homely.

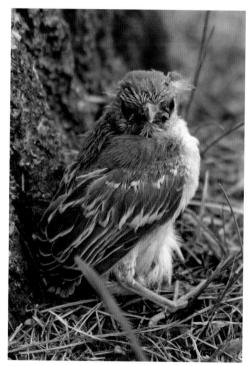

Photo © Bill Diller.

But beauty is in the eye of the beholder, and if you carry your camera and telephoto lens, you just may be able to capture a nest full of these featherless, so-homely-they're-cute babies. Don't stay too long, however, or the parents may think you're taking over for them.
—WTD

Wet Collodion

NOIR, POP BAND

During my years as a young portrait photographer, I was always looking to challenge myself artistically, compositionally, and technically. After I received the commission to shoot an up-and-coming pop duo, called Noir, I decided to shoot a modern band with old technology, using a method that was almost as old as photography itself.

Matthew Brady is a well-known American photographer from the mid-19th century (see page 69), who used the wet-collodion method of making negatives in the field, quite literally, as I then did myself. Using a small tent, chemicals, and mixing trays to coat the negatives, I exposed them in the plate camera while the plate was still wet and sensitized, then fixed the negative image and let the glass plate dry. The whole process is arduous, especially if you do it all on your own, which I did on this occasion, channeling Brady and his team of Civil War photographers.

Suffice it to say that I have never tried this technique and process since, but I'm glad to have this one print, made from the negatives that I made in a tent, exposed, and then processed all in a matter of minutes during a spring day in a field in southern England. —SA

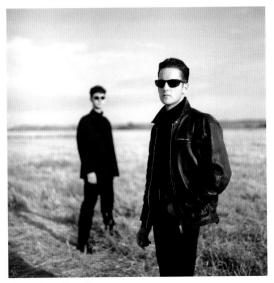

Photo © Simon Alexander.

Off-Field Score

FANS BEHAVING BADLY

Sporting event rivalry games create heightened emotions for both players and fans. During a U.S. Open Cup soccer game, the Portland Timbers fans held up their scarves in response to a Seattle Sounders player's injury. The scarves said "No Pity" or "No Pity in the Rose City," as the Seattle player lay on the field getting medical attention. Though not politically correct, it was entertaining and made for a nice photo. I used a 400mm telephoto lens to concentrate on the fans in the stands with the scarves. Long telephoto lenses have a compressing effect, making the many rows of fans seem like a wall. —TH

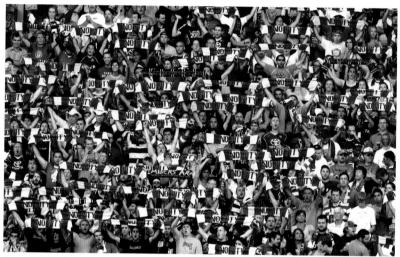

Photo © Tom Hauck.

Urban Location Scouting

TAKING IT TO THE STREETS

The world is your studio! The best way to scout for new locations is on foot or bicycle. This allows for the discovery of the subtle nuances of the location that are missed in a car. Pack a small, lightweight camera with a wide-angle lens, make a preliminary drive by of unvisited neighborhoods, then circle back, park the car, and head out on a scouting adventure.

Pay attention to the surrounding architecture and the local color and textures. Stray from the traffic routes, and explore side streets and alleys. Look for out-of-the-way nooks and passages. Note where the sun is at the time of the scouting photo—this information will come in handy when planning your return shoot. Perform a 360-degree pan of the location, taking photographs at every 30 degrees for future reference.

The girl with the flower in her hair was shot on the sidewalk of a busy street in San Francisco at a 2.8 aperture with a 200mm lens, shutter speed 1/60. The shallow depth of field was chosen to isolate the subject and create a soft color palette out of the background that complements the model's makeup, clothing and floral accessory. To illustrate the compression of space created by the 2.8 aperture, the yellow-colored shape in the background is actually a person and the parked cars are reduced to organic shapes. The blurred urban background is a welcoming contrast against the beauty of the subject. —MR

Photo © Matthew Roharik.

"Witch" Photography

WHAT SORCERESSES WORE

A mainstay of Halloween decorations and costumes is the archetypical "witch," complete with broomstick, black cloak, and pointed hat.

But where did this cultural paradigm originate?

High, pointed black hats were fashionable during the medieval period when witch hunts were carried out on a massive scale in Europe; woodcuts depicting these trials often show the accused wearing the typical clothing of the period.[1] The hats may have been more closely associated with witches later, when they were worn only by country folk, who were more likely to be associated with pre-Christian folk-healing traditions.[2]

The advent of photography, however, would serve to reinforce this stereotype in a unique way. The mid-1800s saw a cultural renaissance in Wales, in which traditional culture was romanticized and encouraged. One iconic element of the Welsh costume was the high, black hat; reportedly, some photographs of the traditional clothing were spread around Europe as "photos of real witches," drawing fascination and terror.[3]

To be sure, the typical witch costume had already been established in popular culture by the 19th century; pointed hats even appear on sorceresses painted by Francisco de Goya. Rather than creating the image from scratch, "witch photographs" from Wales merely reinforced the existing typification. —DJS

Moonshimmering Waterfall and Aurora Borealis

ARNAR VALDIMARSSON

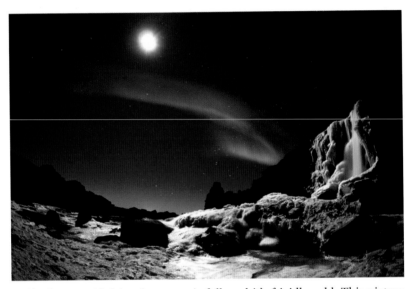

It is almost midnight, the moon is full, and it's frigidly cold. This picture captures the frozen beauty of an evening at Öxarárfoss in Þingvellir National Park, Iceland. Using a Canon 5D full-frame camera and a 15mm f/2.8 fisheye lens, the exposure was set at 30 seconds and the ISO at 100. Very little post-processing was necessary—just a +1.5 boost in exposure and a little contrast enhancement.

Arnar Valdimarsson is a photographer and video director based in Iceland. www.flickr.com/arnar

Gender

WHAT'S HIS, WHAT'S HERS

Gender is defined both biologically, via the anatomy, or socially, through a complex web of ideas about how a person should think, behave, and interact due to biological function. Attitudes about gender are a combination of many influences—cultural, political, ethnic, familial, social, and religious. Social interaction is based on these often illogical roles—males in a moment of emotional vulnerability, and females in roles of anger, power, or violence are not considered "normal."

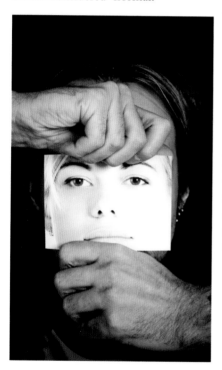

Capturing the essence of gender in a photograph is as complicated as the distorted roles society pushes. It is an illusive topic underscoring the idea that what is seen is not always what it appears to be. Distortion offers an interesting perspective of gender. The use of attire (clothing, makeup, hair, accessories), environment, and lighting may change the viewer's perception of gender. Placing the subject in interaction with others, along with using attire, can also present new ideas about gender identification. —MLR

Lens Add-Ons

MAKE YOUR PHOTOGRAPHS GROOVIER THAN USUAL

Lens ad-ons are nifty little products that attach directly to your lens or in between the camera body and your lens. Some of the add-ons enable you to add special effects to your images, while others allow your lens to function in an extended capacity.

Extension tubes are placed on the camera body, and then the lens is attached to it. They are used to create more distance between the lens and the film plane or sensor, and allow you to photograph an object from a much closer distance.

Extenders are telephoto accessories and are also placed between the camera body and the lens, to increase the focal length of a lens. They are classified as 2x, 3x, 4x, etc., which means that the focal length of the lens is multiplied by that factor. This is an affordable way to increase the focal length of your lens without spending a lot of money on a new lens. The downside is that the optics are somewhat affected by using these and less-than-optimum photographs sometimes result.

There are several products available that attach to the end of a lens and allow you to change the perspective of the lens or add out-of-focus areas to the edges of the photo, in addition to other special effects. These are not standard accessory types and are made by a variety of manufacturers. —CWN

An example of three different extension tubes.

LIFE Magazine and Photojournalism
LETTING PICTURES TELL THE STORY

In the early 1930s, Henry Luce, publisher of *Time* and *Fortune* magazines, became captivated by the idea of a photograph-intensive magazine, and he set out to entice a team of the day's renowned photographers to join him in the endeavor. *LIFE* magazine debuted in 1936, quickly became a cultural institution, and, among other things, a weekly showcase for a talented, new breed of photojournalists who were taking advantage of new, sturdy compact cameras.

From the first issue, with Margaret Bourke-White's beautiful cover image of the Fort Peck Dam through the magazine's final edition in 1972, the world's top photojournalists' work graced the pages of *LIFE*. Among the iconic images presented in the magazine were Alfred Eisenstaedt's photograph of a sailor kissing a nurse in Times Square, celebrating V-J Day in 1945 (see page 260), and Eddie Adams' Pulitzer Prize-winning 1968 shot of a South Vietnamese police chief executing a Viet Cong soldier.

The magazine was much lauded for its stunning images of various wars, but it was no less remarkable for the portraits of world leaders, artists, actors, and athletes as well as average Americans.

Perhaps even more than the individual images that they published, *LIFE* regularly featured photo essays on a wide variety of topics. Photojournalism was no longer just about capturing the action, it was also about telling a story—something that the readers of *LIFE* magazine came to expect from every issue.[1,2] —DJG

Mary Ellen Mark (1940-)

PICTURES FROM THE EDGE

For over 40 years, Mary Ellen Mark has traveled the world extensively, searching for the common threads of human experience. While she tends to focus primarily on the fringes of cultures worldwide—from brothels in Bombay to teenage runaways in Seattle—she has also photographed celebrities and public figures, such as David Bowie and Mother Teresa. Each of her eclectic collection of subjects is given equal treatment. Her work is edgy and gritty, made even more pronounced by her use of TRI-X black and white film. She does not shoot digital.

After moving to New York City in the late 1960s, Mark took to the streets, documenting Vietnam War demonstrations and the advent of the Women's Liberation movement. She began her professional career as a still photographer on a variety of movie sets, documenting the most notorious set of all time—*Apocalypse Now.* Mark has published photo essays and portraits in *Life, The New Yorker, New York Times Magazine, Rolling Stone,* and *Vanity Fair,* and she has created ad campaigns for Barnes and Noble, Coach Bags, Hasselblad, and Nissan.

Mary Ellen Mark is one of the most eminent photographers of this era and has received numerous awards to prove it. They include three fellowships from the National Endowment for the Arts, Photographer of the Year Award from the Friends of Photography, the Victor Hasselblad Cover Award, and two Robert F. Kennedy Awards. —GC

The Macro World

THINKING SMALL

The natural world is full of gigantic things. Elephants and buffalo make man look small in comparison. Mammoth redwood trees reach for the stars, and even sunflower plants or corn stalks give most of us a Napoleonic complex.

And yet, sometimes smaller is better. A crisp, colorful, close-up image of the macro world shows some of nature's finest handiwork. The microcosm of multiple legs and antennae, and the intricate design of normally unseen flower petals, not to mention the contrast of colors, begs to be photographed. In order to do it right, special equipment is needed.

A dedicated macrolens can produce a life-size close-up but with some drawbacks—it's necessary to hold the camera extremely steady because a true macrolens has a very narrow depth of field. If everything is done correctly, though, the reward is an eye-opening view of the macro world. —WTD

Photo © Bill Diller.

Outtakes

THIS ONE'S MINE

After shooting a magazine fashion layout, I had enough time to shoot some personal images of this model. Her black dress had wonderful long sleeves and a great silhouette, which was perfect for shooting in black and white.

In the end, this simple pose proved to be the most effective image in this dress, combined with her direct gaze into the lens. I included the edge of the negative, which acts as a frame.

The moral of this story is that when you get a magazine commission, make sure that you shoot what you are asked to do; then always try to get another shot for yourself that might be even better. —SA

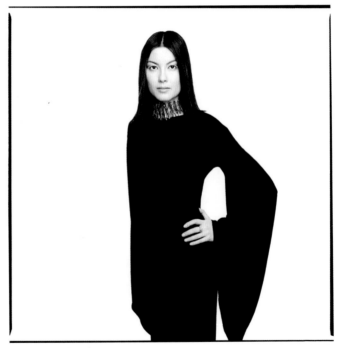

Photo © Simon Alexander.

Jubilation

KEEPING IT WIDE OPEN

Celebration shows itself on the field in a variety of ways: one athlete pumping a fist, two athletes slapping hands or a group of teammates jumping together. In this game, it was clear that the Anaheim Angels were about to finish their 2002 season with a game seven win of the World Series. The first baseline where I was seated provided an ideal angle from which to capture the victors running out of their dugout to celebrate with their teammates on the field.

I decided to use a 70-200mm lens—allowing a wider perspective—to capture the scope of the whole team celebrating at the pitcher's mound. I wanted to include as many players as possible and not cut any arms out of the photo if anyone jumped in jubilation. This photo captures a group of exuberant Angels as well as some individual players running to join their teammates. —TH

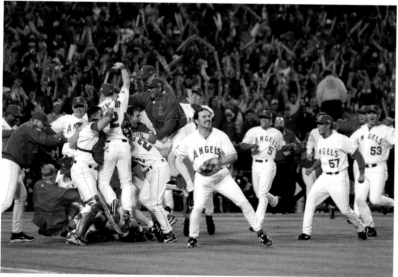

Photo © Tom Hauck.

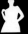
Lights Camera...

MODEL IN A CORSET

A 20-foot length of 2-inch-thick braided hemp rope brought about the idea for this shot. The concept was to create a corset out of the rope by wrapping it around the model from chest to thigh. She is posing in front of an unfinished 4-x-8-x-⅛-foot pine sheet. The aperture is set at 8.0 at a 50mm focal length. The ISO is set to 200 for maximum clarity at a shutter speed of 1/250. The key strobe light has a 5-foot octagonal soft box placed close to the model. Two small strip softboxes are placed on each side. A large 40 x 60-inch silver reflector is laid out on the floor, bouncing light upward. —MR

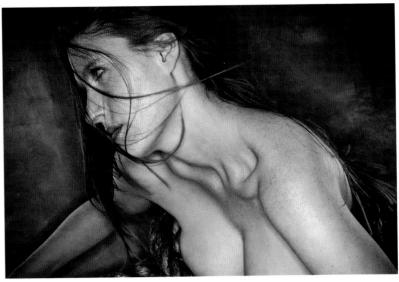

Photo © Matthew Roharik.

Lost Authors

THE ENIGMA OF ANONYMOUS PHOTOGRAPHS

If the story behind a photograph is forever lost, does the image lose its significance—or is its meaning deepened?

One of the most universal genres of photography is the disparate mass of images, which, for one reason or another, have become entirely disconnected from their source. Whether the snapshots are found in an abandoned house, sandwiched between the pages of a book at the flea market, or floating about the dark recesses of cyberspace, they serve as a carte blanche for the imagination.

Robert Flynn Johnson's book *Anonymous* highlights the enigma of authorless photos. We will never know the definitive meaning behind the photograph of a small child with a pacifier in his mouth holding an assault rifle. The toddler sitting at a miniature table and chairs and sharing milk and cookies with three monkeys will forever remain in obscurity, as will the man driving a tiny wagon pulled by a team of six pigs.[1]

In spite of (or perhaps because of) their anonymity, such mystery photos often have an uncannily personal feel to them. The observer can't help but feel that they are looking through the family album of a close friend: innominate photographs often achieve a mythical significance that transcends the accidental details of their particular origin. —DJS

Shadow Bench, Shadow Path, and Dark Door

BY MARGUERITE HOSSLER

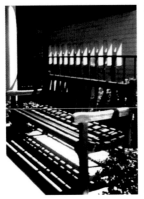

A small and beautiful teak and brass pinhole camera captured these three images. The pinhole camera—a simple little box with a hole for a lens opposite some film—is a stark contrast to the digital camera. When using it to take a photograph, it's necessary to judge the exposure time on your own. The focus is fixed. The benefits are a heightened awareness of light, time, and film.

Marguerite Hossler is a photographer, filmmaker, educator, and sailor. She lives and works in Southern California. margueritehossler.photoworkshop.com

The First Family

CONTROLLING A FAMILY IMAGE

The White House News Photographers Association was created in 1921, President Harding's first year in office. During President Hoover's first year, 1929, the photographer's association got their first office in the White House West Wing. These photographers snapped the president at work, on official business, and occasionally at leisure. Control over photographs of the First Family was a constant battle.[1]

Some presidential families didn't mind family photos while others demanded privacy and control over what photos were released. The Grants (1869-1877) didn't seem to mind one bit that family photos were being taken. Chester Arthur and Grover Cleveland banned the taking of photographs of their children. Edith Roosevelt and Jackie Kennedy took absolute control by hiring their own photographers who released a photograph only upon approval of each of the First Ladies.

The Hardings were one of the first of the First Families to actively seek out photo opportunities that placed the family in a good light. However, Harding and other presidents led dual lives that were referred to as public and private. Gambling and drinking were not photographed or addressed by the press because they were considered part of their private lives.[2] —MLR

White House wedding. Pres. Nixon with Tricia, 1971. Photo by Warren K. Leffler. Courtesy Library of Congress Prints and Photographs Division.

Using Natural Light

LOVE THE LIGHT YOU'RE WITH

When photographing outdoors, the sun is the source of your light. The qualities of the light change, depending on the time of day.

At midday, the sun is at its brightest and harshest. Most photographers prefer not to shoot at this time as the harsher light produces prominent shadows. Early morning or late afternoon light is less harsh, and the resulting shadows are not as prominent. An overcast, or cloudy day, is also preferred since the clouds diffuse the sunlight.

If you must photograph at midday, it is helpful to use your camera flash. Most cameras have a built-in flash, but better yet is an external flash that mounts on the camera or to the side of the camera on a bracket. This is commonly referred to as fill-flash since it is used as an additional source to fill in the shadows and soften the effects of the sunlight.

Photographing a subject in midday sun results in harsh shadows.

Another way to soften harsh sunlight is to take advantage of trees or sheltered areas. Placing your subject in shade will greatly lessen the effects of the midday sun. These photographs demonstrate the difference this will make.

It is always preferable to place your subjects with the sun at their back in order to keep your subjects from squinting from the glare of the sun. —CWN

Photographing a subject in a sheltered area eliminates harsh shadows.

Twin-Lens Camera

SEEING WITHOUT A MIRROR

Twin-lens reflex cameras (TLRs) first appeared in the late 19th century, but by the end of the first decade of the 20th century, they had largely faded from practical use. The cameras had two lenses, one to capture the image of a subject on film and the other used for reflex viewing, allowing the photographer to see what was being shot before, during, and after the exposure.

One of the major benefits of the TLR was that there was no mirror movement that could disrupt the exposure. However, the cameras had some drawbacks, including parallax, which is a discrepancy between what the eye sees and what the lens of the camera sees (usually caused when there is a short distance between the camera and the subject). Also, if one lens needed to be changed, both lenses had to be removed.

In 1928, German company Franke and Heidecke decided to reintroduce the format and produced an all-metal model of the formerly wood-box camera. The Rolleiflex became quite popular, spawning waves of imitators. The original model used 117 roll film but the next model, in 1932, used the more readily available 120 film. The newer model also featured a crank to advance the film, an improvement over the knob function on the 1928 version, which became the standard for all TLRs. Over the next four decades, they continued to modify, perfect, and produce a series of more and more sophisticated cameras. —DJG

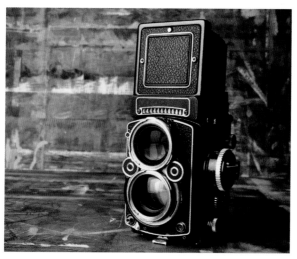

Walker Evans (1903–1975)

FINDING POETRY IN THE ORDINARY

Using his camera like a pen, Walker Evans sought to tell the story of what was American about America, in an unprecedented study of American culture that lasted for nearly half a century. His photos were simple images of common things: Alabama sharecroppers, roadside vegetable stands, and abstract compositions of the twists and turns of New York City. Evans recorded life in its most ordinary forms, without pretense. He was at once historian and anthropologist, believing that "photography is the blade that seizes the dazzling instant from eternity."

Evans taught himself to use a camera in the late 1920s, and when the Great Depression struck America, he worked for the Farm Security Administration documenting rural poverty and architecture. In 1936, while fortuitously on assignment for *Fortune* magazine, he traveled with writer James Agee to write

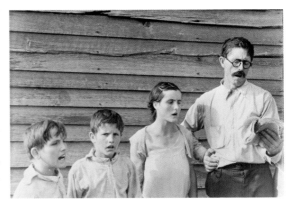

Sunday Singing by Walker Evans. Photo courtesy Library of Congress Prints and Photographs Division.

a piece on tenant farm families. Although *Fortune* chose not to run the article, the collaboration yielded a book titled *Let Us Now Praise Famous Men*, which became some of his best-known work. Shortly after this trip, he turned his focus on the New York City subways and began a three-year project photographing unsuspecting subway riders, which became the book *Many Are Called*. In 1938, his work was featured at New York's Museum of Modern Art and was the first solo photography exhibition for the museum.

In his later years, he taught photography at Yale University, until shortly before his death in 1975. —GC

Hawk In Flight
HUNTING WITHOUT BULLETS

Hunting is a hobby that can take many forms. Some enjoy the challenge but are reluctant to carry a weapon. An alternative is to hunt with a camera, which has some distinctive advantages. There is no bag limit, nor are there any restrictions on the type of game you're allowed to pursue. Birds of prey, like a red-tailed hawk, are a prime example of being excellent game to stalk.

Hawks are extremely quick and shy away from human contact, which makes them hard to get close to. Once you actually get close, capturing a decent image can prove difficult—a hawk as it soars is the ultimate moving target.

The first thing you need is a camera that takes a picture immediately after pressing the shutter button—the shutter delay on a point and shoot camera doesn't work very well for this type of action photography. Use the highest shutter speed you can. Get the bird in focus and pan along the flight path as it soars (called "follow focus"). Lead the hawk a little, as it will be moving into the frame. The background will be out of focus, which only proves the bird was moving quickly. —WTD

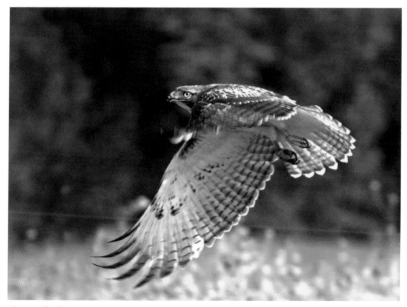

Photo © Bill Diller.

Five Minutes

PHILIPPE STARCK, DESIGNER

On the morning I arrived at London's Design Museum to photograph the great Philippe Starck, I had no idea how long I would get. It was only while there with many other photographers and journalists, that I was given a slot of five minutes. I asked for the balcony outside the offices, where the interviews were taking place. Luckily, it stopped raining just before my time, and I literally had five minutes to set up. I shot one roll of film, thanked Philippe, and then he was back to interviews inside.

When I looked down at my camera, I saw that the shutter was set too fast for strobes, which meant I could end up with a big black shutter line across my images. I loaded a roll of color slide film and asked if I could have just one more minute with Philippe. He reappeared just as quickly as he had disappeared minutes before, with a black colander that he had designed … on his head! He struck a jesterlike pose and quickly moved about as I fired off the camera and strobe to capture his calculated gestures. This image was the last frame and best shot that summed Philippe up. It's a great memory, made sweeter by the fact that the Design Museum bought this image and now displays it in their boardroom. —SA

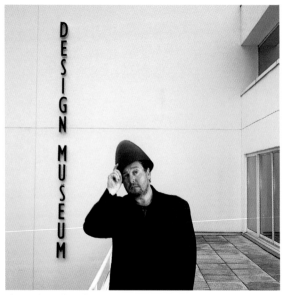

Photo © Simon Alexander.

Panning for Effect

"I MEANT TO MAKE IT BLURRY"

Panning can produce interesting results, if you are willing to take the chance of getting a great shot … or nothing at all. Using a slow shutter speed of 1/160 second or less and following the subject on his or her plane of movement allows you to blur busy backgrounds and show speed. When the frame involves human motion, arms and legs can become distorted and ruin the photo, or with some luck, they complement the streaks of color in the background. —TH

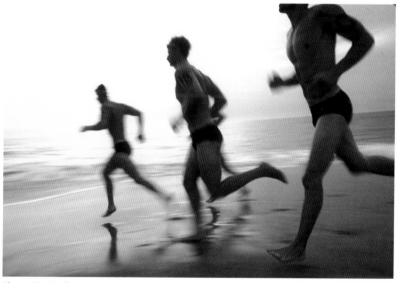

Photo © Tom Hauck.

Collecting Props that Inspire

AN EXCUSE TO HOARD

Props or "property" as they are called on Hollywood movie lots can set the mood, help to tell the story, or suggest a time period for your images. Some people are able to make a full-time career out of collecting and purchasing items for photo shoots. These people are hired by photographers and producers to conjure up spectacular props, from vintage cars to exotic animals. The search and collection of props for future inspiration of photo shoots is a must for every photographer.

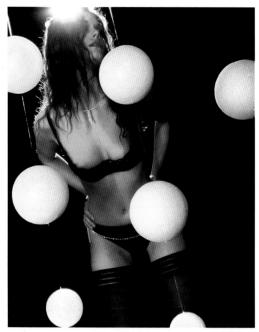

Photo © Matthew Roharik.

Some cities set up business recycling centers where a business can donate odds and ends, ranging from office supplies and furniture to retail display items. Artists can purchase a yearly membership to shop at these facilities. The polystyrene balls on strands of wire in this shot were picked up from such a place and inspired the image after seeing them hung on a background stand in the studio. —MR

> ### FUN FACT
> *Do-it-yourself prop collecting gives you a good excuse to haunt the local flea markets, thrift stores, and the occasional dumpster. Just remember to thoroughly clean these treasures when presenting the props and your vision to your models.*

The Photographer of the Mine
SONG CHAO'S REALISM

A native of the Shandong Province of China, Song Chao creates portraits of the miners from his hometown. It is no accident that the laborers are shot wearing their work clothes, unvarnished and candid. The photographer is intimately familiar with the perilous, gritty conditions of the mine—after all, these men are his former coworkers.

Having worked as a miner for the Shandong Yankuang Group Co., Chao has met international acclaim in recent years as a self-styled photographer. Much like the music of American country singer Loretta Lynn, Chao's art does not merely "rise above" his humble roots—it is informed by his background at its deepest level.

There is a certain inscrutable mystery to the facial expressions of the photographer's subjects. Transcending social commentary, these photos offer to the viewer a connection with these miners that exists at a much broader, universal level.

Miners often carry photographs of loved ones with them as a constant reminder to be careful on the job. Similarly, for the rest of us, Chao's portraits serve as a constant reminder of our shared humanity with those who work in this extremely dangerous profession. —DJS

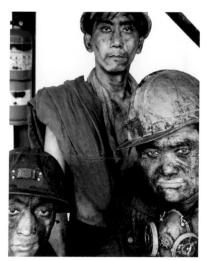 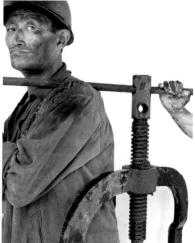

Chinese photographer Song Chao captures the lives of miners with whom he used to work.

Golden Gate PanoPlanet

BY JEROME MUNGAPEN

Multiple photographs form this complete 360° panorama of the Golden Gate Bridge called a polar "PanoPlanet" image. It is warped into a "planet," using a mathematical transformation. This type of image looks similar to the stereographic PanoPlanet with a planet surface being formed (See page 166), except taller structures are compressed rather than magnified as they move farther away from the center.

Jerome Mungapen is a photographer in San Francisco, California. His passion is landscape and still life photography, specializing in PanoPlanets. www.panoplanets.com

Separation

CAPTURING THE SPACE IN BETWEEN

To separate is the act of moving away from a position of unity, becoming singular or individual or cutting off pieces of a whole. In many ways, a separated entity or object can appear to visually be in unity. After all, when we are separate we are whole unto ourselves. Social separation is dual in nature, at once both necessary and a cause of pain—separation created the United States but is also at the root of genocide.

Separation can be shown using a line, a point of demarcation, or a space, or area of separation that intervenes between two figures. Representing separation or division between a person and a concept is a particular challenge. Color can be used to mark the separation between man and concept, like the yellow of the boxcar dividing the concept of stepping up and moving toward a higher ideal (the promise of the open sky) and a man turning his back and walking away from that opportunity. —MLR

At the Vermont State Fair, Rutland, 1941. Photo by Jack Delano; courtesy Library of Congress Prints and Photographs Division.

Using Artificial Light

WHEN YOU'RE STUCK WITH LOUSY LIGHT, MAKE YOUR OWN

There are two main kinds of artificial light: studio strobes and continuous lights. Strobes emit short bursts of light when triggered, and continuous lights stay on all of the time. (These are also referred to as hot lights because they generally emit a large amount of heat.)

Studio strobe with softbox.

Artificial light is most often used in photography studios. Setting up studio lights and adjusting their settings is a complete science in itself and will require practice to obtain consistent results.

Artificial lights are rarely used as-is. There are a variety of accessories for lights that help diffuse their harshness. Like the sun, a bare light emits harsh light. It is preferable to place a diffusion accessory between the light and the subject.

A common item used for this purpose is a softbox. A softbox is a large, black fabric box with a white fabric front that allows light to pass through it while softening its effect.

Another diffusion accessory is a reflective umbrella. The light is aimed into the umbrella so that it reflected back on the subject. As the light travels to the umbrella and bounces back out, it is diffused.

If you decide to incorporate artificial light into your photography, it is imperative that you fully understand how to operate your camera in manual mode and how to use a light meter. —CWN

Studio strobe with reflective umbrella.

Instant Photography

POLAROID PROVIDES INSTANT GRATIFICATION

In 1937, Harvard graduate Edwin Land, who had studied the nature of polarized light and polarization materials as a student, formed the Polaroid Corporation to produce materials for sunglasses, gun-sights and glare-free lights. Over time, his research gravitated into the study of light, vision, and, ultimately, photography. In response to his young daughter's question "Why can't I see it now?" while taking pictures, he began to experiment with the concept of instantaneous self-developing film.

In 1947, he formally presented the successful results of his work, and a year later, the Polaroid Land process was introduced commercially. A person could easily shoot and develop a photograph within a few minutes without chemical processing or any specialized knowledge of cameras. Polaroid photography quickly caught on with the public, making it enormously successful.

While it seemed extraordinarily modern, the concept behind Polaroid film actually dated back to the earliest days of photography: exposing a chemically treated surface, a "plate" (in the terminology of the old days) to light, and then allowing the photo-sensitive elements do their thing, resulting in a fully developed, fixed image.

Competitor Eastman Kodak introduced its own line of instant photography products but, following a barrage of lawsuits against them from Polaroid, they were forced to discontinue this element of their business. Polaroid introduced successful product after product for decades but stumbled at the dawn of the digital era and went bankrupt in 2001. After regrouping, however, it seems poised for a comeback. —DJG

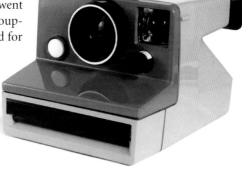

Alfred Stieglitz (1864–1946)

FINE PHOTOGRAPHY IS NOT AN OXYMORON

At a time of one of the most radical transformations of American culture, Alfred Stieglitz drove the simultaneous transformation of modern art and culture. Photographer, writer, and visionary, he was the driving force that broke down traditional boundaries between photography and other fine art forms.

His own photography work was the first to be recognized by American museums when the Museum of Fine Arts, Boston, purchased from his collection. However, he is more known for exerting his wide influence on photographers, writers, and artists. Many sought to be included among the pages of his publishing ventures, *Camera Notes* and *Camera Work*, or displayed on the walls of his art galleries, including 291 (known by its Fifth Avenue address), all vehicles used to exhibit cutting-edge modern art of the time.

Stieglitz and his second wife, Georgia O'Keefe were one of the most dynamic artistic partnerships in American history. Stieglitz first became captivated by her work, which he exhibited immediately in his gallery, and then later by the artist herself, whom he photographed obsessively over time, creating an intimate study of her that remains one the most thorough of its kind.

Stieglitz often worked himself to the point of collapse, and in 1938, he suffered the first of six serious heart attacks. However, each time he healed, he picked up exactly where he left off, in his relentless pursuit of shaping the new American vision of modern art and culture. —GC

Wading Birds

THE GREAT BLUE HERON

If you've ever seen a Great Blue Heron wading through a marsh, slowly lifting its stiltlike legs as it watches intently for the minute movements of a swimming fish, it wouldn't take much to stretch the imagination and visualize a dinosaur wading through a Jurassic-era swamp. This rather ungainly looking creature is surprisingly agile and an extremely accomplished fish catcher.

Observing a Great Blue Heron from a distance isn't difficult, but they spook easily, and getting a frame-filling photograph could prove daunting. A long telephoto lens is a must. A tripod isn't necessary if you have a lens with image stabilization. Shoot at the highest possible shutter speed lighting conditions will allow, focusing on the head, particularly the eyes, which have a startling yellow iris and black pupil. Try to snap the shutter when it's in profile or dipping its beak in the water. If you're fortunate, you may catch the bird catching a fish. —WTD

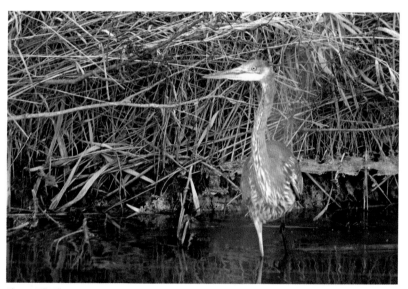

Photo © Bill Diller.

Freeze Frame

RICHARD DORMER, ACTOR AND PLAYWRIGHT

To capture a photographic moment that has inherent movement, you must choose a shutter speed to freeze the motion (above 1/500th of a second), literally making a freeze frame of the action as it appears before your eyes.

Richard wrote his one-man show, *Hurricane,* about the rise and fall of Alex "Hurricane" Higgins, a troubled snooker player. His acting was consummate, powerful, and inspiring throughout. Using effective stage and lighting design, Richard captivated his audience with his complete immersion into the character, realized further by the action all taking place inside an oversized snooker table.

In this portrait of Richard in character, I used strobe lights to freeze the falling paper and beer cans that he throws up in a key moment in his performance while using a slow enough shutter speed to allow the existing stage lights to still illuminate the stage, and by also adding a red-gelled strobe head to side light the action. —SA

Photo © Simon Alexander.

Capturing Action

HARVIN'S TOUCHDOWN

Most sports have an area on the field or court (like the end zone in football) that elevates activity. Athletes seem to try a bit harder in these areas, an intensity that is often matched by their opponents. Players will overextend themselves in sometimes awkward positions; setting out for the goal with a do-or-die mentality. Here Percy Harvin, of the Florida Gators, dives for the end zone against the Michigan Wolverines in the 2008 Capital One Bowl in Orlando, Florida. —TH

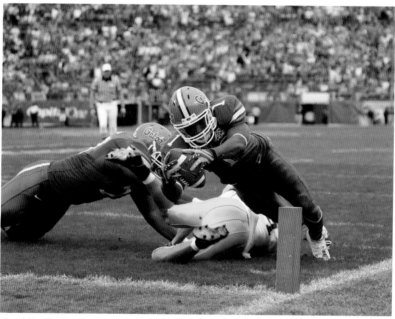

Photo © Tom Hauck.

The Windblown Look

TO FAN OR NOT TO FAN

The windblown look has a lasting place in fashion and beauty photography. When done properly, it seems to never go out of style. Its real charm lies in its ability to suggest movement in a static image.

There are several ways to achieve a controlled wind-blown look in the studio. The obvious is to use a fan.

A professional studio fan has a tube or snoot around the fan-blade cage that acts as a wind tunnel to concentrate the wind in a precise direction. A homemade version can be created by making a tube of thin cardboard about 12 inches to 18 inches long that directs the airflow. Thin sheet metal used for heating ducts also works well. Cut it with tin snips and shape it to fit around the fan. Punch holes in the metal, and use plastic ties to hold it in place.

When using a fan, remember that less is more. The model does not need to look like she is giving a news report on location in a hurricane. A more subtle approach is to waft air upward to the model with a piece of cardboard or foam core. The ideal size is 24 x 24 inches square. An assistant stands off to one side

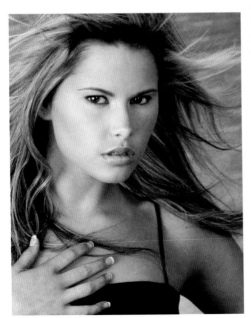

or below the model, and lifts the cardboard up toward the model's hair, pushing the air to lift it. The photographer can do a three-count with the assistant to help time the moment the air reaches the subject. It takes a bit of practice but the results are pleasing and can just add more body and lift to the hair instead of the full-blown wind-tunnel look. —MR

Photo © Matthew Roharik.

Photographing the Past

LOOKING TO THE STARS AND SEEING HISTORY

In Michael Crichton's novel *Sphere,* an American space shuttle from the future enters a time warp through a black hole, crash-landing on Earth 300 years in the past. The series of *Planet of the Apes* films dealt with a similar theme—a crew of astronauts travels into the distant future.

There is a certain appeal to the idea of transcending the boundaries of our own lifetime by witnessing other time periods. And, while time travel is not likely to become a reality any time soon, space photography provides us with a chance to literally watch the past as it happens.

Given the vast expanse of the universe, the light from other heavenly bodies does not reach us instantaneously. (Even the light from the Sun is 8 minutes old by the time it reaches Earth.) The closest star system to ours, Alpha Centauri, is 4.36 light years away, meaning that whatever we see from this system actually happened more than four years ago. Most intriguing are some of the more recent photographs of deep space, capturing supernovas and star births that took place 13 billion years ago—around the beginning of the known universe. —DJS

Light from the Bubble Nebula travels for years before reaching the Earth. Photo © Kent Wood.

The Lonely Pontiac®

BY CHRIS AUSTERBERRY

An interestingly colored classic Pontiac was parked next door, so naturally photography ensued. By experimenting with different angles you can fit the subject into the frame and encourage the viewer to see the subject in a certain way. A second layer was used in Photoshop to mask the car and apply isolated color.

Chris Austerberry, Jr. is a freelance photographer and writer near Philadelphia, Pennsylvania. Specializing in HDR techniques, he enjoys photographing his eclectic interests, especially motorsports. austerberry.zenfolio.com

Technology
PORTRAYING SOCIAL IMPACT

The term "technology" is defined as "a manner of accomplishing a task, especially using technical processes, methods, or knowledge."[1] Technology has a long history, and each sector of society—transportation, agriculture, manufacturing, financial—has advanced in some way due to the impact of technology. As a social issue, technology includes communication—newspapers, books, and its latest incarnations, computers, cell phones, and PDAs—and how it affects patterns of social interaction. Social issues also include moral or ethical aspects of using a particular type of technology (embryonic research), changes in technology that usurp jobs and cause changes in employment (newspapers vs. the Internet), or allow larger numbers of people to work from home, thus causing changes in social interaction.

Convey technology's social impact—place it into a timeline, give it a point of reference, apply it to a place, an industry, or an event. Give it contrast—pair old with new, version against version, one brand with another. Reveal its impact through the use of scale (size), color, and placement within a composition. Inform the viewer of its place in social infrastructures by using repetition and order. Include the tools, people, and processes for a complete survey. —MLR

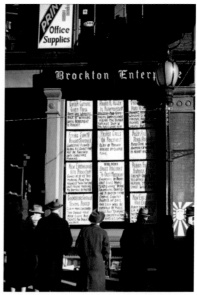

Men and a woman reading headlines posted in street-corner window of Brockton Enterprise newspaper office on Christmas Eve, Brockton, Massachusetts. Photo by Jack Delano; Farm Security Administration - Office of War Information Collection; Library of Congress Prints and Photographs Division.

Subject Matter

GETTING UP CLOSE AND PERSONAL

Ahh, the fun part. Let's let go of the technical study for a while and concentrate on how to produce a more visually appealing photograph.

The first step is deciding on your subject. Point the camera at your subject. Then move in closer. Then move in closer again.

The main problem with photographs is that sometimes it's hard to tell what the subject of the photo is. Say you are taking a photo of the lovely cake your mother made for your birthday. Instead of taking a photo of the entire table that the cake is sitting on, which also shows plates, cutlery and random other birthday party items, move in a little closer and fill the frame with just the cake. It will be obvious that the cake is your subject, and you will have a much more detailed photograph to treasure.

Are you going on a family vacation? Instead of lining up the family and taking the photograph from far away and showing them from head to toe as well as random scenery around them, move in closer and fill a larger part of the frame with them. Your family will be the subject, and you will have captured the expressions on their faces, which would be hard to see in the photograph from a distance.

▼ The next time you take a family photograph like this:

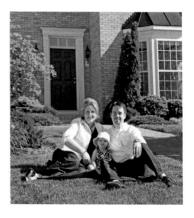

▶ Move in a little closer and take a second photograph like this:

Start incorporating this suggestion into your everyday photography. —CWN

The Nikon F

F STANDS FOR "FAST AND FLEXIBLE"

In 1959, building on the success of the German Exakta, the Contax, and the Leica Single-Lens Reflex cameras that emerged in the '40s and '50s, Japan-based Nikon started a revolution with the Nikon F.

The new Nikon dramatically improved upon the standards of the leading brands, working faster and weighing less. However, the biggest difference was that Nikon produced a variety of interchangeable lenses and accessories for the F so that it was a camera body that could be adapted in any number of ways. The cameras had Nikon's now-signature "F" bayonet mount and were compatible with many different lenses; later viewfinders included a light meter, and there was an optional motor drive that advanced film automatically.

The camera quickly eclipsed the popularity of the German products that had dominated the market. Its technical advantages and a reputation for being durable and reliable soon caused many of the professional photojournalists (who had long favored the Leica) to switch.

In 1971, the company introduced the Nikon F2 series and has continued to release more advanced products, most recently the Nikon F6 in 2004. In 1999, Nikon entered the digital SLR market with the introduction of the D1. But even the D1 and other digital models still use the original F mount that was introduced in 1959.[1] —DJG

Minor Martin White (1908–1976)

THINKING IN THE ABSTRACT

Minor White used photography to create metaphor, with individual objects serving as elements in a greater whole by providing line and form to the composition. His goal was to use the medium of photography to inspire certain feelings within the viewer. A master of the abstract, White's photographs explore patterns in the natural elements of wood, moss, stone, leaves, and rope, or frost on a windowpane, each used as a tool to suggest a story or idea, often with a spiritual flavor. His work was often rendered with infrared film, which gave it an otherworldly, glowing quality.

White counted Ansel Adams among his group of close friends, and together the two developed the Zone system, which allowed them to create photographs with crystal-clear clarity of detail while others were creating soft, painterly images. In 1952, he cofounded *Aperture* magazine (along with Dorothea Lange, Ansel Adams, and Barbara Morgan), which he edited until 1975.

Over the years, White was a professor at many respected institutions, including the San Francisco Art Institute, Rochester Institute of Technology, and Massachusetts Institute of Technology (MIT), where his class on the Zone System, available only to senior-level students, was often overbooked. His work is in the collections of the Art Institute of Chicago, Harvard University, the International Museum of Photography, and the New York Public Library. —GC

Combining Light

SUNLIGHT PLUS FLASH EQUALS DRAMA

The natural world has a charm that few will dispute. Even when the presence of man intrudes, like this cornfield in the foreground, the raw beauty of nature is only heightened.

Recording the scene with a digital camera is a simple matter. Just set the camera to Program mode, point and shoot, and you will undoubtedly end up with a memorable moment captured on the sensor. I did this, and while the image turned out fine, it didn't have the pop I wanted. The solution was to combine natural light with artificial light. I composed the picture as before, but this time made use of the on-camera flash to illuminate the corn stalks. The results were almost three-dimensional: corn stalks, tree, and sky. —WTD

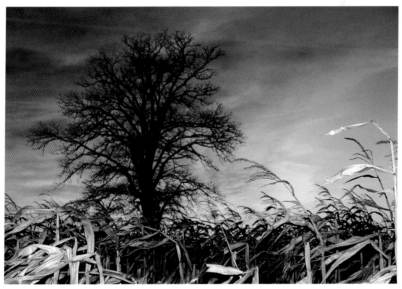

Photo © Bill Diller.

High Speed Strobe

UMBILICAL BROTHERS, COMEDIC PERFORMERS

This amazing image was captured toward the end of a publicity shoot of the dynamic comedy duo and illustrates the amazing capabilities of strobe photography when the duration of the strobe light is at least 1/7000th of a second. At this speed, using a shutter speed of 1/500th, the motion of jumping in air can be fully frozen, even detailing David's flying hair and shoelaces. This shoot was also special, as it was my first completely digital shoot.

Initially, I tried shooting the guys individually on trampolines, which I would then put together using Photoshop in post-production to show one jumping over the other. The whole process was a lot of fun, and the guys were physically incredible, jumping in the most amazing and innovative ways. After we had cleared the trampolines and shot some other portraits and publicity images, David mentioned that he could probably really do what I was going to do in retouching. He would try to jump over Shane, which he did on the third try. We knew we had it only with the instant results of digital photography. —SA

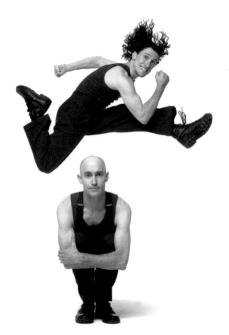

Photo © Simon Alexander.

Framing

YOU CAN'T POSE THIS

I believe photography can draw on many sources for inspiration, including paintings, architecture, or other visual resources. Here, three professional football players were walking off the field. Each had a different body type specific to their position. This scene caught my eye because the manner in which they were aligned walking off the field made me think of the evolution of man drawings. This was almost the evolution of the athlete. —TH

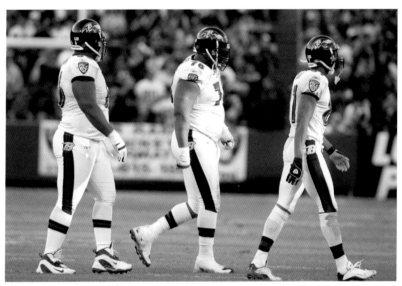

Photo © Tom Hauck.

Black and White Photography
STANDING THE TEST OF TIME

Black and white images have a timeless appeal—not just because they are beautiful but also because they take the focus off of clothing color, which tends to date a photograph.

To create an image that can stay in a portfolio for decades, start by using clothing with classic lines. A white T-shirt and jeans, a sundress, or a black leather jacket are a few good examples. Props and furniture must also be considered in the planning. Hairstyles also are telling of the year of the photograph. Try pulled back hairstyles or that tousled "just got out of bed" look. Wet hair goes a long way in concealing the style of the haircut.

The image of the girl sitting in a stream of water at the base of a small waterfall displays nothing to give away its time period. It was photographed by standing in the water with the model, without any external flash or lighting. The water provided the appropriate amount of reflected fill light. The image was captured on Kodak TMAX 100-speed print film and push-processed to ISO 400 to boost the contrast and add additional film grain. The camera was a medium format Twin-Lens Reflex, with an 80mm fixed lens set to a 1.8 aperture. —MR

Photo © Matthew Roharik.

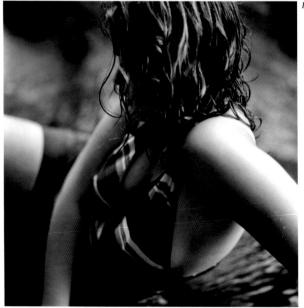

Urban Legends IV
THE KANGAROO'S REVENGE

A group of tourists is driving through the Australian outback when a kangaroo suddenly jumps across the road and is struck by their vehicle. The tourists, assuming the animal to be dead, decide to have a bit of fun—they prop the kangaroo up and begin to photograph each other standing next to it. Eventually, one of them puts his jacket on the animal for a photo. While taking the picture, however, the travelers realize that the kangaroo was only stunned by the blow. It comes to and bounds off into the wilderness wearing the jacket—the pockets of which held all of the tourists' money, passports, and credit cards.

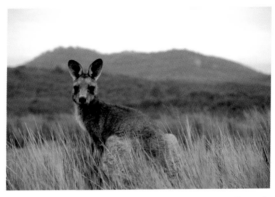

In a North American permutation of this legend, a hunter shoots a prize buck using a recently purchased, costly rifle. Preparing to photograph the animal for hunting-lodge braggadocio, he positions the deer with his rifle carefully laid across its antlers. The deer suddenly regains consciousness, however, and darts into the woods with the expensive rifle still on its head.

Told across Australia, Europe and North America, this tale has inspired everything from an Aussie beer commercial to an American B-movie.

The moral of the "animal's revenge" legend is apparent: The hunter is punished by the cosmic powers-that-be for his hubris, and the tourists for mocking the animal's demise. As with many photographic urban legends, the moral voice of folklore seems to caution listeners against using cameras in a wanton, selfish fashion. —DJS

Under Shifting Sand

BY GARRY SCHLATTER

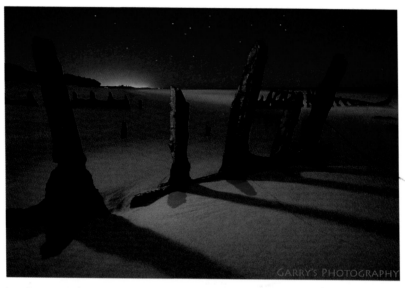

The "SS Dicky" was washed ashore onto Dicky Beach in 1893 during a cyclone. It was re-launched, but again, heavy seas tossed the ship about and back onto the sand where it remains today. This light painting (156 second exposure) was done using a red headlamp—simple as that. Its warm glow was a great contrast to the blue tones in the sky.

Garry Schlatter is an Australia-based photographer enjoying the wilderness of his country. He specializes in landscape, nightscape, and architectural photography. www.visionandimagination.com

The Female Vote

SHATTERING THE CULT OF DOMESTICITY

Now forgotten by many, the fight launched by the suffrage movement in the late 19th and early 20th century was well-documented by camera. Begun in earnest in the early 1800s, the movement sought to remove the stereotypical roles of women and what would later be termed "The Cult of Domesticity," and give women the right to vote and have a political voice. The first women's rights convention was held in 1848 in Seneca Falls, New York.[1]

Gaining the vote of the female population was an issue made for photography. Reviewing photographs from this era, the struggle shows political power being tipped in a new direction. Earliest photographs (daguerreotypes) are portraits of the women behind the revolutionary movement—Sojourner Truth, Lucy Stone, and Elizabeth Cady Stanton. Later photographs reveal parades, picketing, and opponents of women's rights.

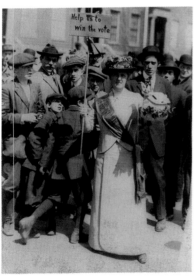

The female vote was obtained in 1920 in the United States. The photographs of the not-so-long-ago struggle serve as a powerful visual reminder of the right to speak our minds, demonstrate, and interject new ideas into society. The female vote continues to hold political power in the voting booth. —MLR

Help us to win the vote, 1914. Courtesy Library of Congress Prints and Photographs Division.

Framing Your Subject Matter

MAKING YOUR SUBJECTS THE (ALMOST) CENTER OF ATTENTION

The main compositional concept of placing your subject within the frame is called the "rule of thirds."

Your subject does not have to be smack-dab in the middle of the photograph. Mentally divide what you see through the viewfinder into three rows across and three columns down, then compose your photograph so that the subject falls along one of the dividing lines.

In the first photograph, the seagull on the piling is centered within the frame. The red lines indicate where the rule of thirds lines are. This is a very acceptable photograph but not as compositionally pleasing as it could be.

The proper way to recompose the shot would be to move myself or move the subject. Since I could do neither, I used my zoom lens to zoom in closer to the subject and recomposed the photograph so that the subject fell on the rules of thirds lines.

In this photograph, two of the lines are used. The horizon is level with the upper horizontal line and the piling is along the right-hand vertical line, which results in the seagull being in the area where the two lines intersect. The intersection of two lines is called a "power point."
—CWN

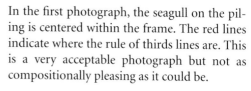

FUN FACT

The term "rule of thirds" was used as early as 1797 as a rule for proportioning scenic paintings.

Underwater Photography

A NEW WORLD

The roots of underwater photography can be traced back to a German inventor unsuccessfully taking pictures through the windows of a Russian submarine during the Crimean War in the 1850s. Around the same time an Englishman took some pictures using a camera in a waterproof box. His photos came out only slightly better than the German's. Shooting underwater is complicated on a number of fronts, not the least of which is figuring out how to keep the camera and film dry. Beyond the practical mechanics of putting a camera into water, there is an element of physics at play: Shooting through liquid into refracted light poses all kinds of issues. The first successful underwater photographs were made in 1893 by French scientist Louis Boutan, who is widely regarded as the father of underwater photography; the principles he established are still applied today.

The public's fascination with underwater photography and cinematography grew during the 1920s and '30s. In 1927, *National Geographic* published the first color, underwater photographs. As advances in diving equipment progressed, there was substantial progress in submersible camera technology. In the late 1950s, famed marine explorer Jacques-Yves Cousteau conceived of an underwater camera, the Calypso, which was then designed by Jean de Wouters and manufactured in France. Production of the camera was later taken over by Nikon, renamed the Nikonos in 1963 and went on to become wildly popular with amateur skin divers as well as academics and professionals. —DJG

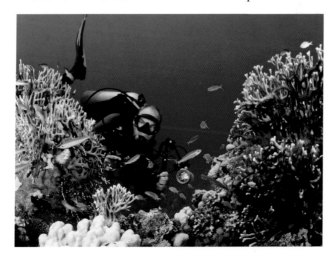

William Eggleston (1939–)
SEEING THE SUBLIME IN THE MUNDANE

In her introduction to *The Democratic Forest*, a compendium of William Eggleston's work, Eudora Welty states that an Eggleston photograph might contain, "old tyres, Dr. Pepper machines, discarded air-conditioners, vending machines, empty and dirty Coca-Cola bottles, torn posters, power poles and power wires, street barricades, one-way signs, detour signs, No Parking signs, parking meters and palm trees crowding the same kerb [sic]." Eggleston photographs democratically, finding beauty in the commonplace clutter of rundown suburban backyards and just about anywhere else. His subjects are often mundane, trivial, and ordinary, an ongoing record of Americana. Eggleston's photographs are bold statements of super-saturated, lurid color, and he is credited with securing the recognition of color photography as a legitimate fine-art medium.

While teaching at Harvard in 1973 and 1974, Eggleston stumbled upon and adopted the dye-transfer printing process, which at that time was used primarily by the advertising industry. This chance discovery resulted in some of his most dramatic and well-known work, including *The Red Ceiling*. In 1974, he created his first portfolio of dye-transfer works, titled *14 Pictures,* which was featured in a 1976 exhibit at the Museum of Modern Art in New York. The exhibit was a watershed moment in the history of photography, the first solo-color photography exhibit at one of the most respected fine-art institutions in the world.

Eggleston's photographs have been used as cover art for a variety of musicians, including the Memphis group Big Star, Alex Chilton, Primal Scream, Joanna Newsom, and Spoon. —GC

Water on the Rocks

GETTING MOVEMENT ON A STILL SHOT

Rivers and streams carry water into lakes and ponds. They can move slowly or roar around curves and over rocks. Sometimes the current can be deceiving. What may appear to be a calm, placid flow of water can in fact be moving swiftly. But when the roar of rapids reverberates, there's no doubt… that water is really traveling, and the power behind it is incredible.

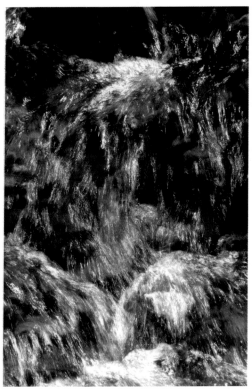

Photo © Bill Diller.

Watching water flow over rocks can be fascinating, even mesmerizing. Imagine where the water came from—a bubbling pool a few miles from where you sit or a crack in the rocks on the side of a mountain half a continent away.

When it's time to leave, taking a picture can help you relive those thoughtful moments. To effectively capture water flowing over the rocks, set your camera on a tripod and use a slow shutter speed. —WTD

Slow Synch Strobe

IAN KELLY, ACTOR AND WRITER

This is another portrait from my *Brits off Broadway* series of the talented actor and writer Ian Kelly. It was to illustrate his performance in *Cooking for Kings*, the one-man show he had written, where he actually cooks on stage and portrays the life and times of the first celebrity chef, Antonin Carême. I came up with the visual of Ian juggling kitchen utensils and a cleaver, to exemplify his dexterity in doing many things all at once, while remaining calm and confident.

The actual photographic technique is achieved by slowing the shutter speed to allow moving objects to create a blur but also using strobe to freeze them in motion at the same time—a double exposure of sorts.

We could not make this image in one shot, so the portrait was shot on film first; then we tested the light and blurred juggling by proofing it on a Polaroid. Next, I shot several exposures of the different items at different points in the air. Later, I scanned the negatives of those exposures into Photoshop, where I pasted the strainer above his head from another exposure into the main portrait file, creating one image. The end effect was as I imagined, and also shot in a safer way. Ian did not have to juggle a cleaver, but he appeared as if he was, which in effect is what acting is all about. —SA

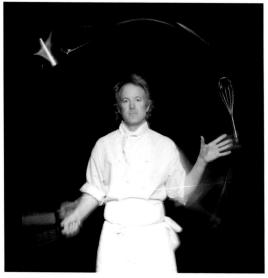

Photo © Simon Alexander.

Negative Space

WHERE THE CROWDS AREN'T

A unique opportunity can arise at any time. I was assigned to get some images of the ocean in Manhattan Beach, California, after a sewage spill. On the other side of the "Do Not Enter the Water" sign, a rare opportunity existed—a deserted Southern California beach.

After capturing the necessary water shots, I started playing around with different lenses, trying to capture empty beach views, which did not convey the beach contamination but instead looked surreal without thousands of beach goers wading in the surf. —TH

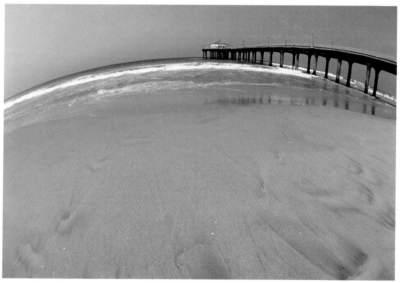

Photo © Tom Hauck.

Fashion Apparel on Location

INSPIRATION FROM A WHEELBARROW

When shooting an assignment for a client, a photographer must create the compositions with the clothing as first priority. Think of the models as props, and the clothing as the main subject.

This photograph was produced from a series of images for a fashion footwear ad campaign that appeared in *Vogue* magazine. The shoot was on location at a ranch in the country. The idea came from finding the wheelbarrow in one of the unoccupied farmhouses on the ranch.

A shady area was selected, with the sun serving as a back light for the models. The exposure was metered for the available light and overexposed one f/ stop for a flattering skin tone. An on-camera flash was used for fill light and another flash was mounted on a stand and placed behind and to the left of the models to add rim lighting. The models were posed to showcase the boots worn by the female model. —MR

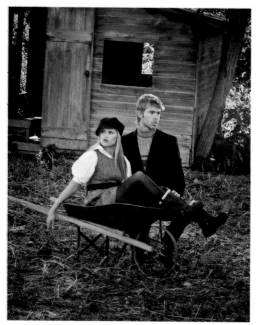

Photo © Matthew Roharik.

Eerie Solitude

THE DARK LANDSCAPES OF RYNO DE WET

"Storm clouds hung in a leaden sky, yet there was a curious stillness, with no wind stirring the reed-patches. The whole atmosphere of the place exuded such chill eeriness that it was a relief to turn back and be linked again to humanity."
—*Witchcraft and Folklore of Dortmoor,* Ruth E. St. Leger-Gordon.[1]

The above description of the desolation and solitude of the moors of Cornwall is equally applicable to the mythical, dystopian landscapes created by Johann Ryno de Wet. Through a unique mixture of analog photography and digital editing, the South African photographer creates scenes that are based in reality but depict a disturbing, inverse dimension of reality—a dark parody of our own existence.

While many of Ryno de Wet's works involve urban settings, they are typically devoid of human presence, presenting a bleak, apocalyptic no-man's land. There is a harsh, post-human emptiness to the images, reminiscent of the future planet Earth depicted by H. G. Wells in *The Time Machine:* Millions of years after the demise of humanity, the planet resembles an uninhabited, barren moonscape.

Rather than being overtly menacing, many of these scenes evoke more subtle undertones of eerie disquiet. And yet, for all their lifelessness, there is a haunting beauty to be found in the desolation of these dreamscapes. —DJS

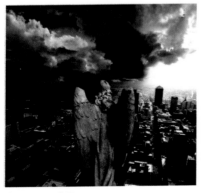
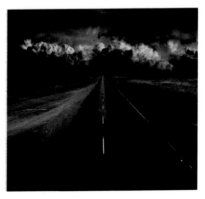

Photos © Ryno de Wet.

Bernal Heights Wormhole

BY JEROME MUNGAPEN

Awormhole image looks like something out of *Alice in Wonderland*. This technique comprises taking multiple photographs to form a complete 360-degree panorama of a particular scene. The images are then warped into a wormhole, using a mathematical transformation. This type of image is characterized by the ground folding around on itself to simulate the view of looking down a pipe at a 360-degree vista, with the sky in the middle.

Jerome Mungapen is a photographer in San Francisco, California. His passion is landscape and still life photography, specializing in PanoPlanets. www.panoplanets.com

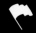

Providing Life's Essentials

LIVING WITHOUT

Poverty as a topic can present a host of issues for the photographer to work through. Paramount to this topic is deciding what poverty might "look" like. Dirty faces and an unkempt appearance is not enough to convey the social dilemma of poverty. The fact of living in a working-class neighborhood, riding a bus, or walking along a street filled with abandoned buildings does not convey poverty either.

In this photograph by Walker Evans, Bud Fields' family is photographed in their home. What is revealed is a moment in time when this family finds themselves with the inability to satisfy very basic needs. Evans' ability to take a photograph that depicts the rawness of a topic and does so in a direct manner is the result of the professionalism and deep understanding of the subject.

Gaining the trust of the family allowed Evans access into their home, a structure that provides inadequate shelter for any time of the year except the warmest of days. The lighting used by Evans, coupled with his linear approach to displaying the family as a whole, further shows a level of poverty not often seen in photographs. The filthy clothing the family wears jumps out as the viewer's eye travels from one family member to the next, visually assimilating what Evans saw. —MLR

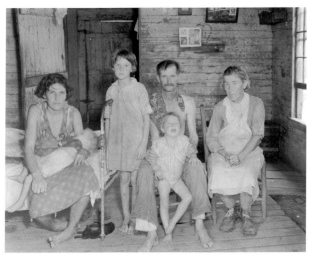

Sharecropper Bud Fields and his family at home. Hale County, Alabama, 1935 or 36.
Library of Congress, Prints and Photographs Division.

Backgrounds

WHAT'S THAT GROWING OUT OF YOUR HEAD?

An important facet of composing is paying attention to what is behind your subject. A cluttered background will confuse your viewer as to what he should be looking at.

When photographing an outdoor scene, observe the area behind the subject while looking through the viewfinder. If there is a tree limb or telephone pole behind the subject, looking like it's growing out of your subject's head, take a step to the left or right. If that doesn't eliminate the problem, move your subject to a different area.

Another method of lessening the distraction of a background is to change the aperture setting to a larger opening (lower f/stop) to reduce the depth of field. This will throw the background out of focus, helping to keeping attention on your subject.

Generally speaking, the less cluttered the background, the better. Recompose your photograph until distracting elements are no longer visible. Take a few moments to move a fallen limb out of the way of your outdoor family portrait.

As you continue to practice your photography, start implementing these hints one at a time. Go ahead and take your photograph as you are first inclined to do. Then pause and take a look at the surrounding area with a critical eye. Make a conscious effort to reduce background clutter before taking a second exposure. —CWN

In order to show the subject in focus and the background out of focus, change the aperture setting to reduce the depth of field as in this example.

Color Photography

OUT WITH THE GRAY

Very early in the history of photography, people were experimenting with ways to render images in color. Starting in the 1840s and continuing for nearly the next two decades, a variety of photographers claimed to have discovered a successful process, but it was not until 1861 that James Clerk Maxwell created what is now widely considered the first color photograph. Maxwell's method involved taking three slides of the same subject and then projecting them through colored solutions.

While other people had degrees of success in fits and starts over the next decades, the first practical way to create color photographs arrived in 1904. The Lumiere brothers in France developed the Autochrome process, which used what is called an "additive system." The effect of color was produced by coating a plate with panchro- 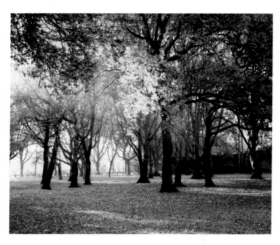 matic emulsion and a mix of primary-color-dyed starches, which acted as filters during exposures. Autochromes and the other, similar processes of the day, Dufaycolor and Finlay Color, caught on with the public and remained the standard up into the 1930s when Kodachrome supplanted them.

Where previous technologies used the additive process, Kodachrome used a subtractive process in which primary colors are subtracted from white light using dyes or pigments. Eastman and others, including Germany's Agfa, continued to perfect the color-film process throughout the 1930s, developing a variety of products. With Kodak's 1947 introduction of Ektacolor film, photographers no longer had to send their film off to be processed; they could shoot, develop, and print their own color photographs. —DJG

Philippe Halsman (1906–1979)

JUMPOLOGIST

Latvian-born photographer Philippe Halsman was a high-caliber portrait photographer from the 1940s to the 1970s, and his portraits of celebrities, intellectuals, politicians, and dignitaries graced the covers and pages of numerous magazines, including *Look*, *Esquire*, the *Saturday Evening Post*, and *Life*. A 1947 portrait of Albert Einstein (a personal friend who helped him emigrate to the U.S.) was later used on a 1966 postage stamp, and again on the cover of *Time* in 1999, when Einstein was named "Person of the Century." Salvador Dali, both a favored subject and a collaborator, was captured in *Dali Atomicus*, showing three cats, a bucket of thrown water, Dali himself, and other assorted props hanging airborne.

Commissioned by NBC to photograph a lineup of comedians, Halsman was struck by their silly antics, which he caught midair. Years later, after a particularly arduous session photographing the Ford automobile family, Halsman offered the suggestion of jumping to Mrs. Edsel Ford, who rose to the challenge, and an entirely new concept was born.

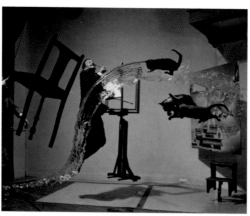

Salvador A. Dali, or Dali Atomicus, 1948, by Philippe Halsman. Courtesy Library of Congress Prints and Photographs Division.

For the next six years, Halsman ended every session with a jump from his subjects. The Duke and Duchess of Windsor, Richard Nixon, numerous high-powered CEOs, and Judge Learned Hand, who was in his mid-80s at the time, are featured midair in the pages of *Philippe Halsman's Jump Book*.
—GC

Stop Action

BLINK, AND IT'S GONE

Wildlife is cautious, and moves very slowly…until the right time. Then they become a blur of motion. If your intention is to get a shot when the action is at its peak, it takes a quick eye and a fast shutter speed.

Watching a robin hop around a newly mown lawn is fascinating. They frequently stop and cock their head to the side, listening for sounds under the ground. When they suddenly thrust their beak downward, if they've calculated correctly, they come up with a juicy worm.

To capture the moment, set your camera to Shutter Priority mode, using the highest shutter speed conditions will allow. If you're fortunate, your LCD monitor will reveal a startling sight: a robin pulling a worm out of the ground.
—WTD

Photo © Bill Diller.

Architectural

JOSEPH VOLPE, METROPOLITAN OPERA DIRECTOR

I received a magazine commission to make a portrait of the long-time director of the New York Metropolitan Opera, Joseph Volpe, and was kindly allowed to use any part of the building as a backdrop. After walking around a day before the shoot, I settled on shooting upward through the lower staircase opening, looking up to the recently gold-leafed ceiling of the front of house. The beautiful curvature of the stairs combined with the famous chandeliers and gold ceiling pull the viewer's eye into the center of the image where Joseph stands looking over.

This commissioned shot needed to have a recognizable Metropolitan Opera house architectural detail, so it truly became driven by the architecture of the space. No one had photographed Joseph this way before and by balancing the ambient light on the ceiling and lighting him as well as the staircase, you get to see him and all the details quite clearly. —SA

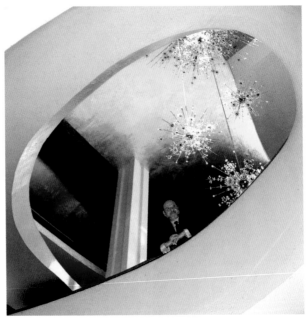

Photo © Simon Alexander.

Up Close and Personal

SHOW ME THE DIRT

Adventure races place participants in a variety of compromising scenarios. Here competitors were required to pass their boats to one another while keeping it above a mud puddle. I was impressed by the concentration, effort, and speed in which they moved through the challenges they were presented. I used a 400mm telephoto lens to isolate the individuals and get visually close enough to the action to capture facial expressions during the gritty, uncomfortable moments. —TH

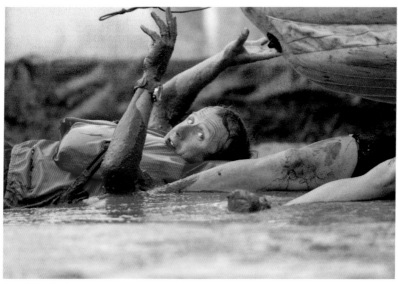

Photo © Tom Hauck.

The Seamless Background

WHY SO GRAY?

Seamless paper backgrounds are inexpensive, durable, and manufactured in over 40 colors in 9-foot-wide rolls. Twelve-foot backgrounds are produced in five colors. Extending them to the floor creates a sweep of color with a gradual curve from the vertical to horizontal ground plane. They can be easily supported with a wall mount system in the studio or on a background stand on location. Every photographer should have background paper rolls in gray, black, and white on hand. White is the staple for beauty imagery and gray for fashion.

Why gray? Gray is a neutral color that goes with any color of clothing; it does not clash or compete with your wardrobe choices. In most cases, it is not necessary to use background lights to illuminate the gray background. A large soft box or umbrella has enough light spill to evenly illuminate the background. When using a white or color background, a strobe light from either above or the side is needed so that the brightness is retained.

Adding color paper to an image can make a strong visual statement. Choose a background color to play off of an accent color in the wardrobe or something as subtle as the eye makeup of the subject. Avoid selecting a dominant color of the wardrobe as a background color. —MR

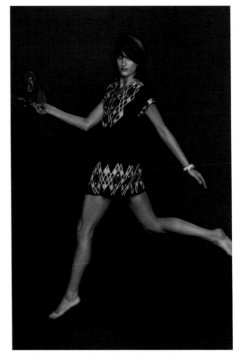

Photo © Matthew Roharik.

Composite Portraits

CHILDREN OF THE FUTURE

As a teenager, the closest I ever came to fathering a child was in a video arcade during a church youth group outing. The arcade had a booth with a camera that would photograph two people and digitally create a composite image; I entered with a less-than-enthusiastic partner and, five dollars later, had a photograph of our theoretical offspring.

Chimères 19. Photo © 2007 Eva Lauterlein; courtesy Galerie Wagner + Partner, Berlin.

We were not the first or last couple to experiment with this technology. Many have toyed with digital composites as a commitment-free glimpse of their possible future child. Of course, mixing two photographs is easier said than done: when two people's features are artlessly cobbled together, the end result is usually androgynous at best.

Even when meticulous finesse is exercised, however, there is always something lacking in a digital composite. This fact has been highlighted by Eva Lauterlein in her series, "Chimères." The Swiss photographer shoots a single model from various angles, eventually melding the shots together into a single image. Although based on a single person, there is still something "slightly off" about the composite photo. Rather than appearing subhuman, Lauterlein's digital Chimères appear almost posthuman, like precursors of some futuristic dystopia. All of the soul and personality have been filtered out of the faces.

Lauterlein's work highlights what many of us have known intuitively for some time—no matter what advances technology may make, there is simply no substitute for a real human face. —DJS

Lightning Assault

BY GARY AVEY

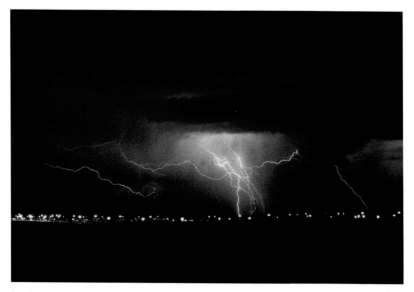

This image was produced using a Canon 50D with a Tamron® 17-50mm lens set at 17mm; ISO 200; f/6.3. A "stack" of five 30-second exposures depicting at least seven cloud-to-ground lightning strikes and several more cloud-to-cloud discharges were used and processed using Photoshop CS4. Also seen are three "ghost" images of a NOAA weather observer who was walking around in the foreground.

Gary Avey is an avid photographer of wildlife and landscapes in Northern California. www.flickr.com/photos/encouragement

Discontent

MARIE LOSES HER HEAD

Social discontent raises its head as protest, a desire for change—better wages, safer working environments, basic education, improved living conditions. Discontent is a marker of evolution, a way of showing dissatisfaction, and an aspiration toward improvement, a point of adjustment in social structure. Defining discontent as a lack of contentment leads the photographer to search for basic social standards for showing this lack—the protest, the argument, situations revealing discomfort, annoyance, grievance.

Historically, Marie Antoinette is seen as a symbol of discontent. Her ability to ignore the discomfort and discontent of the peasantry and greater social community triggered one of history's most radical social and political upheavals, The French Revolution. Although Marie was not the root of the problem, she became the symbol and focus of the anger and fury that erupted. Photographically speaking, portraits of figureheads and notorious instigators of discontent do not show the true foundation of the discontent, they simply put someone in the position of being blamed—it is what the person stands for that triggers a society's response. —MLR

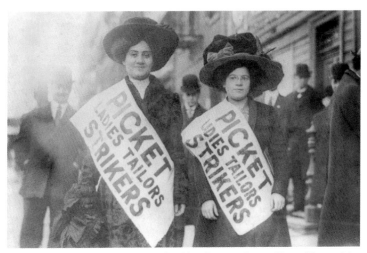

Strikes, ladies tailors, New York, Feb. 1910, picket girls on duty, 1910. Courtesy Library of Congress Prints and Photographs Division.

Using Lines

JUST FOLLOW ALONG

Using lines to draw the viewer's attention into the photo or across the photo is a technique that is very useful in creative photography. This is referred to as using "leading lines."

Just as when we read a book, our eyes scan a photograph from left to right. A leading line along the left side of a photograph will capture the viewer's attention right away and then lead him across the photograph (left).

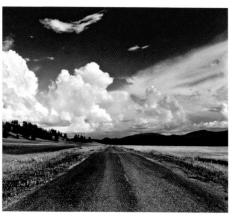

Another use of leading lines is to arrange your photograph so that the line leads into the photograph and draws the viewer's attention more fully into the details of it, as in this photograph of a country road (above).

This usage of leading lines creates high impact and causes the viewer to spend more time following the line and examining the photograph. It also adds depth to your photographs, something that's difficult to do in two dimensions.

When using leading lines, set your aperture for the largest depth of field available. This results in most, if not all, of the leading line being in focus.

The next time you photograph outdoors, look for fence lines, roads, and even walls, and specifically frame your photograph so that the lines created by these features are leading lines. Bonus points if your leading line goes from left to right. —CWN

Collodion Process

MAKE 'EM WHILE IT'S WET

Collodion is a light-sensitive concoction made up of guncotton (cotton specially treated with nitric and sulfuric acids) mixed with alcohol and ether that was originally used to treat the wounds of burn victims. When collodion liquid dries as a result of evaporation, it forms a tough, transparent flexible film. In photographic use, the collodion-on-glass negative process was introduced in 1851 by Frederick Scott Archer and was the process of choice for over 30 years. It came to be known informally as the "wet plate process" because the exposure had to be made and processed before the collodion dried.

Images produced from the collodion-treated plates were virtually grain-free, making the process a considerable improvement over the daguerreotype. The process was difficult because the collodion was extremely sticky and could get dirty or dusty quite easily. Also, because the plates had to be treated just prior to exposure and then processed immediately after, the photographer had to carry a cumbersome mobile darkroom everywhere.

Still, the low-cost and high-quality results outweighed the drawbacks and wet-plate processing was an almost immediate success, remaining the dominant photographic method until the mid 1880s, when the dry-plate process was perfected. —DJG

Alfred Eisenstaedt (1898–1995)

THE ORIGINAL CANDID CAMERAMAN

One of the four original photographers for *LIFE* magazine's premier issue in 1936, Alfred Eisenstaedt was one of the magazine's most prolific photojournalists, completing over 2,000 assignments with images appearing on 90 covers.[1] Over the years, he photographed statesmen and celebrities, from Hitler to Charlie Chaplin, in his unassuming, candid style, becoming a defining force of American photojournalism.

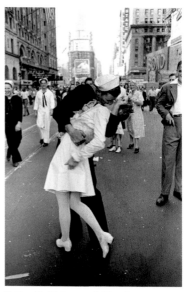

His most famous photograph of an American soldier kissing a nurse in Times Square during the riotous celebrations at the end of World War II clearly illustrates a quintessential moment in American history. A true pioneer, Eisenstaedt received many awards over his lifetime, including the Presidential Medal of Arts, the Infinity Master of Photography Award, and Photographer of the Year from *Encyclopedia Britannica*.

Happy sailor kissing nurse in Times Square during impromptu V-J Day celebration following announcement of the Japanese surrender and the end of WWII, August 14, 1945. Photograph by Alfred Eisenstaedt; courtesy Getty Images.

Originally from Germany, Eisenstaedt was drafted into the German army at age 17, and later seriously wounded when shrapnel tore through both of his legs. He was the only survivor of his battalion, and turned to photography as a full-time occupation during his recuperation. He began working as a photojournalist for German publications in the late 1920s, photographing a meeting between Adolf Hitler and Benito Mussolini before his escape to the United States during Hitler's rise to power.

Throughout his many years as a photographer, he lived his philosophy of finding and catching the storytelling moment. Working with a 35mm Leica rangefinder allowed him to capture intimate portraits of his subjects caught in unguarded moments, creating visually striking and memorable images.
—GC

Narrow Depth of Field

CATCH A SQUIRREL, BLUR THE REST

There is a saying: "Hurry up and wait." Wildlife photography can be that way. You prepare as much as possible, then when you get in the field, you wait, and nothing presents itself. Might as well call it a day. Then, opportunity comes running on all fours.

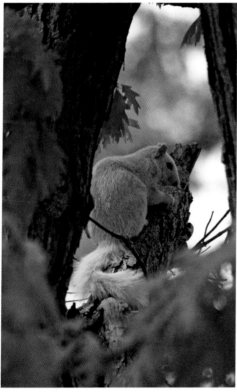

Photo © Bill Diller.

Driving home one day, I remembered a friend mentioned spotting a rare, light-colored squirrel in a local park. I swung by the park on a whim. Lo and behold, there it was: a light-colored squirrel sitting at the base of a tree, eating a nut.

Equipped with a telephoto lens, I walked slowly toward the squirrel. It scampered up the tree as I approached, so I hurried. The best view would be to frame the squirrel with leaves around it, but I wanted the animal to stand out. Opting for a narrow depth of field, and with camera in Aperture Priority mode, I selected the lowest number f/stop, focused, and got my shot. —WTD

Landscape

NIK STRANGELOVE, PHOTOGRAPHER

This is an example of where location can drive the image that you are planning to make.

Nik was deeply influenced by the art and persona of René Magritte, who would often include a bowler-hatted man in his paintings. Magritte had been photographed wearing a bowler hat and a long black coat, so when we discovered this great location in the Peak District of Derbyshire in England, I felt it suitably represented a surreal backdrop and landscape in which to portray Nik dressed as Magritte. The landscape in the image was further enhanced in the frame by distorting it and curving the horizon line by utilizing a fish-eye lens on the medium-format camera.

This portrait was shot on black and white film and while it does not show his face completely, represents Nik enough to recognize him and convey his love of surreal art, landscapes, and Magritte. —SA

Photo © Simon Alexander.

Use of Light
ACCENTUATING THROUGH CONTRAST

This is a portrait of a professional stunt man. Since he was in such good shape, I wanted to highlight his physique. I did this by increasing the contrast of the photo.

Contrast is created when the main source of light hits the subject from a side other than the front. This is good for showing muscles (but typically bad for beauty shots). For this photo, I placed a reflector in an unnatural place: the ground. It reflected the light from a side of the subject and showcased his fitness and finesse. —TH

Photo © Tom Hauck.

Couture Posing and Movement

UNDERSTANDING THE SCIENCE OF BODY LANGUAGE

When instructing a model for a full-length fashion pose, a photographer must be conscious of every inch of the model's body, drape of the clothing, and facial features.

Start with the direction of the feet and positioning of the model's legs and torso. Think about on which leg the model should support her weight and how to pose her hips. A timeless pose approach is the *contrapposto* style. Contrapposto is an Italian term used to describe a figure's position in classical sculpture where the hips and legs are turned in a different direction from that of the shoulders and head, with most of the weight on one foot so that the shoulders and arms twist off-axis from the hips and legs.

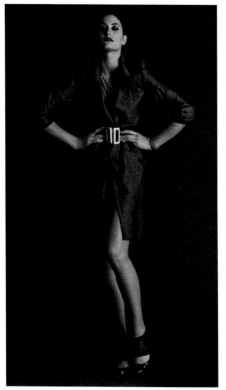

Position the hands where they are inconspicuous. A poorly posed hand or the clenching of a fist can ruin an image. The hands should look elegant and in a relaxed state. Rolling the shoulders forward is also a staple in couture posing. It elongates the torso and tightens the waist.

Be aware of the lines of the clothing and the wrinkling and folds that are caused by the pose. Move the model's head so that the neck is exaggerated and allow the facial features to convey the feeling of the position of the body. —MR

Photo © Matthew Roharik.

Photographic Collages

MANY WORLDS WITHIN ONE

An old fable tells of three blind men who come across an elephant in the jungle. As each man touches the animal's tail, ear and trunk, respectively, they begin to argue, each insisting on the exclusivity of his own limited perspective. None of the men can conceive of a creature that could possess the vastly divergent characteristics described by his companions.

Quantum physicists have suggested that our universe may contain scores of additional dimensions and an infinite number of alternative universes, all seamlessly wrapped around each other. We are provided a glimpse behind the veil of such multidimensionality through Thomas Kellner's photographic collages.

Rather than limiting himself to one angle and one moment, the photographer has collected a series of moments, views and perspectives, drawing them together in perhaps one of the best visual metaphors for postmodern philosophy. If modernism is represented by a single photograph of the Eiffel Tower taken at a particular time and place, Kellner's work is postmodern in its all-encompassing, holistic nature: The tower is seen from all angles simultaneously.

The collages bring to mind the vision attributed to the Zapatista movement of southern Mexico: "We want a world with enough room for all of the worlds that the world needs to really be a world." —DJS

Beijing, Great Wall of Mutianyu; © 2006 Thomas Kellner
Paris, Tour Eiffel; C 1997 Thomas Kellner.

Lights of Independence

BY SUSAN CAPLAN

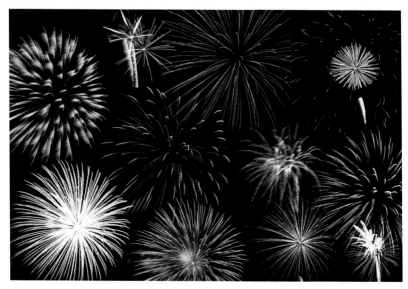

Capturing the magnificence of a fireworks show with clarity and color can be a challenge. This image is a composite shot created with multiple single-shots stacked as layers in Photoshop. When shooting fireworks, it's best to use a tripod and shutter release. Setting your camera to ISO 100, f/8, and using exposure times between 2 and 8 seconds is a great way to capture these elusive lights.

Susan Caplan lives and works in South Florida, where she passionately pursues photography using a variety of innovative techniques. www.photosbysusanc.com

Street Life

PAST, PRESENT, FUTURE

Street life reveals humans in their natural habitat, unposed, moving in their own time, and going about their business. A photograph revealing street life becomes a moment in perpetuity, a snapshot never to be re-created in the same way again. Focused on activity and the variety of available urban experiences, they often reveal a visual complexity. In many instances, this type of image becomes a historical document revealing a way of life that may not exist in the present. As such, photographs of street life become a point of reference to re-create, speculate, compare, or simply ponder the past.

These images communicate universal truths about human behavior, reminding the viewer of ideas, concepts, experiences, and people they have known before or may meet in the future. Through observation, the street photographer has at his disposal the greatest tools of all—his mind and instinct. Knowing the right moment to capture street life means the photographer must practice "looking." The perceptive eye of the street photographer searches for the decisive moment, the juxtaposition of information or the interjection of a passerby. —MLR

Closing of push cart marketing, Saratoga Avenue and Prospect Place, Brooklyn, 1961. Photo by Roger Higgins; New York World-Telegram and the Sun Newspaper Photograph Collection; Library of Congress Prints and Photographs Division.

Using Shapes and Patterns

THE EYES LOVE IT

If you desire to create more of an artistic, abstract photo, capture yourself some shapes and patterns.

There are many patterns observable in daily life: parking meters in a row, fence lines, and architectural features on walls and buildings. Look not only at objects but at the shadows those objects cast. During a recent vacation, I observed an interesting pattern of shadows on a boardwalk (below, right). I photographed this from several vantage points with the view from four stories above it providing the most pleasing composition.

Photo © Christine Walsh-Newton.

It is not necessary to photograph outdoors to find these types of features. This photograph of leather upholstery (above, left) is an excellent example of using shapes and patterns indoors to create a pleasing photograph.

The above examples illustrate photographs of a single item, but shapes and patterns can also be illustrated by photographs of multiple items. A row of jars in a spice rack or an aerial view of an open box of crayons are examples of how multiple similar objects define a pattern.

Take the time to study your surroundings. More often than not, you'll find shapes and patterns in the details of your everyday life. If you don't find them naturally, go ahead and arrange them to suit you. There's no rule that objects in photographs cannot be manipulated in order to create a pleasing composition. —CWN

Magnum and Photo Collectives

STRENGTH IN NUMBERS

A photographer's collective is a group of photographers (often photojournalists) who unite as a way of mutually supporting individual projects and promoting their work. The support that comes from being part of a group allows individual artists freedom to pursue particular topics of interest even if a client has not contracted the work. Once in the group, members contribute funds to a joint account, which can be accessed to finance travel or other professional expenses. Group members also establish editorial and business policies about their organization and often participate in a profit-sharing arrangement.

One of the first and best known of these groups is Magnum photos, founded in Paris in 1947 by Robert Capa, Henri Cartier-Bresson, and George Rodger (see page 80). Beyond maintaining a staff that includes current top photojournalists, Magnum (with offices New York, London and Tokyo) maintains a massive library of more than one million images by its members and others, which it licenses to the press, publishers, advertising, television, galleries, and museums around the world.

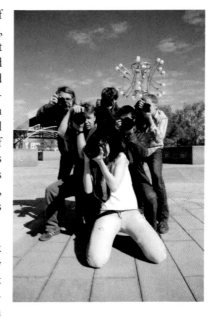

Another prominent agency, Black Star, was founded in New York City in 1935 by three German Jews, Kurt Safranski, Kurt Kornfeld, and Ernest Mayer, who fled the Nazis with a huge stockpile of prints. When LIFE magazine started in 1936, Black Star photographers became regular contributors. The company still exists today, primarily working with the corporate world. —DJG

Howard Schatz (1940–)

DREAMING UNDERWATER

Photography began as a weekend hobby for Howard Schatz, who was at that time a world-famous retina specialist with a thriving practice and a professorship at UCSF Medical Center. Eventually, he decided to take a sabbatical and devote his time to photographic pursuits, which led to a prolific second career.

Schatz's passion for the human body is conveyed in his images of models adorned with roses and sequins, swathed in chiffon, or contorted in impossible knots. The majority of his work is a visual celebration of the movement, grace and form of athletes and dancers, much of which is photographed in a swimming pool. Indeed, his best-known images are otherworldly dreamscapes, watery images of floating, angelic, lithe figures.

Schatz retrofitted a swimming pool on his property to be the stage for his creations. This is a crucial element to his work, as water's unique properties infuse his images with extreme light and clarity. Its buoyancy causes models' hair and clothing to float, making them appear weightless. Over the years he has learned to adjust the water's pH so it doesn't sting the models' eyes, and his physician's bedside manner comes in handy when helping models to relax and hold their breath underwater for long periods.[1]

His images have appeared in *Time, Sports Illustrated, Vogue, Stern, Life,* and *The New Yorker.* His advertising clients include Nike, Ralph Lauren, Escada, Virgin Records, and Mercedes Benz. His books include *H2O, WaterDance, Pool Light, Botanica,* and *Athlete.* —GC

Wide Depth of Field

I WANT IT ALL ...

Photography is painting with light. Instead of using a brush and canvas, you're using a machine to capture a moment in time. The more you understand how a camera captures an image, the less time you spend getting the right setting, and the more time you spend being creative.

Think about depth of field, and whether it should be narrow or wide. When you see that beautiful waterfall in the distance, with the autumn leaves lying on the ground at your feet, you envision a shot that has a wide depth of field. It is in focus from directly in front of the camera to as far as you can see. From experience you know that setting the aperture at f/22 will mean losing the ability to hand-hold the camera (because the shutter speed decreases each time the f/stop number increases), but you also realize that doing so increases depth of field. You set up your tripod, and before pressing the shutter release, you set the self-timer to 10 seconds. You step back and wait, capturing a shot that's in focus from near to far. —WTD

Photo © Bill Diller.

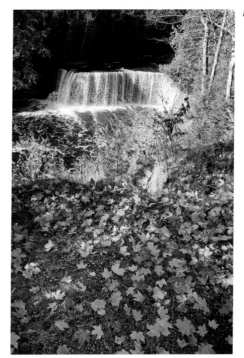

Cityscape

CHRISTOPHER SIMON, PLAYWRIGHT AND ACTOR

For my *Brits off Broadway* portrait series, I choose an in-character moment of performance in the play that best presents the main theme and then ask the actors if they have a favorite place in New York City where they would like to be photographed out of character. Some of the choices ranged from Brighton Beach, a diner banquette, on the Brooklyn Bridge, or in a taxi.

This is an out-of-character portrait of Christopher Simon, who had performed his one-man show *When the Bulbul Stopped Singing* at 59E59, a modern and off-Broadway New York theatre. Chris' show was intense and politically charged, and he himself was a fairly serious man. Chris had enjoyed the view from his apartment where he'd been staying for the duration of the play, and so he chose this location and stunning cityscape background for his out-of-character image. While the city skyline dominates the background, Chris commands the viewer's eye with his direct gaze into the lens and centered position in the frame. The composition of the balcony railings also serves to draw you into the center. —SA

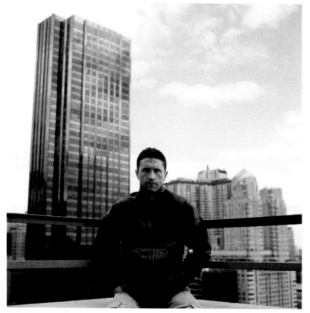

Photo © Simon Alexander.

Framing

GETTING SERIOUS AIR

At the BMX World Championships in Victoria, British Columbia, I scouted the course to find a few locations I thought would showcase the distance the riders were traveling in the air, and show context by including the hills and crowd. This photo is quite peaceful compared to the speed, aggression, and athleticism actually taking place. It has almost an *ET* feel to it. —TH

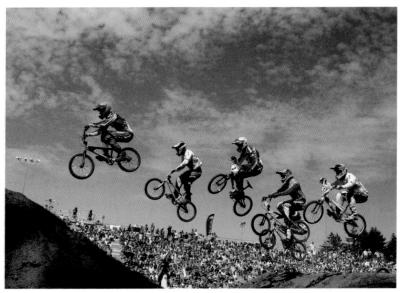

Photo © Tom Hauck.

Posing Two Models

STRANGERS NO MORE

In most professional circumstances, the models that you chose to work with will meet for the first time on the shoot. Start by having them pose side by side, getting a feel for the way each carry themselves and handle direction. If one seems more comfortable than the other, use him or her to lead the other into a pose. Once the awkwardness of posing two strangers together is over, the fun can begin!

It's not necessary that both models look into the camera. Often the image is stronger if each of them is looking in other directions or at each other. Try poses where one looks to the camera and the other is instructed to look in various directions. Then try the reverse.

In this image, the women were directed to pull on each other's clothing for a tug-of-war feel that would add tension and drama to the pose. A slight fan breeze was added to accentuate the direction of the motion. The image was shot with three lights. A 72-inch parabolic umbrella was positioned directly in front of them, with the photographer standing in front of the large light. Two strip lights were used on each side. A Hasselblad HD3 with an 80mm lens was the camera of choice. —MR

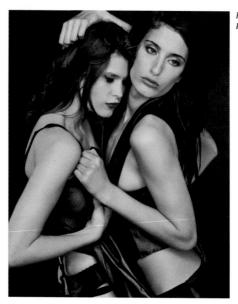

Photo © Matthew Roharik.

Urban Legends V

PHOTOGRAPHY BY LIGHTNING

Around the end of the 19th century, several U.S. newspapers printed stories in which a flash of lightning caused a person's image to be imprinted on a nearby windowpane, creating an "accidental photograph."

While anyone remotely familiar with the mechanics of photography could have debunked these accounts, some of the reports stretched logic even further: According to one version, a flash of lightning etched the silhouette of a cherry tree onto the skin of a child's hip.

At the time, however, the idea of lightning creating an accidental photograph would not have seemed far-fetched for much of the general public. Many viewed it as a semimagical procedure: a bright light would flash, a glass plate was brought into a dark room, and an image mysteriously appeared.

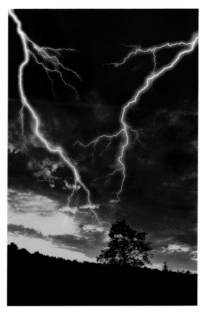

As knowledge of the technical aspects of photography grew and rolls of film replaced glass plates, this story largely disappeared from newspapers by the 1890s. The tale continued to spread as an urban legend well into the 20th century, however, evolving from a matter-of-fact account of a bizarre "scientific" phenomenon into a morality tale with supernatural overtones. The narrative increasingly relied on a wrongful death: An innocent person dies during a lightning storm, only to reappear on the glass of a window. In many versions, the image reappears even after the glass has been replaced.[1] —DJS

Found Cups with Spoon

BY MARK TANNER

This image from a series of found objects was inspired by the late Irving Penn. Where Penn's found objects were clean and crisp, these are more textural and gritty, allowing the viewer to get a sense of the streets they were retrieved from. Upon processing the Polaroid type 55 positive/negative film, instead of clearing the negative, it sat in the open to dry. It picked up dust particles, and even a fingerprint or two (something most photographers go to great lengths to avoid).

Mark Tanner is a photographer in the Los Angeles area. While earning a living shooting advertising and editorial assignments, his passion lies in creating conceptual fine art images. www.marktannerphotography.com

Presidential Presence

WHAT ARE WE REALLY LOOKING AT?

Creating presidential presence is a practiced, formal process. Clothing, stance, physical and verbal responses and gestures all come together to create a particular visual image. Coupled with choices made by a presidential staff about where, when, and how a president meets his public, a presidential appearance is formed. This presence is used to sway public opinion, push an agenda, and highlight topics of interest to the president and first lady.

Photography plays a huge role in creating what the public sees and understands the president to be—the camera is used to communicate the power of the office.

One of the earliest photographs taken of a president in office was of President James Buchanan, our 15th president. The photograph was taken in 1857 by Matthew Brady.[1] Consider the idea of never seeing your president except through drawings and paintings, and then suddenly having a photograph to view. Consider also that deception can be at play in presidential photos. Franklin Delano Roosevelt was stricken with polio in 1921 and held the office of president from 1933 to 1945—his inability to walk was concealed and managed through photography, with a willing press and photographers in on the deception.[2,3] —MLR

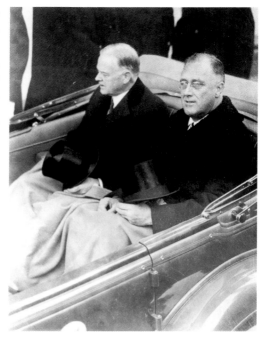

Franklin Delano Roosevelt and Herbert Hoover in convertible automobile on way to U.S. Capitol for Roosevelt's inauguration, 1933; courtesy Library of Congress Prints and Photographs Division.

Using Color and Contrast

COLORING WITHOUT CRAYONS

Creating interest in a photograph can be achieved by the use of contrast and color. Contrast between light and dark elements provides interest and sets apart one part of the scene from another. Light coming from the back of an object will help define its shape and provide rim lighting around the edges. Light falling on an object will increase its contrast to the surrounding scene.

Another method of providing visual interest as well as contrast is through the use of color. Becoming familiar with the color wheel will provide you with an excellent knowledge of contrasting colors and will help you decide on your background and subject placement.

As a child, I was taught to remember the color wheel with the name Roy G. Biv. This will help you remember the colors in order as they appear on the wheel: red, orange, yellow, green, blue, indigo and violet. Colors that are directly opposite each other on the color wheel will provide the highest level of contrast and visual interest.

As an illustration of this concept, to the left is a photograph of a child's hand holding a yellow toy against a blue sky.

Because yellow and blue are opposite each other on the color wheel, the photograph has impact from the color contrast. Observant readers will also notice the leading line, from the lower left to the upper right of the photograph. —CWN

Flash Photography
ON AGAIN, OFF AGAIN

Flash photography emerged in the 1850s and '60s as a tool to brighten subjects and reduce exposure times. Early methods used fire, and more often magnesium, which when ignited, produced an intense, bright light but also created extremely dangerous working conditions. German inventors in 1887 created a safer but still magnesium-based compound that became known as "flashlight powder," and enjoyed popularity for years.

In 1925, Dr. Paul Vierkotter enclosed magnesium wire in glass and used a low-voltage electric current to ignite it, eliminating both the need for an open flame and the acrid, toxic smoke previously produced. "Flashbulbs," as they came to be called, took another leap forward a few years later, when reflective foil material was added to the glass case, increasing the brightness.

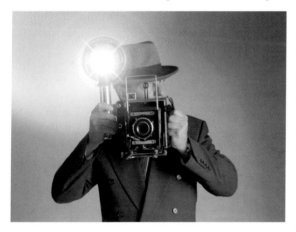

Flashbulb technology remained the standard for decades, peaking with the advent of flashcubes, four flashbulbs in one unit that attached to a camera and rotated after a picture was taken. (The flashcube had to be removed, disposed of, and replaced after four photos were taken.) While Harold Edgerton used an early version of an electronic flash in the 1930s, it did not become widely available to average consumers until the 1970s, when cameras came with built-in or attachable flash units that could be used thousands of times. Electronic flashes work by sending a high-voltage charge between two electrodes in a glass tube filled with xenon gas. —DJG

Man Ray (1890-1976)

ARTIST AND AGITATOR

Emmanuel Radnitsky changed his name to Man Ray in 1912, during time spent among the bohemian circle of Greenwich Village. Initially a Cubist painter, he eventually gave up cubism for dadaism, dadaism for surrealism, and then abandoned painting altogether in his pursuit of photography.[1] Along with experimental artist Marcel Duchamp, Man Ray attempted to break through the constraints of the visual arts first in New York, and then Paris, in the 1920s. Through Duchamp, he met a culturally elite circle—including Pablo Picasso, Ernest Hemingway, Salvador Dali, Gertrude Stein, and James Joyce—and became their unofficial photographer.

Throughout the 1920s, Ray experimented primarily with photography and film. He developed the rayograph process of making photographs by laying three-dimensional objects on photo paper and exposing it to light. Kiki de Montparnasse, a famous performer and model, was his companion, model and muse, and the subject of many of his photographs.

Throughout the 1930s, he continued to paint, sculpt, and photograph with the surrealists but was forced to return to the United States during World War II. He settled in Los Angeles and worked for the next 10 years as a fashion photographer, again breaking the rules and experimenting with bold use of lighting and minimalist representation. He eventually returned to Paris and spent the remaining 25 years of his life exploring the boundaries of visual art, creating the paintings, sculptures, films, and assemblages that made him one of the most influential artists of his time. —GC

Man and the Natural World

DUCK, DUCK, GEESE!

Before the Europeans showed up, North America's indigenous residents subsisted on what nature provided, along with modest fields of maize and other grains. This left wildlife free to roam at will, hampered little by man's inroads.

As Europeans cleared the land to grow crops, the creatures calling those woods home were forced to change their habitats. Gradually, wildlife adapted to its new surroundings. Wild geese, for example, enjoy a continuing source of food as they migrate, thanks to grain left out after harvest.

Slowly driving by a field filled with these birds is a good way to approach as they're busy gleaning the leftover grain. Geese are used to vehicles passing by, which turns them into a good "blind." Taking photographs from a stopped vehicle is an easy way to get memorable shots of these magnificent birds—all you need is a good telephoto lens and some patience. —WTD

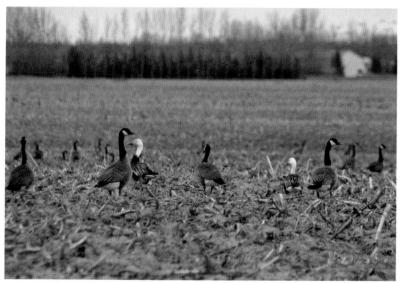

Photo © Bill Diller.

Onstage

LINDA MARLOWE, ACTRESS

Linda Marlowe is a powerful and engaging actress, with a distinct style and stage presence all of her own. For her *Brits off Broadway* in-character portrait, I drew on her scenes on a trapeze, high up over the stage, where she nimbly jumps up and curls a leg over the wooden handle and glides into a seated position. She had mastered the technique and was simply captivating in her role in *No Fear!* What was more amazing was her ability to very confidently sit up there and recount her life's experience as part of the play, seeming to be sitting in a comfortable chair, nonchalantly swinging a leg back and forth. She kept the audience on the edge of their seats and so impressed me that I could not imagine photographing her doing anything else.

This was lit with a single strobe head into a silver umbrella positioned behind the camera and balanced to allow the colored stage lights to come through in the background. The composition was further enhanced by her outstretched arms, in effect showing her ease of sitting high above the stage without a safety mat or harness—truly showing no fear. –SA

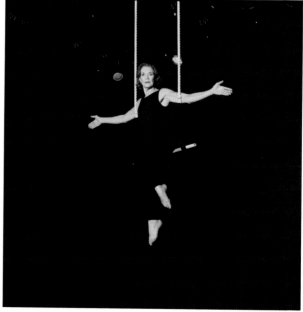

Photo © Simon Alexander.

Being Patient

GET 'EM WHILE THEY'RE LAUGHING

Faces are a great way to draw the viewer in. Here, baseball player Manny Ramirez stretches before his major league playoff game. I maneuvered my way to an area that provided a clean background and sat patiently as he progressed through a regimen of stretches. I snapped this great moment as he rolled over and laughed at a teammate. —TH

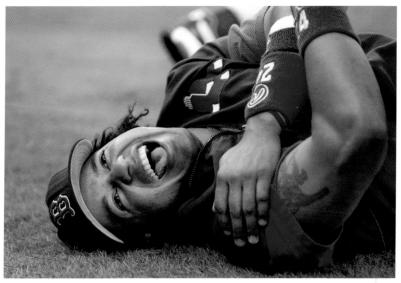

Photo © Tom Hauck.

Beauty Headshot Basics

USE YOUR LIGHTS WISELY

There is a basic lighting setup format for a beauty headshot. The main light, or key light, should be centered to the direction the subject is facing. A beauty dish with a diffusion sock will do nicely. This light should be placed as close as possible to the face and at correct height so that the shadow below the nose is very slight.

Another diffused strip light should be placed in front, close to the ground, focused at the eyes, and filling under the neck. White fill cards or reflectors can be placed on each side of the subject, close to the face, to decrease the shadows. A hair light should be placed above and behind the subject, angled so it skims across the top of the hair. There are two strip lights just off the background placed behind the model aimed toward the model's back on each side. This provides the rim lighting on the cheeks and shoulders. The white background needs to be well-exposed so that it appears true white in the exposure.

A clean and simple studio headshot on white background. Photo © Matthew Roharik.

Regardless of what aperture is chosen for depth of field, always sharp focus on the eyes. The eyes are the gateway to the soul! —MR

Scanner as Camera

BEYOND PRACTICALITY

Ever since the first brave pioneer dared to photograph his own hindquarters using the office copy machine, creative types have chafed against the constraining definitions of "acceptable" artistic expression.

Many would view the conventional desktop scanner as a utilitarian office tool before considering it for creative purposes. As scanner technology has developed, however, the boundary between the definitions of scanner and camera has grown increasingly blurred. In addition to the conventional flatbed model commonly used with personal computers, mobile scanners have emerged, running the gamut from the three-dimensional scanners used by engineers to handheld wands that can scan text. The world's smallest scanner, in fact, could easily be mistaken for a conventional pen; created by the Canadian company Planon System Solutions, it measures only 226mm by 12mm.[1]

Be that as it may, the more bulky desktop model is seriously limiting when it comes to taking artistic photos—the glass plate must be protected, the object to be scanned must be shaded from outside light. So why would anyone opt for using one over a simple handheld camera?

Photographers the world over have made a name for themselves by purposefully working within the constraints of a particular medium, whether they have opted for using only black and white film, shooting with archaic toy cameras, or focusing on a process-intensive medium, such as the daguerreotype. Such self-imposed parameters place greater strain on the artist's creativity, showcasing their innate talent. —DJS

Rose in the Rain

BY JEROME MUNGAPEN

This image is a macro shot of a rose petal covered in raindrops. It was actually taken in broad daylight. The camera was set to underexpose significantly in order to render the background to black. Next, an off camera flash was used to illuminate the rose petal, giving hard directional lighting.

Jerome Mungapen is a photographer in San Francisco, California. His passion is landscape and still life photography, specializing in PanoPlanets. www.panoplanets.com

War

REMINDERS OF WHERE WE DO NOT WANT TO GO

Most symbols of war qualify as universal in their understanding—missiles, guns, tanks, and people attired in varying levels of military dress allow viewers to draw similar thoughts and expectations. War journalists and photojournalists are charged with approaching this topic objectively—without manipulation or conscious forming—by simply photographing what they see. These images are disarming, disturbing in many cases, and often grab the attention of the world. Eddie Adams' photograph of the execution of Nguyen Van Lem captured a moment that revealed the brutality of the Vietnam War.

Varying states of hostility, antagonism, and conflict occur in society and never reach the proportions of a declared war. Photographs of these incidents brim with power and can become a symbol of a particular struggle. John Filo's famous photograph taken at Kent State (while he was a photojournalism student) was awarded a Pulitzer Prize and catapulted a 14-year-old girl into the limelight. The girl's reaction to witnessing the shooting of a protester became the symbol of the grief and shock of a nation. The photo does not contain a gun, missile, tank, or military personnel—just the emotional aftermath of their presence. —MLR

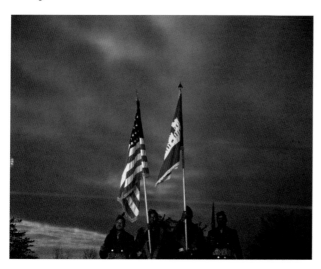

Color guard of Negro engineers, Ft. Belvoir (?), Virginia, 1941-45. Photo courtesy Library of Congress Prints and Photographs Division.

Using Perspective

HELLOOOOO DOWN THERE!

Earlier in the Photography 101 lessons (see page 148), we discussed using perspective as it related to lenses. This time, perspective is where you place yourself in relation to your subject while taking the photograph.

Photographing your subject from above creates the impression that your subject is small while photographing from below makes it seem as if your subject is very large.

Try photographing your subject as you normally would, then take a second and third photograph from two different height angles. You will find that in addition to changing the appearance of size, these angles will also add drama to your photographs.

Below (left) is a typical vacation photograph of the Eiffel Tower. While the tower is large, this photograph does not convey its immenseness.

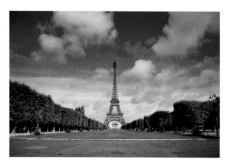

On the other hand, this photograph, taken from the base of the tower looking straight up, shows the sheer height of the tower and results in a dramatic and powerful photograph (below).

This concept can also be applied to people. Photographing your subject from below can make him or her appear not only taller but even threatening, imposing, or powerful. Photographing from above can make him or her appear small, vulnerable, and powerless. —CWN

FUN FACT

One technique I use in my studio is to photograph my subjects from a very slightly elevated position. This angle requires my subject to look slightly up at me and portrays a sense of friendliness and approachability.

The Instamatic Camera
NO THINKING REQUIRED

Of all of the products introduced by Kodak, the instamatic camera was arguably its most successful. Actually referring to a line of cameras rather than one specific model, the instamatics were inexpensive (often made of aluminum or plastic), point and shoot cameras that hit the market in 1963, and essentially allowed anyone to become an amateur photographer.

The key appeal was a combination of low cost and extraordinary user-friendliness. The cameras had a fixed shutter speed, aperture, and focus, eliminating the need for any technical knowledge of how to take a picture. The process was so simple that the camera owner only had to aim the camera at the subject, and press a button. Kodak's new 126 (and later 110) size film, came preloaded into plastic cassettes with a built-in mechanism for advancing the frames. Rather than finding a dark space in which to insert a canister of roll film and then thread the leader into a slot, the consumer merely had to snap the cassette into place, close the back of the camera, and be confident that the film was loaded correctly. The convenience came with a trade-off, relatively low-quality photographs that satisfied the "man on the street" but held no value for professional photographers.

The company (and inevitably the copycats) went on to manufacture tens of millions of instamatic cameras over the course of the next 25 years. Wildly popular from the very beginning, the cameras evolved from the original, basic version to later models that were packed with special features. —DJG

William Wegman (1943–)

IT'S A DOG'S LIFE

When people hear the name William Wegman, they think of his quintessential images of deadpan Weimaraners in costumes, colorful and wryly humorous work that pokes fun at the oddities of life. Wegman's use of the 20x24 Polaroid camera produces crisp, colorful images of his canine muses set in a variety of staged scenes that have culminated in comical modern renditions of children's book favorites, such as *Cinderella, Little Red Riding Hood, ABC,* and *Mother Goose.* He has also created numerous books for adults, including *Man's Best Friend, Fashion Photographs, Fay,* and *The New York Times* bestseller, *Puppies.*

Wegman holds both a B.F.A. and an M.F.A. in painting, underscoring the fact that he is also an accomplished painter. He has passed on this knowledge at various universities over the years, including California State College in Long Beach, where he first became interested in video work, and made it into a career.[1] Over the years, he created video segments for *Sesame Street, Nickelodeon,* and *Saturday Night Live.* His work has also been shown at the Sundance Film Festival.

His photographs, paintings, videos, and drawings have been exhibited internationally and are held in the permanent collections of the Hammer Museum, the Los Angeles County Museum of Art, the Montgomery Museum of Fine Arts, and the Smithsonian American Art Museum. —GC

Winter's Fury

SOMETHING GOOD COMES OUT OF THE COLD

For those who live in Northern climes, winter's fury is simply something to be expected. It's inevitable that a storm will come. The wind is going to howl, and the snow will fly. When you glance at the thermometer, it probably registers a number somewhere near zero, or below.

But there is beauty in that misery. Snow is piled high and drifted by the wind into shapes that would make an abstract artist swoon. If you happen to catch it at just the right time, when the storm is abating, and the setting sun is peaking through low-lying clouds, winter's fury becomes a work of art…the perfect moment for you and your camera.

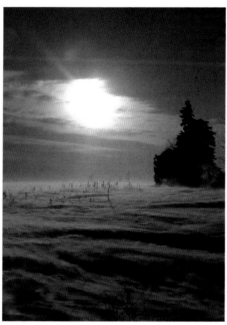

Photographing the scene can be accomplished quickly, and hopefully you won't have to venture far from your home or vehicle. Wait for a gust of wind to blow snow off the edge of a drift, with the sun at an angle so it's illuminated by the colors of the setting sun. Use a fast shutter speed to stop the action, and the tableau is yours. —WTD

Photo © Bill Diller.

Serendipitous

LIZA PULMAN, SINGER

Even if I had planned this shot—outside a major New York department store, with a cool-looking sports car to drive by—I could not have planned the gust of wind that caught Liza's skirt, a la Marilyn Monroe's famously staged photo shoot. Serendipity is often the additional element that is never factored into a photo shoot but so often and miraculously shows up at the perfect time.

This portrait captures Liza reacting to the sudden whoosh of air that surprised us both, and her instinctively pushing down her skirt to avoid embarrassment. What I did not expect was that a perfectly colored sports car would then pass by as this was happening, creating a perfect shot. Her expression adds to the moment in the image—the smile is completely natural and genuine, showing her happy surprise and relief that she caught her skirt just in time! —SA

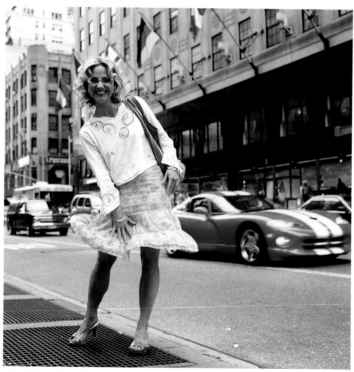

Photo © Simon Alexander.

Capturing Action

PREDICTING A COLLISION COURSE

Capturing action is equal parts skill and luck. Many times a catch or a collision takes place in front of you, but like marbles smashing into one another, there is a random component as to which direction everything will end up. Here Plaxico Burress, #17 of the New York Giants, hangs on to a pass as he collides into Atari Bigby, #20 of the Green Bay Packers, at the 2008 NFC Championship. —TH

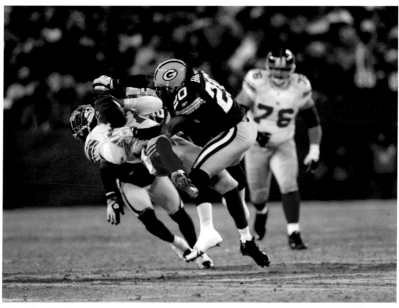

Photo © Tom Hauck.

Competition Quality

WHEN IT ALL COMES TOGETHER PERFECTLY

The image of the girl looking over her shoulder was captured on Fuji medium-format transparency film with a Hasselblad 500 series camera body. This Swiss series of cameras arguably are the most durable and well-crafted manual cameras in production. So reliable, they have been travelling to space with astronauts since the Apollo program. The crispness of the focused areas and range of color and detail is characteristic at all apertures of the finely crafted German Carl Zeiss lenses that are paired with the camera.

An aperture of 4.0 was used to focus the viewer's attention on the face while allowing the body to become a soft blur. Shot in studio, the earth-tone palette of flooring, furniture, and clothing were selected to complement the model's skin tone and feature the work of the makeup artist. All of the strobe lights used were diffused with small soft boxes at several angles to bathe the subject in softly directed light. The final image required almost no retouching of the skin due to the nature of the soft lighting and limited depth of field.
—MR

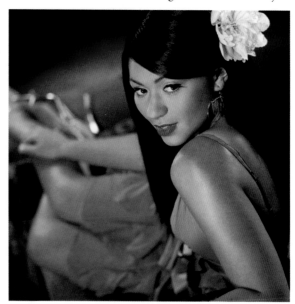

Makeup: Megan Faccenda. Photo © Matthew Roharik.

Dog Photography
THE SUBCULTURE OF CANINE COMPANIONS

One dog wakes up on a bed of silk. She is bathed, groomed, and massaged in preparation for a show later this week.

Another dog is dressed in a T-shirt bearing a political slogan and carried by its owner to an antiwar rally.

A third dog scratches its fleas as it scrounges amid piles of refuse. The dog sleeps on the roof of a cinder block structure, seeking shelter from the rain wherever it can. It will likely spend its entire life without knowing the taste of commercial dog food.

Hard as it is to believe, all three animals descended from a common ancestor.

Nowhere is the disparity between rich and poor humans so apparent than in the disparate treatment of pet animals. Bernadette Johnston has highlighted the peculiar subculture surrounding pet dogs in this photo-documentarian series.

The photographer roams the streets of New York, London, and San Diego, using a lightweight Mamiya 7 II to capture the fleeting moments that are most illustrative of "dog culture." In stark contrast with these urbane scenes, Johnston also includes images of dogs from poverty-stricken neighborhoods in Colombia—where residents doubtless have more pressing priorities than finding the right orthodontist for their Shih Tzu. —DJS

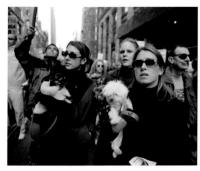 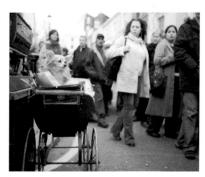

Image at left: Antiwar protest, Manhattan, 2004. Image at right: Portabello Road, London, 2005. Photos © Bernadette Johnston. To view more images from Johnston's series on dog culture, see www.narrativephotoprojects.com.

Earth Hour–Brisbane

BY GARRY SCHLATTER

During Earth Hour, people throughout Australia and around the world turn off their lights for one hour to send a powerful message to global leaders that we need action on climate change. An IR thermal conversion captured this moment in a unique way—the blue dots are all lights.

Garry Schlatter is an Australia-based photographer enjoying the wilderness of his country. He specializes in landscape, nightscape, and architectural photography. www.visionandimagination.com

Sexual Orientation

WHO IS THE PHOTO ABOUT?

Why is this subject such a hotbed of controversy and disagreement? Why is it confusing for some and easily accepted for others? How does one visually define sexual orientation?

Being able to name someone a man or a woman is an act of self-preservation for many and for others a momentary designation. Presenting the viewer with images that are difficult to define instigates discussion and consideration and often a point of confusion. Documenting sexual orientation is not always about the person being photographed but can be about the person viewing the photo. It can become an opportunity for the viewer to accept, identify, or deny. For those who have never been presented with anything other than traditional views about sexuality, this can be difficult.

Explore this topic with an eye toward the larger social topic of what society defines as normal. Choose to place the subject in a variety of environments. Follow the subject through daily rituals and routines. Ask them to show you who they are. —MLR

Cheyanne Pretty at the Albuquerque Social Club. Photo by Russell Maynor.

Finishing Your Work

SOFTWARE TECHNIQUES AND FINAL TOUCHES

More than likely you use a digital camera. If you do, you can easily add some final touches to make your photographs even better.

A popular photo manipulating software is Adobe Photoshop; however, it isn't necessary to purchase expensive software to make basic changes to your digital photograph files. Most computers come with photo-editing software installed, so check your computer documentation to see what is available.

The first adjustment you can make is the brightness of your photograph. Adjust the brightness controls until the photo looks balanced.

Contrast is sometimes part of the brightness controls, so adjust this until the dark areas seem dark enough to you without losing the detail in those areas. This will add a bit of clarity to your photos and take care of the flatness that results from overexposure.

Color balance is another important adjustment. Most often this adjustment is required when your photograph is indoors where there are fluorescent or incandescent light sources that cause yellow, blue, or green casts to your photos.

Refer to your photo-editing software's instruction manual, or purchase a basic manual pertinent to your software before continuing to explore editing software. It's very easy to get caught up in special effects and lose sight of the basic functions that will enable you to produce finely refined photographs. —CWN

Stock Photography
IMAGES FOR ALL OCCASIONS

Stock photography agencies hold vast collections of images that are available for a usage fee to consumers in a variety of fields. With stock collections as an option, people working in advertising, journalism, publishing, or marketing can choose from a database of photographs rather than hiring a photographer to go out and create new images. Agencies sometimes hold the rights to classic, widely recognizable photographs, but they also have collections of "generic" images—objects, landscapes, landmarks, animals, models making specific gestures, or expressions—that capture and convey the visual buyers are looking for.

In the early days of the industry (the first major agency, H. Armstrong Roberts, was founded in 1920), stock photography collections were usually made up of unused images (outtakes) from magazines and advertising houses. However, by the 1970s and '80s, many photographers were creating images specifically for the stock photo market. If one of their images was used, the fee was split between the photographer and the agency.

In the 1990s, industry giants Getty Images and Corbis Images (founded by Microsoft's Bill Gates) emerged, a result of acquiring the holdings of many smaller agencies and work by higher-end professionals. The vast bulk of the stock industry is now Internet-based, with companies making their databases easy to browse online. More recently—a product of the digital age—a number of less pricey agencies known as "microstock" photography services have emerged, allowing amateur photographers to upload their images with hopes of selling them. —DJG

Andy Goldsworthy (1956–)

A NATURAL TALENT

Known as both an environmental artist and a photographer, Andy Golds-worthy draws his inspiration and his working materials from whatever is at hand. He has created his unique variety of sculptures all over the world, in places as diverse as the North Pole, the Australian Outback, and the streets of London. Goldsworthy uses a variety of natural materials that he often molds with only his bare hands and teeth. His work ranges from countless pains-takingly balanced piles of rocks to a curtain woven from over 10,000 horse-chestnut leaf stalks.[1] Whether using leaves, stones, and twigs, or mud, dung, and icicles, his installations all have a common theme: the celebration of the beauty of nature and its ever-changing, dynamic energy.

Goldsworthy uses photography as a tool to capture the end results of the hours or days he's put into his creations, many of which are published in collections in his books. His labor-intensive process was documented in the film *Andy Goldsworthy's Rivers and Tides* by German filmmaker Thomas Riedelsheimer in 2001.

Goldsworthy has created installations worldwide at the J. Paul Getty Museum in Los Angeles, the Metropolitan Museum of Art in New York, and the Tate Liverpool museum in England, among others. Permanent sculptures reside at the de Young Museum and the Park Presidio in San Francisco. In 2000, he was appointed officer of the Order of the British Empire. He is also an Andrew D. White Professor at Cornell University. —GC

Natural Camouflage

I SPY WITH MY LITTLE EYE

Nature has a way of providing security for the denizens of forests and marshes. Natural camouflage, working hand in hand with inherent instincts, equips predator and prey alike with the means to carry on their everyday lives. The goal: survival!

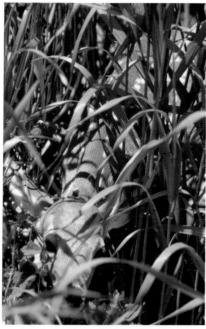

Photo © Bill Diller.

An example of this is a white-tailed fawn. When this most innocent of creatures is born, it is virtually helpless. Unable to even stand for a period of time, the fawn is protected by its instinct to remain motionless and its natural camouflage. The fawn's white spots on brown fur give the newborn a chance to blend with its environment until its legs are strong enough to run.

In order to photograph a newborn fawn, you first have to see it. This one was spotted standing in a ditch near the road. I stopped the car, waited a few minutes, then slowly walked closer to the fawn. I took a few quick shots and then left. Even that close I had a hard time seeing my camouflaged subject. —WTD

TIP

Train yourself to see outlines that break up the scenery or anything that looks out of place. Have your camera ready, and then leave without disturbing the animal.

Soft Strobe Lighting

DIANA QUICK, ACTRESS

This portrait of the famous and beautiful actress Diana Quick almost did not happen. I had first asked to photograph her early in my career. Diana contacted me and while she liked my portraits very much, she said it was not a good time to make the portrait. A year passed, and I was visiting my old neighbor at my first flat in London. We were standing outside chatting, when his neighbor called out of the window to him, asking if he knew a Simon Alexander. Diana had called my old telephone number at my old flat and asked to speak to me, and here I was, by sheer luck.

This example of classic black and white portrait photography shows the subtle play of soft light upon the face. To achieve this direct and yet soft lighting effect, I used two shoot-through silk umbrellas, which were pointed directly at the subject. I then placed my camera between the two, using a long lens shade to prevent the bright strobe lights from affecting the exposure of the subject and black background.

This image was purchased with several other portraits for the archives of the National Portrait Gallery in London and appeared in a book as an example of a shadow-less lighting technique. —SA

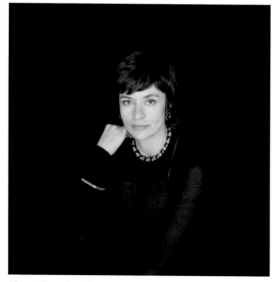

Photo © Simon Alexander.

Jubilation

WHAT VICTORY LOOKS LIKE

Every so often there is a victory for a school or team that creates fanatic reactions from students and alumni. To celebrate, they breach security, jump onto the field, and run wild.

Here the University of California quarterback, Aaron Rodgers, is lifted in the air by fans. I used a wide-angle 17-35mm lens to allow close proximity to the subject. I also set the camera to a faster shutter speed to freeze the action and compensate for all the bumps I would absorb in the melee. —TH

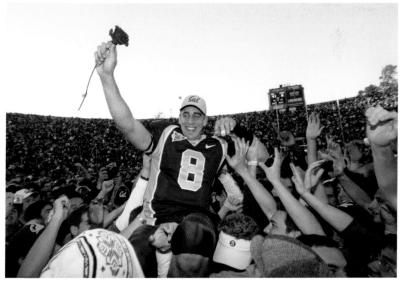

Photo © Tom Hauck.

Retouching

TOOLS FOR ACHIEVING PERFECTION

Adobe® Photoshop empowers today's photographer with a stunning arsenal of photo enhancing and manipulation tools. Retouching a model's face and body in a convincing manner can be achieved with a reasonable amount of ease with patience and practice.

Avoid using the one-click softening and blurring filters to treat the entire face or body. These effects come off as amateur and cheapen an image. The clone stamp and healing brush are very effective tools for removing blemishes, lines, and improving skin quality. Focus on small areas of the face, and try to retain the pores in the skin.

For those who plan on spending a lot of time editing images and want to obtain professional results, invest in a pen and tablet set. These tablets have a stylus that is used in place of a mouse much like a traditional pen or brush and respond to the amount of pressure the user applies. The pen has assignable functions that allow left and right clicking, and some artists have done away with the mouse altogether. A medium-size pad that is the same ratio as the screen that is used for retouching is recommended. —MR

Camera Tossing

FLY-BY SHOOTING

A photographer finds a setting that is almost entirely dark, pierced by a few points of light. The camera is thrown upward; a timer has been set for the shutter to click while it is suspended in midair. The spinning camera catches the lights as they whiz past its lens, creating wild, abstract patterns and formations in the resulting photograph. (Precautions are taken, of course, to softly catch the camera as it falls.)

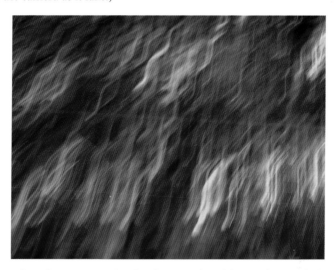

The practice of camera tossing has been explored by professional photographers and amateurs alike. The resulting images are, of course, largely random, as the only factors directly under the control of the photographer are the positioning of light sources and the motion of the tossed camera.

Of course, the idea of leaving the specifics of a piece largely up to chance is nothing new to art. Robert Morris allowed large pieces of felt to fall to the ground at random, letting gravity determine the final form that they would take. Entire schools of postmodern art have incorporated uncontrollable, "chaotic" elements into artistic expression, including Japan's "Gutaï Group" and the Fluxus movement.

Perhaps what sets camera tossing apart, however, is an added element of risk: Not only is the photographer leaving the resulting image up to chance, but the equipment itself is placed in harm's way in the process. —DJS

Brooklyn Bridge

BY RICK SZCZECHOWSKI

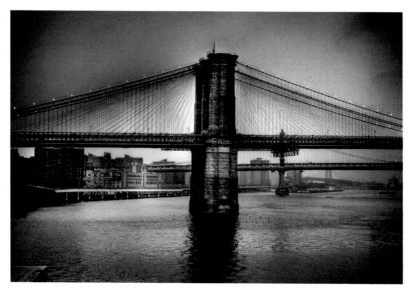

Only one image was available for this HDR attempt, so four additional versions were created: an under and overexposed version; a black and white image; and an all blue image, made by converting to gray scale, then back to RGB using only blue. All of them went through Photomatix (a software program) to create an HDR image. A filter added noise for a grainy effect.

Los Angeles-based Rick Szczechowski is a commercial photographer. He is particularly interested in the art of polymer photogravures. His can be seen at Island Weiss Gallery in New York City and at Hunsaker/Schlesinger Fine Art in Santa Monica.

The Vote

A TRAIL OF ENDLESS DRAMA

Let's talk drama. Political campaigns are full of dramatic moments whether created on purpose, revealed during due diligence, or dredged up by the curiosity of the press. The fight for votes is preceded by campaigning, promises, photo opportunities, and revelations both political and personal. Images captured during the campaign, during the actual voting procedure, and through the counting process become visual commentary about the vote and about political power.

Images stay put long after votes have been counted, returning again and again to vex the winners and the losers, prove a point that didn't exist at the time, or destroy a political career. Photographs add to and feed the ever-changing landscape the candidates operate in. One bad photograph and the political power could tip in the other direction.

According to U.S. Senator Joe Lieberman of Connecticut: "Look, over American history, we've always had spirited politics, particularly in election years. But for most of our history, that partisan political stuff usually ends for a while after elections. Nowadays, the campaigns never seem to end. That makes it very hard to get anything done."[1] And so, photographing the vote appears to be an endless pursuit. —MLR

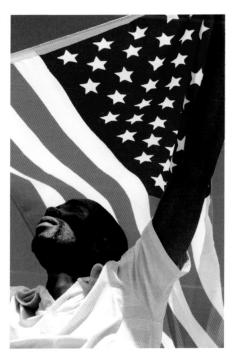

What Is a Cropping Ratio?

HINT: NOTHING TO DO WITH FARMING

The last step in preparing your work to be printed is to crop it. Cropping is the method of removing part of the image; however, you must be careful to crop the photo so that it will fit the paper size you wish your final print to be.

A cropping ratio is a mathematical designation that compares the photograph's width to its height. Digital camera file ratios are all 4:3, which means that most prints you make should be cropped in some fashion.

The standard ratios are:

1:1 Length and width of the photo are equal, resulting in a square photograph.

2:3 One side is ²⁄₃ the measurement of the other. For example a 4 x 6 print is a 2:3 ratio, as is an 8 x 12.

4:5 This is a traditional format used by portrait photographers for many years. This is also the same ratio that an 8 × 10 is, so everything that you see on a 4 x 5 proof will be shown in an 8 × 10 final print.

5:7 This ratio is most often used for finished photographs to be printed as 5 x 7s.

Digital photograph files can be cropped within photo-editing software, or you can send your file directly to the lab; just hope it doesn't crop off an important element. —CWN

Photography Museums

TWO REMARKABLE REPOSITORIES

Widely considered one of the finest collections of photography in the country, The Nelson-Atkins Museum in Kansas City, Missouri, holds both a wealth of historical images and also features the work of top contemporary photographers. In 2006, the museum acquired one of the world's finest private collections of photographs, the Hallmark Collection—from Hallmark Cards chairman Donald J. Hall, Sr.—and in so doing, grew its own collection from just over a thousand pieces to more than 7,000.

The museum's collection always slanted toward the work of American artists, and now, as a result of the Hallmark acquisition, has pieces going back as far as 1839 with an extensive collection of early daguerreotypes.

The Museum of Modern Art (MoMA) in New York City first started to collect photographs in 1930 and, in 1940, set up its photography department. Photographer Edward Steichen was the initial curator of the museum's world-renowned collection of fine art photography.

The Museum owns 25,000 works and is considered one of the most important collections of modern and contemporary photography in the world. Over the years, MoMA has presented major exhibitions of work by nearly every prominent figure in the field as well as a number of group shows dedicated to a particular subject or style. Notably, MoMA includes not only the work of major artists in the field but that of amateurs, scientists, and journalists. —DJG

Sally Mann (1951–)

SUBLIME IMPERFECTION

Sally Mann's large, black and white photographs portray a variety of subjects, from her young children, to death and decay and Southern landscapes. Although she is a modern-day photographer, Mann chooses to work with the archaic wet-collodion process, which was introduced in the 1850s and requires a long exposure time (see page 259). The finished photographs contain a dreamy, eerie sensibility, often dusted with serendipitous streaks and imperfections.

A self-taught photographer, Mann's best-known work, titled *Immediate Family*, chronicled her young children swimming and playing nude at the family's remote summer cabin. The images generated both censure and praise from national newspapers and journals. Regardless of public opinion, Mann continued to shoot her family, including self-portraits and a six-year series of nudes of her husband, who has muscular dystrophy.

Mann has received three fellowships from the National Endowment for the Arts and a Guggenheim fellowship. Her work is included in the permanent collections of the Metropolitan Museum of Art, the Corcoran Gallery of Art, the Whitney Museum, and the San Francisco Museum of Modern Art. Her life has been the subject of two documentary films, *Blood Ties: The Life and Work of Sally Mann* and *What Remains*, both directed by Steven Cantor. —GC

The Insect World

ZOOMING DOWN TO THEIR LEVEL

As sophisticated as people are, with the belief that we are the superior species on this planet, there are creatures that just don't seem to care what we think of them. They display an alien appearance, with multiple appendages, and weird methods of mobility—buzzing around with impossibly tiny wings or with outsized, transparent sails.

Of course these aren't aliens at all—they're merely insects. Insects may look strange, but they make interesting, challenging photo subjects. To get a good, close-up image of an insect, it's advantageous to get within a few inches of them, which can be difficult. An easier way is to use a telephoto lens and snap away at a distance. A tripod isn't necessary if a lens with image stabilization is used. Wait for the insect to come to rest. With your camera set on Shutter Priority at the fastest shutter speed lighting conditions will allow, take the shot. If everything is done correctly, the picture will always be fascinating. —WTD

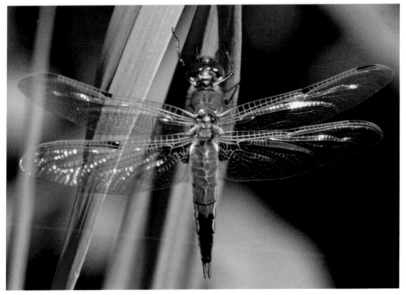

Photo © Bill Diller.

Eyes to the Soul

LOUISE LOMBARD, ACTRESS

If there was one of my portraits that I had to choose as an example of an image showing the sum of a subject's soul, it would have to be this one of Louise Lombard, shot on color transparency film and cross-processed to produce a contrasty negative with saturated color and muted skin tones.

To see this image printed life size and to gaze into Louise's transfixing eyes is to dive into the blue ocean of her soul—truly this is one of those portraits where the eyes stare back, relaxed and intense at the same time. Adding to her unblinking gaze is her subtle and enigmatic smile, which further draws you in and makes you ask yourself, "Are her eyes smiling too?" This image was exhibited and later acquired for the archives of the National Portrait Gallery in London. —SA

Photo © Simon Alexander.

Perspective

A LEAP OF FAITH

My goal was to create a unique photo that captured the essence of the Smuin Ballet for their marketing material. I had a several dancers perform their favorite moves with the San Francisco skyline in the background. Their jumps from the ground were not high enough to eclipse the skyline.

Then one of the dancers suggested jumping off a nearby picnic bench. He did a freestyle leap that provided enough clearance to make it feel as if he was jumping over the city. (No dancers were injured in the production of this image.) —TH

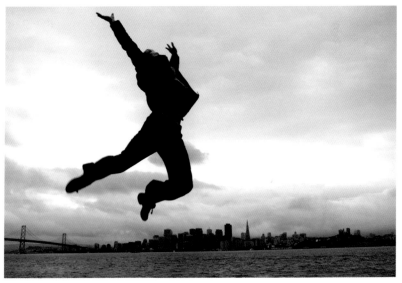

Photo © Tom Hauck.

Post-Production Effects

FILM GRAIN AND DESATURATING

Digital images captured in the RAW format can be edited for color balance, exposure, and contrast to enhance properly captured images or resolve problems in images that were not shot under ideal lighting conditions.

This image was first opened in Camera Raw in Photoshop and saved as a tiff. A duplicate layer was made for all retouching of the image, and it was edited in a film-grain plug-in that emulates all characteristics of classic film stocks. This tool is like a traditional film processing lab, allowing the user to control all aspects of grain, contrast, and density. This unifies the use of the clone stamp and healing brush, blanketing the image in a uniform grain pattern, and giving it more of an analog feel that digital images lack. A black and white adjustment layer is created, and the opacity is reduced to 20 percent to desaturate the entire image and condense the color palette. —MR

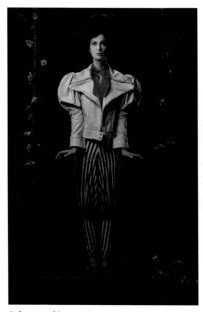 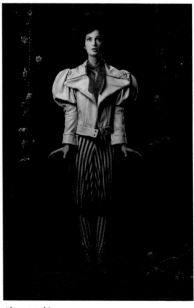

Before retouching.

Photos © Matthew Roharik.

After retouching.

Surreal Dreamscapes

PLUMBING THE DEPTHS OF THE SUBCONSCIOUS

"Listening to Irene, I lapsed into reverie. This dream of hers was pure gold, intellectual ambrosia—a gift from the gods."
—Irvin D. Yalom, M.D.[1]

Sigmund Freud once personified the human subconscious as an anthropomorphic "dream-weaver" who sat in a person's mind spinning yarns as they slept, enshrouding profound messages within an enigmatic tapestry of images and symbols.

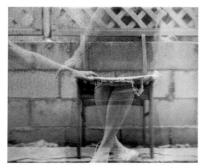

"Neither Here Nor There." Photo by Rachyel Puleo.

While the abstractions and dark mysteries of the dream world have influenced art since time immemorial, they have been given new life in the medium of surreal photography, as images are melded and distorted into visual depictions of the immaterial.

The late Francesca Woodman became famous for her haunting black and white photographs that often betrayed profound emotional angst in the form of female figures with obscured faces. Duane Michals examines the ever-present issues of death, human relationships, and grief with his compositions.

San Francisco photographer Rachyel Puleo draws heavily on images from her own dreams for inspiration. She describes the dream which inspired the ethereal piece, *Neither Here Nor There* (above): "I was talking to the people around me, but they couldn't see or hear me. It was like I was invisible, or dead…but I didn't know it." Her work *Feet on the Ground* (below), on the other hand, is a challenge to "examine your inner self—even the darker side of it." —DJS

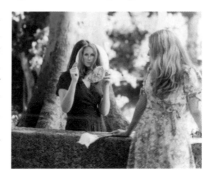

"Feet on the Ground." Photo by Rachyel Puleo.

Waning Gibbous

BY TED ROGER KARSON

On an autumn evening, this image of the moon, about 65 percent illuminated, was captured using an Olympus SP-590UZ. The photo is untouched SOOC (straight out of the camera), except for some cropping. It relies purely on the moon's natural texture and light for effect.

Ted Karson teaches "Extreme P&S Photography" as well as several other classes at a nearby college. His flickr site has had more than 500,000 views in the past two years. www.flickr.com/photos/tedsla

Quality of Life

THE DOCTOR VISIT

Conveying ideas and concepts requires photographers to place themselves into the action and movement of the topic. In order to convey the concept of quality of life, Dorothea Lange placed herself in an environment that caters to supporting it: health care. Documenting an actual visit to the doctor places the children in the appropriate environment to convey the concept. The actions of the doctor and nurse are obvious and recognizable to the audience. Environment and setting are important to creating a whole photograph, a photograph that speaks fully to the viewer.

Symmetry is an important component of this photograph's composition. It is used here to convey tradition and a highly developed level of order. The body and its health are based on systems of order. The work of the doctor and the nurse are based on a particular order that is repeated for every patient—the checking of vital signs, the testing of reflexes, the measurement of weight and height in relation to age. The doctor and nurse stand back to back, one's actions reflecting the other's. The doctor stands in the foreground, indicating a level of dominance and control. —MLR

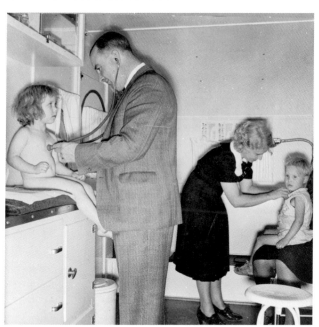

Doctor examining children in trailer clinic. Farm Security Administration mobile camp, Klamath County, Oregon, 1939; Library of Congress, Prints and Photographs Division.

Papers and Printing

PAPERWORK FOR ARTISTS

Now that you are ready to print your finished photographs, the next step is to determine where to have your photographs printed. Of course, a convenient option is to take your photographs on a memory stick down to your local one-hour photo lab. For special prints, however, consider a professional lab with state of the art equipment and a variety of professional archival papers, finishes, and mounting options.

Your first consideration is to decide what kind of paper you would like your photographs printed on. The two major manufacturers of photographic paper are Kodak and Fuji, both excellent options. Some labs also use Ilford paper for black and white prints. Ask the staff members for their recommendation and look at samples if possible.

In the past, the surface options available were limited to glossy and matte. Now there's something called metallic that is worth exploring, especially for photographs with deeply saturated color.

Many labs have begun to offer a variety of textured paper as well. Textured papers, such as linen or canvas, can add a richness and elegance to a photograph that is not found in a glossy or luster version. My favorite combination is a photograph printed on canvas paper with an ornate frame. The finished product is truly stunning. —CWN

Canon EOS

A STAR IS BORN

To compete with other leading manufactures in the new, extremely popular autofocus SLR market of the 1980s, Canon aimed to produce a camera unlike anything else. In 1987, the company introduced the EOS (for Electro-Optical System), named both for the technical specifications and for Eos (in Greek mythology, the goddess of dawn), symbolically announcing the arrival of a new generation of SLR cameras.

The EOS was the result of an exhaustive research and development process, during which several innovations and new technologies created by Canon were employed. The resulting camera had a highly sensitive focusing sensor, a high-precision ultrasonic motor, and a microcomputer to aid in super-high-speed calculations and control settings. Interestingly, Canon had lagged behind the other major camera-makers when it came to autofocus technology in the mid 1980s, but with the introduction of the EOS, they made up for lost ground, producing a picture-taking machine that found both widespread popularity with the public and high praise from professionals.

Building upon the high standard of technical ingenuity, Canon has continued to innovate and improve upon earlier models with each new camera or accessory they introduced, putting out faster, lighter, quieter, and more versatile products year after year. The EOS 10, for example, introduced a bar-code system where photographers could input data from a coded sample image and have the camera automatically adjust its settings to achieve the same effect as the sample. —DJG

Cindy Sherman (1954–)

QUEEN OF SELF-PORTRAITS

Fame came to Cindy Sherman early through her extraordinary body of work called *Untitled Film Stills*. This series of photographic falsifications, in which she plays the role of the ubiquitous B-movie actress in all her archetypal glory—as housewife, prostitute, dancer, and tearful woman in distress—was created with a diverse and incredible array of wigs, costumes, makeup, and props. Sherman first cast herself as starlet, director, set designer, and photographer in 1977.

Taking pictures of herself has proved to be quite lucrative—in 1999, the average selling price of one of Sherman's photographs was between $20,000 and $50,000[1]. And in 1999, the Museum of Modern Art in New York purchased the entire *Untitled Film Stills* collection for $1 million. She has received numerous awards, including American Academy of Arts & Sciences Award, the National Arts Award, and a MacArthur Fellowship, also known as the "genius award," which grants its recipient $500,000 and full creative license.

Sherman's more current projects include *Sex Pictures*, a series that uses dolls and prosthetic body parts grouped together in a suggestive manner. Critically acclaimed as both campy and powerful, it is yet another series in her ongoing examination of cultural trends and ideals. —GC

Out My Back Door

THERE'S SOMETHING OUT THERE

Life in an urban environment has definite advantages. The convenience of walking across the street to get a loaf of bread, or hopping in your car for a short drive to see a major sporting event, is undeniable.

But whether you're a small-town boy or girl, or a city dweller; whether you live in farm country or the backwoods, looking out the back door can yield marvelous photographs. Wildlife abounds in every backyard, and you can enjoy it immensely if you just keep your eyes open and your camera ready.

Perhaps Creedence Clearwater Revival had that in mind when they recorded *Lookin' Out My Back Door* four decades ago. —WTD

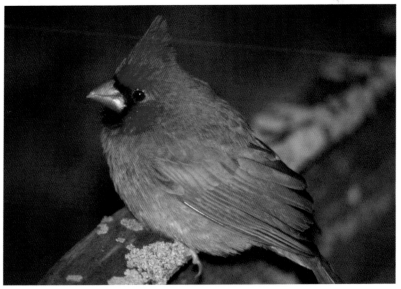

Photo © Bill Diller.

Inspired

ED KLEIN, AUTHOR

I received a commission to photograph Ed Klein, who is not only a bestselling author but also former editor in chief of *The New York Times Magazine*. I felt trepidation and inspiration all at once, and I wanted to make a commanding portrait.

Using a V-shaped background similar to Irving Penn's series of studio portraits, I chose a large softbox strobe light above the camera, instead of daylight from above. This background conveys the subject between two "walls," almost trapped yet completely relaxed. The final result is, as I had hoped, a strong and yet relaxed portrait of Ed, confined by his background but somehow not trapped at all.

I have been inspired many times by other photographers and then made the final image my own, hopefully leaving my own brand upon it. It's a wonderful process to see images old and new that inspire you to make new photographs. Sit with a good photography book and immerse yourself in it, soaking up all the visual stimuli and educating yourself as to what is possible if you set your mind to it. —SA

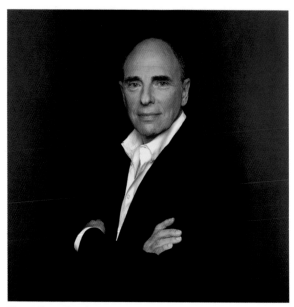

Photo © Simon Alexander.

Using a Motor Drive

WANT SOME GATORADE® WITH THAT?

One of the main objectives of action photography is capturing the quintessential moment. The use of a motor drive can help produce several usable images. A motor drive is an internal mechanism that quickly advances film and cocks the shutter for the next frame to be captured.

Here, the University of Alabama head coach Nick Saban is showered with Gatorade by players celebrating their 2010 BCS National Championship win. This composite image showing the progression of the liquid splash was created from three of nine images shot in a one-second burst. High-end, professional cameras can record up to 10 frames per second. —TH

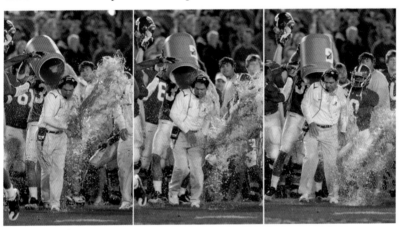

Photo © Tom Hauck.

Collaborating

TEAMING UP WITH A CLOTHING DESIGNER

Every city has up-and-coming and established designers who are in constant need of strong photographs to exhibit their creations. The garments are often one-of-a-kind and can bring a unique look to a fashion shoot. Review their collections and samples, and often the style of their design will inspire photographic concepts and editorial narratives.

Plan on what accessories will complement the clothing and the type of lighting that will do justice to their work. Inquire about the size of the garments. Most designers create clothes best suited for tall, slender runway models from sizes 0-4. In this photo, a model that was a finalist from the show *America's Next Top Model* fit the bill nicely. A fitting before the actual shoot is always suggested. It's very helpful if the designer is present at the shoot to collaborate in the process and to style the garments properly. —MR

This stunning image is a team effort from fashion designer Esther Myong Chung; model Dominique Reighard; hairstylist Bryan Beaver; and makeup artist Tim Maurer. Photo © Matthew Roharik.

Infrared Photography

SEEING WITH A SERPENT'S EYES

Countless Hollywood films and self-proclaimed television "ghost hunters" have introduced the image of green-colored "night vision" to the popular consciousness. Infrared photography, however, is much broader than simply seeing in the dark.

To be sure, infrared imagery is fully functional in pitch darkness. (Snakes have similar infrared sensors which allow them to see at night.) Infrared light covers a wide range of wavelengths, ranging from light that is closer to the wavelengths of visible light, known as "near infrared," to "far infrared," which is on the border of microwave frequency.

Rather than being reserved exclusively for nighttime use, however, infrared technology is also used to complement conventional photography. Infrared photographs are often taken in broad daylight, as they pick up details that are not always visible within the spectrum of visible light.

To the human eye, an object may blend with its background if both have the same colors and shading. A similar phenomenon occurs with infrared photography, known as "thermal crossover"—if an object has the exact same heat as its background, it can be "camouflaged" in an infrared photo. For this reason, an infrared photograph is often taken in tandem with a conventional image, allowing for a broader range of features to be seen.

In addition to its practical applications in a variety of scientific and professional fields, some artists, such as Italian photographer Elio Ciol, have employed infrared-sensitive film for purposes that are aesthetic rather than purely utilitarian. —DJS

St. Joseph's Church

BY SHANE MOSS

Ogden, Utah's St. Joseph's Catholic Church was built in 1899, when the railroad city was booming. Using only natural light from the stained glass windows and a long exposure with narrow aperture, this modern-day photo reflects its history. Aging techniques used include processing as sepia tone, adding texture to simulate scratches, and adding edges to the photo to simulate acid burn.

Shane Moss is a photographer, writer, and web designer living in Northern Utah. He specializes in architectural, landscape, and urban decay photography. www.rampantphotos.com

Wealth

PORTRAYING STATUS SYMBOLS

Illusion veils the true meaning of wealth. Often portrayed as a group of status symbols—cars, jewelry, property, clothing, fur—money appears to be a deciding factor of wealth in social and political context. The distribution of this financial prosperity and abundance causes wealth to become a social issue, often referred to as a social justice issue (fair and equitable treatment of all citizens). Social classes are defined by economics—who has the money and who does not.

Photographs of wealth capture elaborate displays of prosperity from weddings, to christenings, to personal events by culture—the quinceanera, the bar mitzvah—and the wearing of gold, a long-held status symbol. Color photography provides a visual experience when interacting with wealth—the glint of gold, the gleaming facets of gemstones, the liquid surface of a new vehicle. But the black and white photo will show the truth behind the glitz and block the shiny, glittering illusion. The black and white photo tells the story behind the wealth through the use of light. —MLR

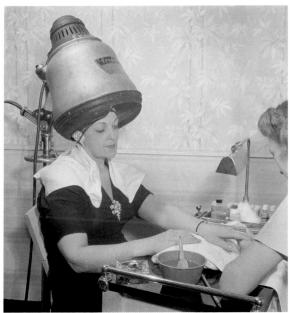

New York, New York. Getting a manicure while drying hair at Francois de Paris, a hairdresser on Eighth Street, 1942. Photo by Marjory Collins; courtesy Library of Congress Prints and Photographs Division.

Mounting

GETTING A BACKBONE

Mounting adds stability and a finished look to a print, especially if it's enlarged to 8 x 10 or greater. Before deciding on a mount type, you must decide if you are going to frame your photograph or not.

For framed photographs, a thinner mounting is the most practical and convenient. (Thicker mountings may keep the print from fitting properly in the frame.) The most common form is mat board, which is available in single or double weight. I recommend single weight for prints 11 x 14 and smaller, and double weight for larger print sizes. These thinner mounting substrates also work beautifully for displaying a print on an easel.

Some popular thicker mountings, specifically designed for photographs that are to remain unframed, are canvas gallery wraps and standouts. Gallery wrapped prints are printed on canvas and then secured across stretcher bars. The printed area wraps around the side of the canvas, eliminating the need for a frame. Standouts are photographs mounted on a heavy-duty foam board (like Gatorfoam), for a contemporary finished look.

As you explore your printing lab options, take note of their mounting selections. Most labs have a website with photographs of the types of mountings they offer and what types and sizes of photographs they are suitable for. —CWN

Photo © Christine Walsh-Newton.

Adobe Photoshop®

TRICKS OF THE TRADE

Image manipulation is nothing new; photo-trickery, airbrushing, and photo-compositing have been around for years. Still, the 1990 introduction of Adobe's revolutionary software program Photoshop and 20 years of new incarnations, innovations, and additional products have completely changed the way we produce and look at images.

The initial impact of Photoshop was primarily in the professional world, where not just photographers but everyone from graphic designers and advertising agencies to architects, engineers, and even doctors now had a tool that quickly let them accomplish tasks that, in the past, required hours and hours, not to mention tremendous skill with complicated processes.

Today, even though we see photoshopped images everywhere, from magazines and billboards to movies and even missing-children notices, the biggest impact might be in the nonprofessional world, where almost anyone with a home computer can create and manipulate images or even original art. Speaking in anticipation of Photoshop's 2010 20th anniversary, Adobe president and CEO Shantanu Narayen said, "Photoshop has played many different roles—it has given creative people the power to deliver amazing images that impact every part of our visual culture and challenged the eye with its ability to transform photographs. It's no exaggeration to say that…Photoshop has changed the way the world looks at itself."[1] –DJG

Robert Frank (1924–)

AN AMERICAN STATEMENT

In 1955, at the prompting of friend and fellow photographer Walker Evans, Robert Frank secured a Guggenheim grant to travel across America.[1] Over the next two years, Frank took over 28,000 shots, eventually edited into a book titled *The Americans*. It was a fresh yet skeptical view of American society, which the Swiss-born photographer found to be fast, lonely, and far too concerned with money.

Frank's distinctive photographic style, with its asymmetrical compositions and blurred edges was completely unconventional at the time. Some say it is the visual counterpart to the Beat culture, and Frank did have close ties with both Allen Ginsberg and Jack Kerouac. The book generated huge controversy, and was widely panned in photography magazines.

The bleakness of Frank's work is a pervading theme, which is not surprising, as he originally turned to photography for solace during the dark period of World War II. He emigrated to the United States in 1947, and was hired by *Harper's Bazaar*, but soon left to travel extensively, before returning to work for *McCall's, Vogue,* and *Fortune.*

After the publication of *The Americans,* he gave up photography to work in video, with one of his more infamous films chronicling the drug-fueled sexploits of the Rolling Stones. He returned to photography in the 1970s and now creates collage works that incorporate words and multiple frames of images that are intensely distorted and scratched. —GC

Back Lighting
SETTING FLOWERS ON FIRE

A photograph consists of three major parts; subject, composition, and exposure. Whatever you're taking a picture of is the subject. Composition refers to the relationship of elements in a scene and their position in that scene. A combination of how long and how wide the aperture of a camera is open determines how much light reaches the film plane or digital sensor, and that gives you the exposure.

Light reaching a film plane or sensor can be different from the overall lighting of a scene, which is accomplished by cropping or changing your position in relation to the light source. All other things being equal, it is lighting that determines the artistic value of a photograph.

Backlighting in bright sunlight can yield dramatic results. Here you have direct sunlight shining through a flower's petals, which makes them glow. Flowers are the perfect subject for backlighting, because the petal is thin enough for the light to filter through. If done correctly, it looks like the inside of the flower is on fire. —WTD

Photo © Bill Diller.

Painterly Lighting

POSSESSION: SNAKE

Before graduating from college, I had been on a long three-year search to find my final chosen specialist area of photography. This image is taken from my final award-winning degree show and made my mind up for me. It was exhibited with 19 other life-sized framed *Possession* portraits in England and Germany in 1992.

The whole series was inspired by the paintings of Rembrandt and utilizes a lighting style that is aptly named after him. After posting on-campus ads requesting subjects and their interesting possessions, I photographed over 100 people at half-hourly intervals over the course of a week, allowing myself one roll of film per sitter.

These classically beautiful portraits are timeless and represent my keen eye for detail and need for collaboration with my subject on pose and composition. It's not easy to see, but the snake, which was moving all the time during the shoot, has its tongue out, captured in a split-second exposure. It balances the pose of my subject and her hands as they hold her pet snake for my camera. —SA

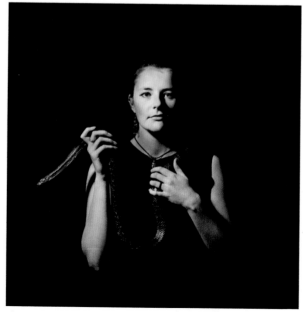

Photo © Simon Alexander.

Casting Shadows

GOING FOR DRAMA

Manipulating the direction and quality of light striking your subject can dramatically affect the results. In order to cast a shadow on the front of the subject and create a three-dimensional look, I placed light sources on each side and slightly behind the ballerina's legs.

When using this technique, you should attempt to only cast one main shadow on the ground. Too many shadows will give the image an unnatural feel. —TH

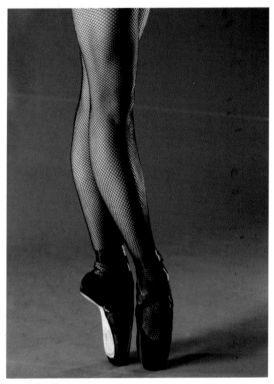

Photo © Tom Hauck.

Working with Water

SPLISH SPLASH

Working with water in a studio setting can be a wet and wild time! But it can also be a disaster if not well planned, so take precautions to keep electrical cords and lighting equipment away and out of contact with water. Keep in mind the model's comfort and have a heater that can fan air to keep her warm.

To achieve the softened look of shooting through a mist of water in this photograph, two assistants stood on each side with spray bottles. One stood near the model and the other a few feet closer to the lens to create a depth in the mist. Each sprayed the water upward to allow it to rain down. Four strobe lights without diffusion were aimed toward the model and camera to get the water to show up in the exposure. The whole set was sprayed prior to the shoot to saturate all of the branches and swing. A 22-inch beauty dish on a boom stand provides the key light, and 72-inch octagonal soft box is placed 12 feet away to provide a soft fill light. —MR

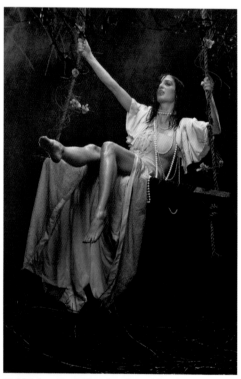

Model Kathryn Nova Williams keeps her cool through a wet photo shoot. Photo © Matthew Roharik.

Photographing the Invisible

NOW YOU DON'T SEE IT...NOW YOU DO

A certain mystique has always surrounded methods of photography, which allowed us to view what was previously invisible. In the early years of the X-ray, Dr. Duncan MacDougall theorized that the technology might even be used to see the departing spirit of dying patients (see page 125).[1]

We may not be able to see the human soul, but SODAR (Sonic Detection And Ranging) technology does allow scientists to visually depict and track the wind. Alternately, sonar and radar present us with alternate methods of seeing objects that cannot be photographed by traditional means.

Heat-based imagery, such as thermal imaging and infrared photography, cannot necessarily see through walls—such cameras typically photograph the waves that bounce off an opaque surface. Nonetheless, a person standing behind a wall or door may change the temperature of the adjacent surface, thus showing up as an irregularity on a thermal photograph.

Perhaps the closest that we come to truly seeing through walls occurs in the form of ultrasonography—the technology that allows doctors to take detailed photographs of a human fetus without ever invading the mother's uterus with a camera.

In fact, nearly every form of alternate imaging technology has only replicated the innate abilities that bats, insects, whales, dolphins, snakes, and fish have always possessed. For all of our technological "advancement," we may only be scratching the surface of what some of our fellow creatures are able to see. —DJS

For Molly
BY BROOKE SHADEN

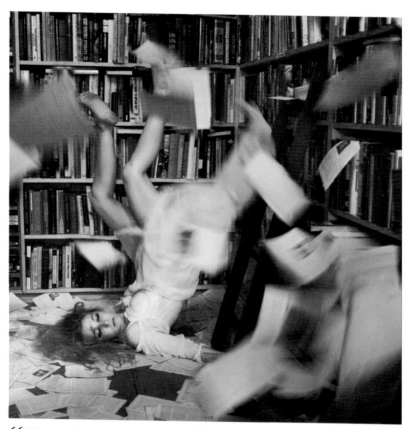

"For Molly" is a combination of two images. The first captured the motion of the papers, and the second established the position of the subject. The colors were altered to create a vintage look by skewing the black curve to a dark gray tone.

Brooke Shaden is a fine art photographer who began photography in December 2008 with a unique style of incorporating visual storytelling with surrealist elements. www.flickr.com/photos/brookeshaden

Child Labor

CAPTURING ITS ENORMITY

Perpetrators of child labor cover up or prevent the truth from being revealed. Capturing the truth can be dangerous and lead a photographer into unknown areas and countries. Although most countries have laws designed to prevent child labor, many do not enforce them. Children at work in places that are dangerous, working long hours every day, receiving low wages, with no opportunity to acquire schooling and without the concept of hope or a future are victims and a missing link in the community. Photographing their plight is a calling.

Photographs depicting child labor visually establish that the task being asked of the child is larger than the size and knowledge of the child. Capturing visual imbalance happens by using scale to portray the distortion—child against machine, child with a stack or pile of required work for the day, child mixed in with an adult population of workers. In doing so, the photograph conveys the enormity, the monumental crime of tying a child to adult burdens. Added to scale are the revelation of working conditions—cramped quarters, not enough light, dirty facilities. —MLR

"Boy Wanted" sign, West 19th Street, New York City, 1916. Photo by Lewis Wickes Hine; from the records of the National Child Labor Committee, Library of Congress Prints and Photographs Division.

Matting

A FRAME'S CLOSEST FRIEND

Matting is the process of adding a raised border around the print. It sits above the print but below the glass and framing. Standard sizes are 5 x 7, 8 x 10, 11 x 14, and 16 x 20. Larger and odd sizes will generally need to be custom ordered from your local framing and matting store.

Take your photograph with you to the store when shopping for your mat so that you may see what your photograph looks like against the color and size mat you are considering.

At first, you may be inclined to purchase a mat only one size larger than your print—for example, an 11 x 14 mat for an 8 x 10 photograph. Experiment with even larger-sized mats, perhaps even double matting your photograph so that two borders surround it.

An example of some common mat sizes and colors available in local craft, art supply, and photography stores.

You may have to try several different mats until you find the one that suits your photograph perfectly. If you are grouping several prints together, it may make sense to have the mats the same color in order to project a sense of harmony between the different prints. At times, you may prefer to coordinate the mat with a prominent color in the photograph. Review the color wheel (see page 278) to help you make decisions on what mat colors will help provide impact to your final presentation.

—CWN

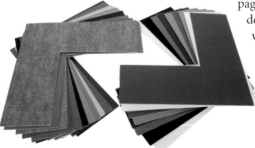

A collection of mat samples similar to what a custom-framing store will show you to help you decide which mat to order. In addition to special colors, there are also a variety of textured mats available, as seen on the left.

Digital Photography

OLDER THAN YOU THINK

While we tend to think of digital photography as a distinctly late-20th century innovation, its roots actually go back to the 1950s.

In 1957, Russell Kirsch, working for the U.S. government, created what today we would call a scanner and produced the first digital image by scanning a 5cm x 5cm photograph onto a computer. In the 1960s, NASA used digital signals to map the surface of the moon, and, in processing them later, essentially created digital-photography editing. Then came the "charged-coupled device" in 1969 (or CCD as it is commonly known), which gauges the color and intensity of light, a device that all digital cameras now have.

Advances continued through the '90s in both CCD image sensor technology (that could capture and encode visual information known as "pixels" digitally) and storage formats for the images once they were captured. By the mid '80s and early '90s, digital photography was becoming more and more possible, but costs were prohibitive and software was still in its infancy. In this era, the camera sensors were capable of picking up 600 to 720,000 pixels—cameras of today can record as much as 6 megapixels.

By the late '90s, the first affordable user-friendly models started to hit the market. By 2002, sales of digital cameras, with features that allowed photographers to store, edit, and email pictures using a home computer, surpassed sales of film cameras. —DJG

Robert Doisneau (1912-1994)

THE FRENCH KISS

Robert Doisneau's interest in people and the excitement of everyday life lead him to the streets and cafés of Paris, where he photographed an eclectic mix of people from all walks of life and social classes. In a career that spanned more than 60 years, his images of humanity and reportage captured the pulse of the times. His most famous image, *Kiss by the Hotel de Ville* (*Le baiser de l'hôtel de ville*), was taken on the fly, captured in one of many serendipitous moments he witnessed.

Doisneau was born in Gentilly, a suburb of Paris, and came from a creative family of craftsmen and artisans. He studied lithography in his teens before working in advertising at Atelier Ullman. He began work as a photographer in the 1930s, and became particularly interested in working with people when he was staff photographer for Renault in 1934.[1] His career came to a halt with the German occupation of Paris during World War II, but he continued to put his photographic and lithographic talents to use forging passports and documents for the French Resistance.

After the end of the war, he worked with the Rapho agency, and was sent on assignment throughout France, and sold his work internationally to publications, such as *LIFE* and *Vogue*. He achieved further international recognition after his work appeared in a group show at the Museum of Modern Art in New York in 1951. —GC

No Tripod? Find an Alternative

STEADY AS SHE GOES

It's a crisp, clear autumn day. The sun is getting low in the sky and shadows are deepening. You're driving home from work. Your stress level is up. It was a tough day. You need something to relieve the tension, when suddenly you remember you promised to take pictures of your neighbor's garden. You also realize it's getting dark, and your tripod is home—in the closet. Photographing that beautiful garden, with its lighted pond and waterfall, would be the perfect way to relax. It's time for improvisation.

In this case it should be easy—the landscaping around the pond and waterfall is lined with stones of varying sizes. The perfect alternate tripod.

You place the camera on a rock and stick a glove under one corner to align the shot. You set the aperture to f/22, which will provide significant depth of field. It also means a very slow shutter speed. The rock is a steady platform, the self-timer is set, and 30 seconds later you have a terrific shot. Instant stress relief! —WTD

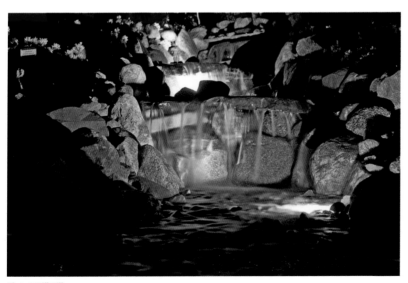

Photo © Bill Diller.

Use of Perspective

PETER TATE, ACTOR AND STAGE DIRECTOR

When making a portrait, there are many variables to consider and many choices to make. Depending on its final destination, your image should please your client while still exemplifying your best work, true to your style and chosen area of photography.

I had always wanted to use this classic location in upper Manhattan, under a bridge, which exudes depth and perspective easily while a tunnel of curved steel supports surround and frame the subject.

Peter Tate's intense gaze, casual position and clothing are balanced with his hat and the visual drama of the depth of the background and disappearing perspective behind him. The distant background is off-center and while it adds depth to the portrait, it does not dominate, as your eyes go first to Peter's face, his position and arms, to the car, and then off into the distance. I used available daylight from the right and a little fill-flash off camera to highlight Peter's face and to make sure his hat did not cast a shadow over his eyes. —SA

Photo © Simon Alexander.

Use of Light

A YOGA MOMENT

Take a picture in such a way that it emphasizes the point you are trying to make. During a photo session of a yoga instructor, I took advantage of a skylight in the building that provided diffused directional light. You get a sense of the deep concentration and tranquility of the subject, and her practice, from the fingers interlocking around her foot. The red yoga mat reflected the light in such a way that the photograph had an overall warm tone. —TH

Photo © Tom Hauck.

Shooting Lingerie

THE GLAMOROUS LIFE

Beautiful lingerie accentuates curves, forms the torso, lifts the bust, and provides an air of seduction. The style choice can direct attention to the desired parts of the body and conceal distracting parts (like tattoos). Stockings can add graphic appeal and save the photographer a lot of time in retouching all of the skin on the leg and knee areas. Vintage corsets can be found in antique dress shops and modern apparel in upscale retail stores. A fitting is recommended before the day of the shoot.

In this image, a classic three-piece set was chosen that complements beautifully the model's body type and skin tone. The cross stitching of the high-waisted garter elongates the torso.

The lighting was a combination of softboxes to the front and sides of the model. The camera was set on a tripod to accommodate a slow shutter speed of $\frac{1}{8}$ of a second at 400 ISO to allow the incandescent modeling lights in the soft boxes to add warmth to the image. —MR

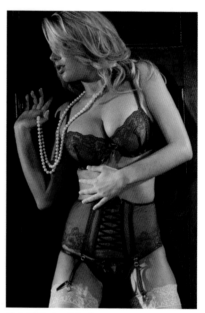

Photo © Matthew Roharik.

Urban Legends VI

DOCTORED PHOTOGRAPHS AS URBAN LORE

A fortuitous photographer snaps a shot of a great white shark leaping out of the ocean, about to chomp on a soldier dangling above the water's surface from a helicopter ladder.

A haunting image of the Devil, complete with horns and tail, appears in the smoke emerging from the Twin Towers during the September 11 terrorist attack.

A politician is caught on camera holding a book or telephone upside down.

These are just a few of the myriad urban legends that have been disseminated across cyberspace over the first decade of the 21st century. The ready availability of photo-editing software has contributed to this most recent permutation of the urban legend—stories supported by realistic visual illustrations.

Not all of these images were originally intended to be passed off as accurate photographs—some were lifted from the website Worth1000.com, which holds ongoing photo-editing contests. Others have obviously been created in jest, such as the depiction of George W. Bush wearing J.R.R. Tolkien's mythical "Ring of Power" while discussing the invasion of Iraq. Many of the doctored photos, however, are purported to be authentic by the spurious back-story that accompanies them.

Widely forwarded emails that rely on such "fauxtography"[1] present a different breed of urban legend: In contrast with the organic, gradual manner in which other tales have evolved, these legends were created by a conscious act of trickery. Indeed, it is possible that new developments in photographic technology may significantly alter the dynamics of contemporary folklore. —DJS

Motorway Mayhem

BY CHRIS AUSTERBERRY

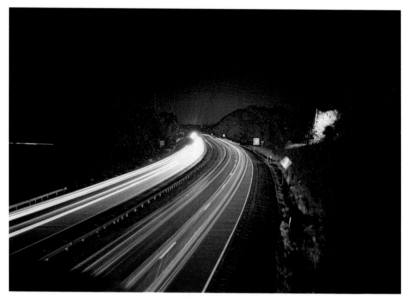

Long exposure times created the streams of head and taillights seen in this nighttime photo. The most important thing when taking long exposure images is keeping the camera extremely still. The posterization tool in Photoshop, along with some tone curve manipulations, was used to create the illusion of a textural oil painting.

Chris Austerberry, Jr. is a freelance photographer and writer near Philadelphia, Pennsylvania. Specializing in HDR techniques, he enjoys photographing his eclectic interests, especially motorsports. http://austerberry.zenfolio.com

Industry

CULTIVATING AN IMAGE

Photographs are a marketing tool used by industry to gain political power and eventually control public opinion. These photographs are used to portray an industry as being worthwhile, offering progress and ease. They also show industry as large, physically daunting, and too complex for the general population to understand much less keep track of. Once an industry employs a huge number of people and embeds its products into everyday life, it has the ability to sway political agendas. The gas, oil, and automobile industries are prime examples.

On the flip side are the startling revelations revealed by photographers documenting the actual practices of an industry, the results of daily routines like dumping chemical waste into rivers, releasing incinerated debris into the air, or the result of the disposal of computer hardware containing harmful metals. Photographers making these photographs are revealing conditions and instilling awareness into the psyche of a society. But is it too late to change the course of opinion? Can political power truly be stamped out and reassigned by these documentary photographs? —MLR

Sawmill at the Greensboro Lumber Co., Greensboro, Georgia, 1941. Photo courtesy Library of Congress Prints and Photographs Division.

Framing

THIS TIME, BEING FRAMED IS A GOOD THING!

Framing is one of the secrets to making your prints look sensational. For a long time, I didn't frame the photographs that hang in my own studio. I had them mounted on substrates that added a finished edge and allowed them to be hung on the wall with no distraction. But once I discovered the finished look that framing adds to a print, I never hung another without having it framed.

The photograph or your own sense of style will often dictate the style of frame. You may also base your decision on the furniture and décor in the room. You will want to consider whether your print will hang in groups, and make your frame choice accordingly.

Standard-size frames up to 16 x 20 are generally available in local stores, but for a truly custom look, you should become familiar with your local framing gallery. If there is not one near you or you want a more affordable option, online retailers offer a wide selection of frames in custom sizes. Be aware that some

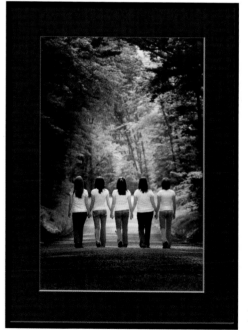

of these frames are delivered unassembled; frames that require assembly are generally referred to as kits and may require a screwdriver or an Allen wrench. —CWN

Since a mat in a coordinating color to the photograph was chosen, a simple black frame keeps the focus on the greens. Photo © Christine Walsh-Newton.

Camera Phone

TALK AND SHOOT AT THE SAME TIME

A nearly ubiquitous piece of technology in much of the world, a camera phone is a cellular phone, which has a built-in device that can capture still photographs and, in some models, video. Camera phones generally have fixed focal lengths, perform badly in low-light situations, can have a long shutter lag, and, unlike digital cameras, usually do not have a USB connection or removable memory card. Yet, with over 2 billion cell phones in use, they are an immensely popular feature.

If there is one major advantage of camera phones over digital cameras, it is the ability to shoot a picture, save it as a jpeg file, and instantly upload and share photographs on the Internet, as opposed to connecting the camera to a computer, downloading images, and then uploading them.

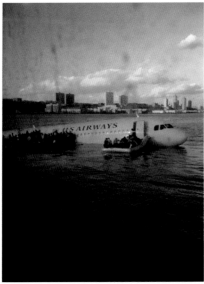

"There's a plane in the Hudson!" Janis Krums took this famous photo of USAir flight 1549 with his cell phone camera before any news crew. Photo © Janis Krums.

The camera phone and its potential was first realized in 1997 when, using a device he designed, Philippe Kahn photographed his newborn daughter in the hospital and, within minutes, had distributed the image worldwide to over 1,000 of his friends and family members. A variety of companies actively pursued development of the technology that would make camera phones possible.

More than a novel way to share snapshots, the camera phone has developed into an increasingly important part of the way we experience the world, with images of breaking news taken by average citizens showing up on TV, the Internet, and in periodicals. —DJG

Yousuf Karsh (1908-2002)

NATURAL-BORN SHOOTER

"Karsh of Ottowa," as he was widely known, traveled the world, photographing political and military leaders, as well as celebrated artists, writers, and entertainers. A master of the carefully composed, dramatically lit, formal studio portrait, Yousuf Karsh worked with an 8 x 10-view camera and employed the lighting techniques he had learned during his membership in a theater group, often using a battery of lights and lighting the subject's hands separately.[1] He became such an acclaimed photographer that he had access to every prominent figure of his time.

Born in Turkey, Karsh was sent by his parents to Canada to live with his uncle, a studio portrait photographer who recognized his nephew's potential and gave him basic training before sending him to Boston to study with John H. Garo. After a three-year apprenticeship in Boston, Karsh returned and opened his own studio in Ottawa. His fate took a dramatic upswing when he was given two minutes to create a portrait of Winston Churchill, the result of which has been said to be the most widely reproduced portrait in photographic history.

His work is included in the permanent collections of the Metropolitan Museum of Art, the National Museum of Modern Art in Tokyo, the Museum of Modern Art in New York, and the National Portrait Gallery in London. —GC

The Digital Revolution

TECHNOLOGY THAT'S GOOD FOR NATURE

With the advent of digital technology, nature photography has undergone a revolution. Being able to control the entire process from snapping the shutter to printing an image is within reach of anyone.

A digital camera allows nature photographers to experiment, like with this shot of daisies at sunrise, which was taken using on-camera flash to illuminate the underside of the flowers. The daisy picture looked fairly good in the LCD monitor, but there was room for improvement. Unfortunately, the background light changed immediately and dramatically, so there was no opportunity to capture another image. So I enhanced it, using basic features, such as Shadows and Highlights, Brightness and Contrast, Color Variations, and Unsharp Mask. Chalk up another success story for the digital revolution. —WTD

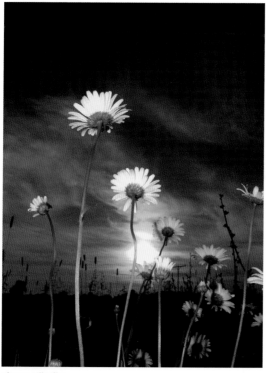

Photo © Bill Diller.

Optical Illusion

BARRY FISHMAN, TAI CHI CHUAN MASTER

After being commissioned to photograph Barry in a variety of Tai Chi Chuan positions for his teaching needs and publicity purposes, I asked if we might try some portraits, too, as he was so striking looking. He has often been compared visually to Einstein, but he has a unique presence all his own.

This image was the result of a two-hour session, where we decided to have him hold his own head and effect a floating feeling, as if he might be trying to stop his own head from flying away out of the frame. The illusion created here is achieved by darkening the black sleeves and shirt he was wearing to then disappear into the same tone as the background. This was initially achieved by printing the cross-processed transparency negative and burning in the clothing, with additional exposure to the print in the color darkroom.

The use of the daylight darkroom known as Photoshop and other software by Adobe has revolutionized the way we use our imagination by allowing many effects to be produced and edited easily in digital layers. What previously took days and multiple processes, including often-hazardous chemicals and solutions, now takes minutes on a computer. —SA

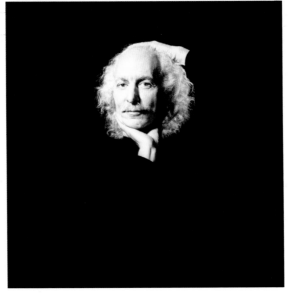

Photo © Simon Alexander.

Anticipation

QUIET BEFORE THE STORM

The fog billowing out from the dimly lit tunnel—a giant inflated football helmet—creates a moody moment as shadowy figures wait to run out on the field before the San Francisco 49ers playoff game against the New York Giants. It is a silent, motionless juxtaposition to the screaming fans and fireworks outside. —TH

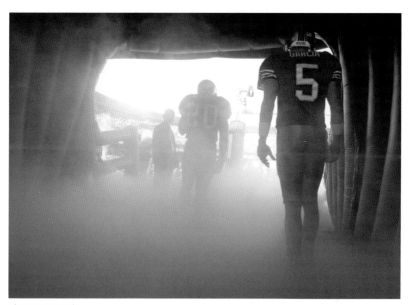

Photo © Tom Hauck.

Natural Lighting and Beauty
A BIT OF OBSCURITY IS A GOOD THING

The model was seated in a tree and the camera was approximately 20 feet away, with branches in the foreground 10 feet from the lens. The soft overall quality of the image was created by shooting though the foliage with a 200mm lens at aperture 2.8 and the ISO 200 at 160/seconds.

Allowing just the right amount of branches to obscure the lens is key. Too much, and the subject will have a gray cast. The exposure was metered for the model's skin tones and an on-camera flash provided fill flash for the face. —MR

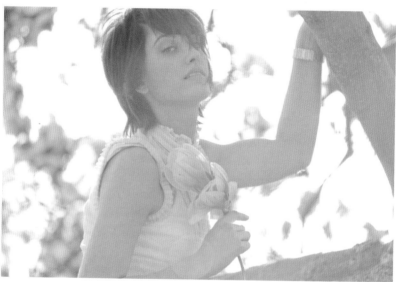

Photo © Matthew Roharik.

The Kaleidoscopes of Ryo Ohwada

PATTERNS FROM CHAOS

As a child, I remember reading a book with a series of dioramas that recreated the Seven Wonders of the Ancient World. There was something warm and comforting in these miniature environments, which, while they represented the hustle and bustle of ancient life, were safely contained within a few inches of space.

A similar feeling is evoked by the simulated structure of Ryo Ohwada's kaleidoscopic photographs. Many of the images are created from outdoor panoramic photos and cityscapes. While the reality behind these photographs is full to the brim with unpredictable elements—disease, flora and fauna, constantly changing sights and sounds—Ohwada has taken an image and safely wrapped it in an encasement of itself. Order is imposed onto chaos. What was once a crazy quilt of asymmetric natural growth has been clamped down into neat, matching patterns within the confines of this visual kaleidoscope.

Even shots that were taken outdoors no longer appear to belong to the anarchy of the forest. The wild, indomitable features of the wilderness, the savage insects and creeping vines and moss and grass, have all been locked into a soft, warm box.

The fireflies have been swept out of the air and into a glass jar, forever contained, forever contemplated in comfort. —DJS

Photos © Ryo Ohwada.

Alone

BY RICK SZCZECHOWSKI

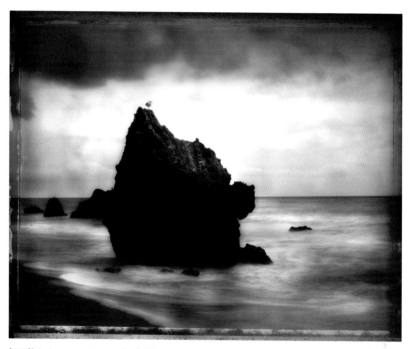

This image was made with a 4 x 5 camera, using a type 55 positive/negative Polaroid that was not processed until much later in the day. After processing, the black and white negative was placed on a scanner, gooey side down. The result is the sloppy border effect. The image was taken with a very long (30-second) exposure and was manipulated in Photoshop using curves, layers, gradation, and just a smidgen of noise.

Los Angeles-based Rick Szczechowski is a commercial photographer. He is particularly interested in the art of polymer photogravures. His can be seen at Island Weiss Gallery in New York City and at Hunsaker/Schlesinger Fine Art in Santa Monica.

Health Care

DOCUMENTING ILLNESS AND ITS CAUSES

The health of an individual is a complex story that includes emotional, mental, and spiritual components as well as the obvious physical requirements. Health and its deterioration has a timeline associated with it. Approach the subject of health care by building a portfolio of images reflecting the complexity of the chosen illness and its causes. Illness comes with symptoms, symptoms come with causes, causes are rooted in lack of information. Investigate how the issue manifests, the conditions in which it flourishes, the people behind the disease, the way in which it is treated, addressed, communicated, or misunderstood.

Health care has a trickle-down effect—one generation passes information onto the next. Consider generations of health-care patterns and symptoms. Approach health care from the inside of the social body—the community. Compare communities, lore, and solutions. Follow health-care research and the process of defining a worthy health-care cause to explore. Photograph an undiluted and direct story to receive the largest impact from exploring the topic. —MLR

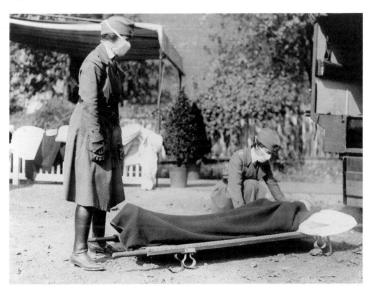

Demonstration at the Red Cross Emergency Ambulance Station in Washington, D.C., during the influenza pandemic of 1918. National Photo Company Collection, Library of Congress Prints and Photographs Division.

PHOTO
101

DAY 351

PHOTOGRAPHY 101

Creative Projects for Digital Photographs

LET LOOSE YOUR IMAGINATION

Imagine the look on the face of great-grandma as she opens a gift from you to find a sweet portrait of her grandchildren, captured by you and printed on a blanket.

There are many companies offering items personalized with photographs supplied by their customers. These online photo-sharing sites provide nearly limitless potential for ways to display your photographs, either for personal enjoyment or for gift-giving. Since becoming a photographer, my family and friends have been the grateful recipients of many photography-themed gifts for birthdays and holidays.

The basic offerings of these companies are prints, from wallet-sized to poster-sized. In addition to prints, they also offer photo books, calendars, novelty items, including photo mugs, mouse pads, playing cards, puzzles, and T-shirts. Several offer jewelry items—watches, bracelets, earrings, and dog tags—and I've even discovered a few that offer purses, wallets, tote bags, and pillows. The options seem to be endless. I recommend that when trying one of these companies, order a small, inexpensive item first to determine if the quality level is acceptable before placing a larger order.

An added bonus is that most of these companies allow you to store your photographs online in galleries and then share the galleries with friends and family, giving them the ability to purchase photo prints and gifts of their own.
—CWN

Photo books created with wedding photographs and printed by an online company.
Photo © Christine Walsh-Newton.

Autofocus

CLEARLY A TURNING POINT IN PHOTOGRAPHY

Before the advent of automatic focus in the early 1980s, photographers relied on their eye, hand, and a bit of math to manually bring their subject into clear view. Even now, with sophisticated autofocus cameras offering both ease of use and flexibility, the debate of autofocus vs. manual focus rages on.

Regardless, autofocus was a significant turning point in photography. Major camera makers like Canon, Pentax, and Chinon offered models in the late 70s and early 80s that could provide automatic focus using a special motorized lens. But it was Minolta that in 1985 "rocked the entire photographic community" with its Maxxum series featuring autofocus capabilities built directly into the camera body.[1]

Today autofocus is nearly ubiquitous on all SLR and compact digital cameras. The technology relies on image contrast to select a focal point—the more contrast there is, the more likely the camera will provide maximum focus on that point. In fact, more than the technology itself there are three factors that deeply impact proper focus: light level, subject contrast, and camera or subject motion.[2]

Many photographers, both amateur and professional, still use manual focus over auto focus, relying on their own artistic judgment—especially in the fields of macro and portrait photography. —DJG

David "Chim" Seymour (1911–1956)

ALTRUISTIC PHOTOJOURNALIST

Known as "Chim" because his Polish surname, Syzmin, was difficult to pronounce, David Seymour was a photojournalist who covered wars and their aftermaths from the 1930s to the 1950s. Born in Warsaw, he became interested in photography while studying in Paris, and began working as a photojournalist in 1933, documenting the plight of the French working class, from coal miners to gun-makers. He was known for his compassion for and treatment of human suffering, especially that of orphaned children, the refugees of the many wars he documented.

Seymour worked with a Leica, a camera that allowed him a high level of mobility and anonymity, and was favored by his photographic colleague Henri Cartier-Bresson, with whom (along with Robert Capa and George Rodger) he founded the world-famous Magnum Photos, a photographic cooperative now in its sixth decade of existence (see page 269).

Seymour enlisted in the U.S. Army in 1940 and served in Europe as a photographic interpreter during World War II. He later became a naturalized U.S. citizen. He also covered the Spanish Civil War, demonstrations by French workers in the 1930s, and struggles in Greece, Poland, Italy, and Israel. He became president of Magnum Photos after Robert Capa's death in 1954, until his own life was ended suddenly in Egypt during the Suez crisis of 1956, when he and fellow photographer Jean Roy were caught in machine-gun fire. —GC

Be Prepared
THE RIGHT PLACE AT THE RIGHT TIME

The old Boy Scouts' motto, "Be Prepared," is a valuable phrase to remember. It's useful in all manner of situations, including nature photography. Having your camera with you and ready to shoot is one way to be prepared.

While driving, it's an easy matter to have your camera where you can get to it rapidly. Carrying it on the seat beside you, in a case or covered with a cloth so it doesn't get dusty, means it will be available at a moment's notice. That way, if you happen to be in just the right place at just the right time, that memorable shot is yours for the taking.

This shot of a rooster pheasant was taken that way—on the fly, so to speak. The bird was huddled in a bush adjacent to the driveway. Although it was camouflaged by its surroundings, the rooster's colorful plumage made it noticeable.

Training your eye to be aware of anything out of the ordinary, and keeping the camera close at hand, could prove to be the difference between capturing the shot or telling your friends about the rooster that got away. —WTD

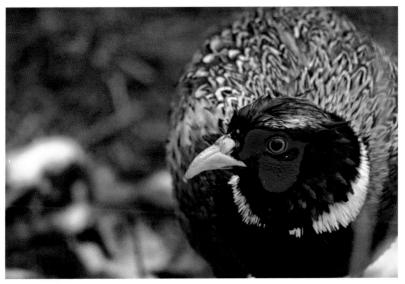

Photo © Bill Diller.

Spiritual

MARTY PINNECOOSE, NATIVE AMERICAN DANCER

Having been interested in the plight of Native Americans in North America, even before moving to the U.S. and becoming a citizen, I was delighted and honored to receive a commission by Peter Buffett to produce publicity photography for a show he created, called *Spirit – The Seventh Fire*. The show was finishing rehearsals for a tour across America, culminating in a performance on the Mall in Washington in conjunction with the opening of the brand-new Smithsonian National Museum of the American Indian.

During the several days that I photographed, I felt compelled to do justice to the strong, gifted, and proud group of people who brought the show to life. Marty Pinnecoose was one of the key dancers and a driving force behind much of the choreography by Jody Ripplinger. He is featured here in a simple yet dramatic backstage portrait that captures his essence and spirit. We had some good conversations before, during, and after the shows, which shed light on his strength and convictions in life. —SA

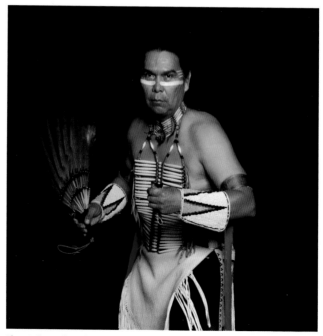

Photo © Simon Alexander.

Peace Out

KEEP SHOOTING TIL THE CAMERA DIES

I was in Japan covering Major League Baseball's opening-day game between the New York Yankees and the Tampa Bay Devil Rays. After shooting the game, I wandered about Tokyo trying to capture a scene unique to the culture. I photographed for a few hours and just as my camera battery was running very low and I was out of time, I stumbled on some families exiting a ceremony wearing very ornate clothing. I took the photo of the child giving me the peace sign just as my camera battery died. I barely made it to the airport in time for my flight home, but it was well worth the risk. I have always affectionately called this photo "Peace Out." —TH

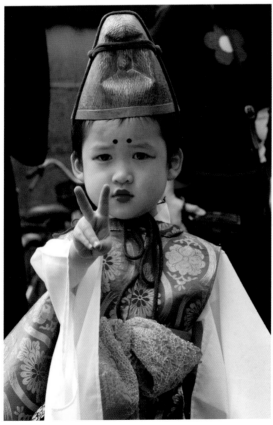

Photo © Tom Hauck.

Your Book, Your Future

THE PORTFOLIO BOOK PRESENTATION

Despite our presence in the digital age, a print book still stands supreme. In addition to a website, a well-executed presentation in book form is a must for all photographers. A book consisting of prints from a lab or photo printer is more true to color, detail, and density than images online since most screens display at 72 dpi.

The art buyers and photo editors who work in print media value printed photographs in a book that one can hold and experience. Traditional books that display images in separate pages allow for the switching and updating of your book. This is the best format for beginning photographers. One-off print books have become affordable and offer high quality, with various size options and bindings.

Go with the biggest presentation size that best fits your needs. If you want something handy to travel with and less expensive to send out in the mail, an 8 x 10-inch book is an appropriate choice, whereas 11 x 14 inches is typically the large end of the spectrum.

Resist the urge to fill up a book just to make it thicker. Ideally, 30 images should illustrate your unique style and comprise a standard professional portfolio. As a novice, set your goal at 20 images so you can start getting feedback and in the habit of talking about your work.

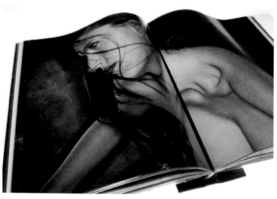

Photo © Roharik Productions.

A book should represent the personal style of a photographer without the presentation competing with the images. You only have one chance for a good first impression so make it count. —MR

Remembering the Revolution

PINHOLE CAMERA MEETS DIGITAL TECHNOLOGY

A heavy cloud of patina surrounds the culture of the Mexican Revolution. Songs from the period between 1910 and 1920, revolutionary *corridos*, *rancheras*, and *sones*, continue to stir nostalgic sentiments years after most of the war's contemporaries have passed on.

Having occurred only 100 years ago, the Mexican Revolution was one of the world's first armed insurrections to be widely photographed and even filmed. American director Christy Cabanne signed a contract with Francisco "Pancho" Villa to record his troops in battle; the revolutionary commander reportedly promised to schedule his fighting for times when the daylight was optimal for filming.

In commemoration of the centennial anniversary of the Revolution, Mexico City photographer Arturo Betancourt has created a series of images that replicate the style from this historical period, developing a fusion of the primitive pinhole camera with modern digital technology.

Betancourt uses the sensor from a digital camera held within a chamber; in lieu of lenses, an aluminum can with a 3mm-wide perforation is used. (The size of the hole determines the resolution of the photograph.) The image is captured using the principle of "physical optic projection."

Titled *Reminiscences of the Revolutionary Past*, the exposition features a series of photographs depicting the streets, parks and monuments in modern-day Mexico, which have been dedicated to the heroes of the Revolutionary War. A century later, they remain indelibly branded onto the national consciousness.
—DJS

Reminiscencias de un Pasado Revolucionario. *Technique: pinhole, 2009–2010. Photographs by Arturo Betancourt.*

The Hunt

BY BROOKE SHADEN

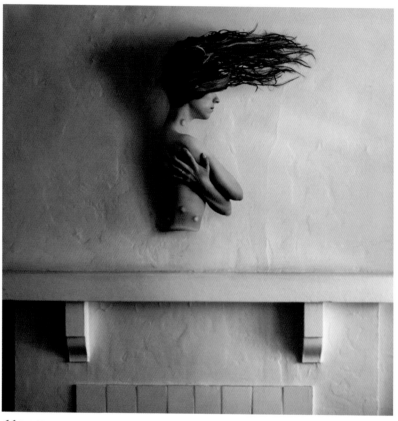

"The Hunt" was created with the idea of turning the human form into a representation of the things we hunt. The image consists of two photographs to turn the frame into a square. Only the torso appears in the image by using layering, combined with dodging and burning.

Brooke Shaden is a fine art photographer who began photography in December 2008 with a unique style of incorporating visual storytelling with surrealist elements.

Community

CIRCLING THE TRUTH

Community indicates a group connection via a common bond—shared ideas and goals, same characteristics, common social, economic, or political interests. Community knows no size limits, it can encompass people on different continents, in a variety of states or different sides of the street. Symbols that indicate a continuous connection are often used to identify community—the circle, the hand, the spiderweb, the eternal knot. In its most basic sense community is a supporting structure as in the palm of the hand supporting the individual fingers.

Social documentary and portrait photographer Susan Braun warmly shows community as a place of sharing and nurturing in her series *Cooking with Marion*. The act of cooking, the steaming bowls of freshly cooked food, and the round pots simmering over an open flame serve to comment on the pleasures of community and the sharing of food as a communal ritual. Reflected in Braun's work are the circle, the hand, and the web of creativity infused into the sustenance Marion provides—a welcome reflection of the beauty of community. —MLR

Men of the community of Pie Town, New Mexico, eating at the barbeque, 1940. Photo by Russell Lee; courtesy Library of Congress Prints and Photographs Division.

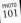
For Further Study

YOU'VE ONLY JUST BEGUN

To further your quest for knowledge, look into photography courses at your local college or adult education center. If you are not located near a college or night school and desire to learn photography through online courses, check out www.betterphoto.com. The website contains informative articles, and they also offer four- and eight-week courses taught by professionals in the industry. Each week's lesson is provided in document format and contains examples of the results desired. There are also assignments to be completed on a weekly basis and a private website classroom where you may leave messages for the instructor or communicate with other classmates. At the end of the course, you will receive a certificate of completion.

Several books worth reading:

One of the first photography books I received still sits on my bookshelf. *John Hedgecoe's Complete Photography Course* is no longer in print, but used copies can be obtained online. Hedgecoe also wrote a number of other books on photography that are in lesson and project format.

My current photography "bible" is *Photography* by Barbara London, John Upton, and Jim Stone. This is the resource used in most college introductory photography courses and is very technically written.

For Adobe Photoshop enthusiasts, anything by Scott Kelby is an excellent resource. From introductory texts to volumes about specific special effects, he is a master on the subject. —CWN

Kodak Goes Digital

COLOR FILM FOR SALE—CHEAP!

After years of declining sales, in 2004 industry giant Kodak announced that they were dramatically reducing their line of 35mm products in response to the rise of digital technology. The company ceased production of the APS (Advanced Photo System) line of 35mm cameras that they introduced in 1996. While, they also announced plans to stop distributing reloadable 35mm cameras to the United States, Canada, and Western Europe (though the popular 35mm disposable cameras would stay on the market), they did not completely abandon the 35mm format. In fact, they decided to increase production of film and cameras for emerging markets in China, India, Eastern Europe, and Latin America where sales were actually growing by double digits at the time of the announcement.

In 2009, the company did the once un-
thinkable, and retired Kodachrome,
the world's first commercially suc-
cessful color film and a staple of
their business for 74 years
(see page 159). After de-
veloping a reputation
as the film of choice
for top photojour-
nalists, peaking in
overall sales and pop-
ularity during the 1950s and '60s, but in
the early 21st century, it represented less
than 1 percent of the company's total sales of
still-picture films. The message was clear: Digital rules, at
least until the next technology rolls around. —DJG

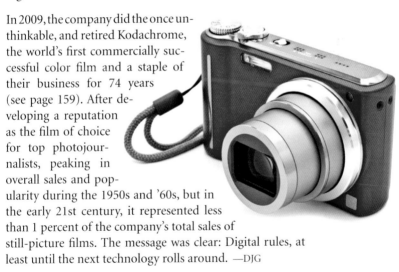

Robert Mapplethorpe (1946–1989)

OF BLOOMS AND BONDAGE

It's difficult to say which of Robert Mapplethorpe's images are more sugges-
tive; the curling tendrils and projectile stamens of his floral images or the
frank, homoerotic studies created during his fascination with the S&M com-
munity in New York City in the late 1970s. Either way, he had the remarkable
ability to find a common denominator between the two and portrayed the
subjects in a simple and technically masterful way.

Mapplethorpe was known for using unusual technical processes, such as
Cibachrome prints (a type of color print on a special paper that gives the
finished photo a metallic sheen), dye transfer, and platinum prints. But he
was also well-known for his celebrity studio portraits of Richard Gere, Grace
Jones, Philip Glass, and Andy Warhol, and his two favorite subjects: himself
and singer/poet Patti Smith.

Mapplethorpe's relationship with Smith began before his rise to fame, when
the two were lovers living at the Chelsea Hotel.[1] At the time, Mapplethorpe
was photographing primarily with a Polaroid camera, and soon had his first
solo exhibit, aptly named "Polaroid" at the Light Gallery in New York. A Map-
plethorpe photo was the cover art for Smith's album, *Horses,* the first of many
cover-album collaborations he had with a variety of musicians.

Calla lilies, vibrant poppies, nude-figure studies, and graphic bondage were
all given equal treatment as subjects of fine art, proving that Mapplethorpe
was a master photographer in the entirety of man, myth, and legend. —GC

Changing Perspective
THERE'S ALWAYS MORE THAN ONE WAY TO LOOK AT IT

Relationships are built on the association of one thing to another and come in many forms: a parent to a child, a wife to a husband, an employer to an employee, or a student to a teacher. Inanimate objects can also have a relationship: a leaf to a tree, a nail to a board, or ink to paper. It all depends on how you look at it. It all depends on your perspective.

Applying that to photography, perspective has a distinctive meaning—the relationship of one subject to another. Two objects, such as a flower and the setting sun, can show a significant change in perspective, depending on what lens you use.

When photographed close up with a wide angle lens, the flower will be significantly larger than the sun. A shot taken from the same angle with a telephoto lens, keeping the flower in the same position in the frame, will compress the scene, causing the sun to appear much larger. The longer the lens, the more the compression. —WTD

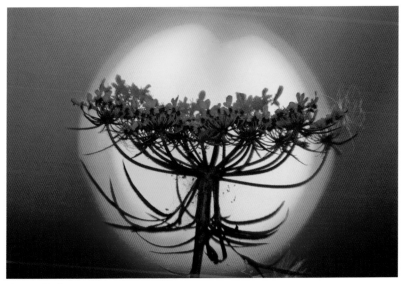

Photo © Bill Diller.

Interior Location

MICHAEL GRAVES, ARCHITECT AND DESIGNER

Meeting and photographing Michael Graves was in itself an honor and pleasure—a commission to make images that would appear on a front cover of a magazine was an added bonus. This image was shot in his house in Princeton, New Jersey, where he created a museum of sorts and homage to the concept of the "Grand Tour," showing off antiques and *objets d'art* that he had collected on his trips to Europe.

The challenge in this portrait was to allow enough space for the magazine's cover logo and feature lines as well as lighting Michael and the background with the right balance of color and contrast. In reality, this was a tight space to shoot in and did not allow enough space to set up many lights, so I bounced two small strobe lights off walls into the room and used a medium soft box as my key light for the portrait. The tulips were a colorful addition to the foreground table and later were sampled as a color of the cover's logo and font.

This was a very successful shoot and a good example of making a location work for you as a background for a location shoot and portrait setting. —SA

Photo © Simon Alexander.

SOURCES CITED

Page 8
1. IT Facts. "20% of digital camera owners exercise their artistic skills." May 30, 2007. http://www.itfacts.biz/20-of-digital-camera-owners-exercise-their-artistic-skills/8545 (accessed May 2010)

Page 15
1. Giz Mag. "The world's smallest camera." http://www.gizmag.com/go/7823/ (accessed March 2010)

2. Engadget. "Smallest Camera Wants to Meet Your Innards." http://www.engadget.com/2006/06/23/worlds-smallest-camera-wants-to-meet-your-innards/ (accessed March 2010)

3. *Guinness World Records 2010: The Book of the Decade.* Guinness World Records, 191.

Page 18
1. Merriam-Webster Online Dictionary. "Photograph." http://www.merriam-webster.com/dictionary/photograph (accessed May 2010)

2. Merriam-Webster Online Dictionary. "Photography." http://www.merriam-webster.com/dictionary/photography (accessed May 2010)

Page 20
1. The New York Times. Bellafante, Ginia. "Herb Ritts, Photographer of Celebrities, is Dead at 50." December 27, 2002. http://www.nytimes.com/2002/12/27/us/herb-ritts-photographer-of-celebrities-is-dead-at-50.html?Pagewanted=1 (accessed January 2010)

Page 25
1. Hemmy. "Kids Drawing Reenacted Using Professional Photography." http://www.hemmy.net/2008/03/12/kids-drawing-reenacted-using-professional-photography/ (accessed March 2010)

Page 27
1. Library of Congress. "The Most Famous Poster." http://www.loc.gov/exhibits/treasures/trm015.html (accessed February 2010)

Page 45
1. Whitehot Magazine. "Joe Heaps Nelson interviews Spencer Tunick." March 2009. http://whitehotmagazine.com/index.php?action=articles&wh_article_id=1786. (accessed February 2010)

2. La Jornada. "México muestra cómo un país puede ser libre: Spencer Tunick." May 7, 2007. http://www.jornada.unam.mx/2007/05/07/index.php?section=cultura&article=a02n1cul (accessed February 2010)

Page 50
1. Anne Geddes. "Anne:Biography." http://www.annegeddes.com/modules/anne/Biography.aspx (accessed December 2009)

Page 55
1. Snopes. "Tents Situation." http://www.snopes.com/photos/animals/beartent.asp (accessed December 2009)

2. Snopes. "Bull Shot." http://www.snopes.com/photos/animals/bullshot.asp (accessed December 2009)

Page 65
1. Eaton, Jim. *Ghosts Caught on Film 2.* David & Charles, 2009, 156.

Page 70
1. The New York Times. Grundberg, Andy. "Irving Penn, Fashion Photographer, is Dead at 92." October 8, 2009. http://www.nytimes.com/2009/10/08/arts/design/08penn.html?_r=1 (accessed December 2009)

Page 75
1. Levy, Joel. K.I.S.S. Guide to the Unexplained (Keep It Simple Guides).

2. The Skeptic's Dictionary. "Loch Ness 'monster.'" http://www.skepdic.com/nessie.html (accessed January 2010)

3. Ellis, Bill. *Aliens, Ghosts and Cults: Legends We Live.* University Press of Mississippi, 2001, 145-146.

Page 90
1. PBS. Horse Capture, George. "Edward Curtis: Shadow Catcher." American Masters. http://www.pbs.org/wnet/americanmasters/episodes/edward-curtis/shadow-catcher/568/ (accessed December 2009)

Page 95
1. Gustavson, Todd. *Camera: A History of Photography from Daguerreotype to Digital.* New York: Sterling Innovation, 2009, 101.

Page 100
1. NPR. Stamberg, Susan. "Bourke-White's 'Photography of Design': Early Work Found the Hidden Beauty in Industry." February 26, 2003. http://www.npr.org/templates/story/story.php?storyId=1175402 (accessed January 2010)

2. Time. Gray, Paul. "Books: Fortunate Life of Margaret Bourke-White." June 2, 1986. http://www.time.com/time/magazine/article/0,9171,961511,00.html (accessed January 2010)

Page 115
1. Sports Illustrated. Wolff, Alexander. "Unraveling the Jinx." January 15, 2002. http://sportsillustrated.cnn.com/inside_game/alexander_wolff/news/2002/01/15/wolff_viewpoint/ (accessed December 2009)

Page 120
1. The Virtual Museum of the City of San Francisco. Fowler, Dave. "Dorothea Lange and the Relocation of the Japanese." May 10, 1998. http://www.sfmuseum.org/hist/lange.html (accessed January 2010)

Page 125
1. The New York Times. "As to Picturing the Soul." July 24, 1911, 1. Quoted online, http://query.nytimes.com/gst/abstract.html?res=9406E5DD1131E233A25757C2A9619C946096D6CF (accessed January 2010)

2. Jeeves, Malcolm A. and Barry, R. J. *Science, Life and Christian Belief: a Survey of Contemporary Issues.* 1998, 139.

Page 130
1. The New York Times. McKinley, Jesse. "Helmut Newton Is Dead at 83; Photos Were Vogue Mainstay." Jan 25, 2004. http://www.nytimes.com/2004/01/25/nyregion/helmut-newton-is-dead-at-83-photos-were-vogue-mainstay.html?scp=2&sq=helmut%20newton%20ddead&st=cse (accessed January 2010)

Page 135
1. *Guinness World Records 2010: The Book of the Decade.* Guinness World Records, 197.

Page 137
1. City University of New York. Abdelkader, Rima. "Live Blogging Discussion on the Power of Wartime Photography." Feb. 4, 2010. http://blogs.journalism.cuny.edu/rimaabdelkader/2009/02/04/ethics-of-war-reporting/ (accessed February 2010)

Page 140
1. Foto Flock by Epson. Khaire, Kadambari. "The Legends of Photography: Patrick Demarchelier." http://www.fotoflock.com/index.php/learn-photography/history-of-photography/54-history/3538-the-legends-of-photography-patrick-demarchelier (accessed January 2010)

Page 150
1. Baron Wolman. http://www.fotobaron.com/?section_id=121& (accessed February 2010)

Page 165
1. Connolly, Bob and Anderson, Robin. "First Contact." Documentary. 1983. Australia, 1:11-1:23 of film.

Page 167
1. Stanford University. "Researchers Say Voters Swayed By Candidates Who Share Their Looks." http://news.stanford.edu/news/2008/october22/morph-102208.html (accessed February 2010)

Page 169
1. Ihagee and Exakta Products and History. http://www.ihagee.org/ (accessed January 2010)

2. The Camera Site. "Exakta Varex IIa." http://www.thecamerasite.net/01_SLR_Cameras/Pages/exacta.htm (accessed January 2010)

Page 170
1. The New York Times. Glueck, Grace. "Photography Review: Its Portrait Is Taken, then the Subject Is Eaten." Aug. 22, 2003. http://www.nytimes.com/2003/08/22/arts/photography-review-its-portrait-is-taken-then-the-subject-is-eaten.html (accessed January 2010)

Page 175
1. Brunvand, Jan Harold. *Curses, Broiled Again! The Hottest Urban Legends.* New York: W.W. Norton, 1989, 305-310.

Page 190
1. PBS. "Reporting America at War-The Reporters-Robert Capa." http://www.pbs.org/weta/reportingamericaatwar/reporters/capa/ (accessed January 2010)

Page 195
1. St. Leger-Gordon, Ruth E. *Witchcraft and Folklore of Dortmoor.* Bell Publishing Company, 1972, 128.

2. Controverscial. "The Witches Hat." http://www.controverscial.com/The%20Witches%20Hat.htm (accessed February 2010)

3. Buckland, Gail. *First Photographs: People, Places, & Phenomena as Captured for the First Time*. New York: Macmillan, 1980, 253.

Page 199
1. Britannica Online Encyclopedia. "LIFE (magazine)." http://www.britannica.com/EBchecked/topic/340026/Life (accessed February 2010)

2. Things and Other Stuff. "LIFE Magazine and LOOK Magazine Popularize Photojournalism in the 1930's." http://www.things-and-other-stuff.com/magazines/life-magazine.html (accessed February 2010)

Page 205
1. Johnson, Robert Flynn. *Anonymous: Enigmatic Images from Unknown Photographers*. Thames & Hudson, 2004.

Page 207
1. Sferrazza Anthony, Carl. America's First Families. 2000, 342. http://books.google.b ooks?id=44elUBU7FZkC&pg=PA342&dq=phot ographers+first+family&as_brr=3&cd=4#v=on ePage&q=photographers%20&f=false (accessed February 2010)

2. Watson, Robert P. Life In the White House. 2004http://books.google.com/books?id=FDjeF ogvUy4C&pg=PA7&dq=influence+of+%22th e+first+family%22&as_brr=3&cd=7#v=oneP age&q=photo&f=false (accessed February 2010)

Page 227
1. Merriam-Webster Online Dictionary. http://www.merriam-webster.com/dictionary/technology (accessed January 2010)

Page 229
1. Nikon Historical Society. Rotolini, R. "Nikon Rangefinder." 1981. http://www.nikonhs.org/history.html (accessed February 2010)

Page 237
1. Library of Congress. "One Hundred Years Toward Suffrage: An Overview." http://lcweb2.loc.gov/ammem/naw/nawstime.html (accessed February 2010)

Page 245
1. St. Leger-Gordon, Ruth E. *Witchcraft and Folklore of Dartmoor*. Bell Publishing Company, 1972, 126-127.

Page 260
1. The New York Times. Grundberg, Andy. "Alfred Eisenstaedt, 90: The Image of Activity." November 12, 1988. http://www.nytimes.com/1988/11/12/arts/alfred-eisenstaedt-90-the-image-of-activity.html (accessed February 2010)

Page 270
1. The New York Times. Barbour, Celia. "Coming Up For Air." December 17, 2007. http://www.nytimes.com/2007/12/16/realestate/16habi.html (accessed February 2010)

Page 275
1. Bogart, Barbara Allen. *Contemporary Legend: a Reader*. "The 'Image on Glass': Technology, Tradition, and the Emergence of Folklore," 133-148.

Page 277
1. PBS. "Presidential Photos." http://www.pbs.org/newshour/media/

presidential_photos/photo1.html (accessed February 2010)

2. Lindop, Edmund and Goldstein, Margaret J. America in the 1930s. 2009. http://books.google.com/books?id=2QPM9czl8HQC&p g=PA31&dq=photographers+FDR+polio& as_brr=3&cd=10#v=onePage&q=photogra phers%20FDR%20polio&f=false (accessed February 2010)

3. Oshinsky, David M. Polio: An American Story. 2005. http://books.google.com/books? id=cTliwSU62KIC&pg=PA42&dq=photogr aphers+FDR+polio&as_brr=3&cd=2#v=on ePage&q=photographers&f=false (accessed February 2010)

Page 280
1. Time. "Art: Rayograms." April 18, 1932. http://www.time.com/time/magazine/article/0,9171,743589,00.htm (accessed February 2010)

Page 285
1. *Guinness World Records 2010: The Book of the Decade*. Guinness World Records, 190.

Page 290
1. William Wegman. "About the Artist." http://www.wegmanworld.com/about.html (accessed February 2010)

Page 300
1. Time. Brunton, Michael. "Q&A With Andy Goldsworthy." April 13, 2007. http://www.time.com/time/arts/article/0,8599,1610464,00.html (accessed February 2010)

Page 307
1. National Journal. "2009 Vote Ratings: Politics As Usual." http://www.nationaljournal.com/njmagazine/cs_20100227_3230.php (accessed February 2010)

Page 315
1. Yalom, Irvin D. *Momma and the Meaning of Life: Tales of Psychotherapy*. 2000, 86.

Page 320
1. Cindy Sherman. "Biography." http://www.cindysherman.com/biography.shtml (accessed February 2010)

Page 329
1. Adobe Photoshop Hits Twenty. http://www.adobe.com/aboutadobe/pressroom/pressrel eases/201002/021810PS20Anniversary.html (accessed February 2010)

Page 330
1. Wall Street Journal. Sante, Luc. "Seeing Beauty in Our Shadows: Robert Frank's 'The Americans,' unpopular when first published, has shaped the way America looks at itself." September 18, 2009. http://online.wsj.com/article/S B10001424052970204518504544169533546202 432.html (accessed February 2010)

Page 335
1. The New York Times. "As to Picturing the Soul." July 24, 1911. Quoted online, http://query.nytimes.com/mem/archive-free/pdf?_r=2 &res=9406E5DD1131F233A25757C2A9619C94 6096D6CF (accessed March 2010)

Page 340
1. The Independent. Williams, Val. "Obituary:

Robert Doisneau." April 2, 1994. http://www.independent.co.uk/news/people/obituary-robert-doisneau-1367399.html (accessed February 2010)

Page 345
1. Fauxtography. http://www.snopes.com/photos/photos.asp (accessed March 2010)

Page 350
1. The New York Times. "Yousuf Karsh, 93, Who Photographed Famous and Infamous of 20th Century, Dies." July 14, 2002. http://www.nytimes.com/2002/07/14/obituaries/14KARS.html (accessed February 2010)

Page 359
1. Maximum Impact Research. Foo, Leo. "Minolta Maxxum 7000 AF SLR camera - Index Page. http://www.mir.com.my/rb/photography/hardwares/classics/maxxum7k/index.htm (accessed June 2010)

2. Cambridge in Colour. "Understanding Camera Autofocus." http://www.cambridgeincolour.com/tutorials/camera-autofocus.htm (accessed June 2010)

Page 370
1. The New York Times. Carson, Tom. "The Night Belongs to Us." Sunday Book Review, January 29, 2010. http://www.nytimes.com/2010/01/31/books/review/Carson-t.html (accessed February 2010)

BIBLIOGRAPHY

Davenport, Alma. *The History of Photography*. Albuquerque: University of New Mexico Press, 1992.

The International Center of Photography. *Encyclopedia of Photography*. Crown, New York: Random House Value, 1984.

ADDITIONAL CREDITS

Images on the following pages courtesy of Shutterstock®: cover (camera), 15, 28, 48, 55, 59, 68, 78, 79, 87, 88, 99, 108, 109, 115, 117, 118, 125, 128, 138, 139, 148, 157, 158, 168, 175, 178, 188, 195, 197, 198, 205, 209, 218, 219, 235, 239, 248, 249, 258, 268 (upholstery), 269, 275, 278, 279, 285, 288, 289, 298, 299, 304, 305, 307, 318, 319, 325, 329, 335, 338, 339, 368, 369.

Photograph on cover and spine: Happy sailor kissing nurse in Times Square during impromptu V-J Day celebration following announcement of the Japanese surrender and the end of WWII, August 14, 1945. Photograph by Alfred Eisenstaedt; courtesy Getty Images.

ACKNOWLEDGMENTS

Thank you to those who helped make this book possible: Leslie Alexander, Jay Cooper, Laura Itzkowitz, and Marisol Villamil.

About the Authors

Simon Alexander (SA) is an English portrait photographer living in New York with his wife, Leslie, and son Jack. Since graduating with a BA Honors Degree in Fine Art Photography, Simon has exhibited in Europe and America. His work is in the permanent archives of The National Portrait Gallery, London, and The Design Museum, London. Simon's work has also appeared in many books and magazines across the world.

Grier Cooper (GC) has been a working commercial photographer for more than 15 years. Her work has appeared on the cover of *Unity* magazine, and has been used in NBC's *Leap of Faith* and *Trauma*. She currently resides in San Rafael, California.

Bill Diller (WTD) is a self-taught freelance writer and photographer from Pigeon, Michigan, who specializes in nature-related subjects. Over the last 19 years, he has been published in numerous regional and national magazines, and for the last seven years has rented booth space at art and craft shows throughout the state, offering his photographs as prints and note cards.

David Greenberg (DJG) teaches screenwriting and film history at Drexel University and The University of The Arts in Philadelphia. David Greenberg's film *The True Meaning of Cool* won an award from the American Film Institute. His interest in photography led him to filmmaking, and he still regularly finds inspiration in still images. www.davidjgreenberg.com

Tom Hauck (TH) is an action photographer who has been capturing great athleticism for more than 20 years. Tom was a staff photographer for Getty Images before launching Tom Hauck Photography, an editorial and commercial photography company based in Portland, Oregon. He covers noteworthy events from the Super Bowl to the World Series and creates high-impact images for a variety clients, including *ESPN the Magazine*, Nike®, and Under Armor®. www.hauckphoto.com

Melissa M. LaRose (MLR) is an artist, a photographer, a writer, and a member of the film-making community in New Mexico. She holds a Fine Arts degree in Environmental Design from the University of Houston and an MA in Information Management. She hunts daily for inspiring, revolutionary, and authentic stories, concepts, and images on the streets of Albuquerque.

Matthew Roharik (MR) holds a BFA in Painting and Drawing from the Ohio State University. He is an internationally published editorial and advertising photographer. His advertising and commercial work has graced the pages of national magazines, television, newspapers, and billboards for the last 10 years. Some of his notable clients and publications include *Vogue,* MTV, and Nationwide Insurance.

David J. Schmidt (DJS), holder of a BA in Psychology from Point Loma Nazarene University, has written for publications in the US and Mexico regarding a number of topics, and co-authored *The Daily Book of Art.* Schmidt has been to 24 different countries, speaks 6 languages fluently, and is able to fake about a dozen others—a talent that helped him immensely in contacting some of the artists for this book. Schmidt is always fascinated by the diverse and unique ways in which human beings express themselves.

Christine Walsh-Newton (CWN) is an award-winning, published photographer and freelance designer from Dover, Ohio, where she is the owner of CWN Photography. She holds a BA in Management from Malone College and the Certified Professional Photographer designation from the Professional Photographic Certification Commission. She enjoys married life with her best friend, Dwight. www.cwnphotography.com

Erika Kotite (Editor) is an editor, writer, and lover of photography. After many years editing consumer magazines, including *Entrepreneur, Romantic Homes, Victorian Homes,* and *Hybrid Mom,* she currently produces books for major publishers. She also develops storylines and concepts for short- (online) and long-form television shows. Erika lives in Lambertville, New Jersey, in a 250-year-old house with her husband and three children.